W9-CKV-626

8/09

SPI
EGE
L&G
RAU

TALL TALES, TRUE STORIES, AND MY LIFE IN INK

JEFF JOHNSON

SPIEGEL & GRAU

NEW YORK

2009

This book is based on my true-life exploits.
To protect the rights of those whose paths have crossed mine,
most of the names have been changed and some of the events have been altered.

Copyright © 2009 by Jeff Johnson

All rights reserved.

Published in the United States by Spiegel & Grau,
an imprint of The Random House Publishing Group,
a division of Random House, Inc., New York.

The SPIEGEL & GRAU Design is a registered trademark of Random House, Inc.

ISBN 978-0-385-53052-1

www.spiegelandgrau.com

2 4 6 8 9 7 5 3 1

First Edition

Book design by Chris Welch

FOR ALL THE SWAMP PANTHERS DRAWING LATE TONIGHT.
DREAM HARD.

CONTENTS

PART THREE
LOVE & HATE

PART FOUR
WINE, SONG, AND YOUR MAMA

PART FIVE
TINY REVOLUTIONS

PART SIX
SMILE NOW, CRY LATER

TATTOO MACHINE

TATTOO MACHINE

INTRODUCTION

reeze image.

The curve of a hip is positioned in front of me, a warm, pink arc of living canvas draped in a pristine white towel. Just to my right, on a polished stainless steel counter, is an array of carefully arranged colors in small transparent cups. Of the ten million colors the human eye can detect, fewer than fifteen hundred have names. Some of these colors are mixed to broadcast from that unnamed region.

A wet razor sits beside this, dusted with delicate white peach fuzz, a furry remnant from our time in the trees. A translucent mound of petroleum jelly waits nearby. My gloves are robin's-egg blue. If you were to see this tableau without anything else in it, your imagination would likely lead you down an unpredictable road. Then you catch sight of the tattoo machine, a precisely tuned, custom-made brass liner with the kinetic potential of a hummingbird about to take flight, and it all starts to make sense.

Resume.

The atmosphere crashes in, a singular vibe refined by generations, part carnival midway and part hypermodern clinic, with a splash of a foreign bar from a fragment of a dream, all wrapped in a fragrant mélange of soap, solvents, and pheromones. It's Saturday, and the stereo blares an opera from the Met. A creepy German woman is going on about something, God knows what, but she's clearly insane

and has found her perfect venue at long last. Every square inch of the walls is covered in a dense riot of bright, twisting images. Everything is buzzing, the atmosphere charged to explode, like a claymore mine packed with acorns of magic.

In front of me this beautiful canvas sighs, indicating her willingness to proceed. There is a dimple in the swell of her hip. A lone freckle rides high on her side. These features will be my frame for the next few hours.

I've spent my life preparing for this moment. The odd, organic process that brought me and many of my colleagues to this instant again and again is not found in the curriculum of any school. It's more a combination of luck, being saddled with a seemingly unemployable spectrum of otherwise incompatible interests, and an inability or unwillingness to fit in anywhere else, probably in exactly that order.

This moment started with an idea. This developed into a story, a detailed description of a thing that did not yet exist, designed for a place that was previously blank, a snowy Fargo between a dimple and a lone fleck of pigmentation. Words form the first picture, pencils the next, until we arrive at the brink of transformation, the moment when something formed by nature is further formed by the imagination nature gave it.

Right now.

NO ONE SPEAKS for the tattoo industry. We have no president here, or even a representative. All the evil shit I've witnessed, and even done myself, all the bizarre events I've been sucked into or narrowly avoided, are only part of a larger picture. There are tattoo artists out there who go to church, who have never had a drink of any kind or even cursed. This may seem sad, and I certainly agree that it is, but it serves to illustrate the scope of the people involved. It has been my

pleasure to sample everything this strange occupation has to offer, and I'm both surprised and delighted to have survived to share it.

You'll want to read about the bloodbaths, the heroic tales of madness overcome, the rise and fall of empires, and recoil with an exhilarating wash of disgust and delight at the final bubbling gasp of earnest young men and women ejected from the life. It's all here.

Professionals reading this will sometimes smile, on occasion frown, and more than likely succumb to recurring bouts of paranoia if my attempts to drag their darkest fears into the light succeed. If they haven't been there, chances are the person next to them has. I expect to catch some shit about what I've related here. But I've always maintained that it's better to regret something you have done than something you haven't.

This isn't simply a memoir. It is also a personal look at the people behind an art form that has undergone a rebirth and is shaking the natal mucus from its drying wings as a new pool of exciting, schooled, and committed artists take their places. This is also a book about street shops and the artists that flourished or inexcusably withered in those fertile grounds. I want to give the reader a more complete picture of a tattoo artist's life and the lessons learned along the way, the things that a TV show or a visit to your local establishment can't capture, the things people wonder about when they look through the window that first time and ask themselves, *what's really going on in there?* This is what I've seen. You might not want to get a tattoo from me after reading this, but there you go. This is a story worth telling, a portrait worth painting, and the time to do it is now.

Tattoo artists graze many subcultures, more so, perhaps, than any other occupation. I like the world I'm part of the best. I fit in here, like so many other oddly shaped pegs, and that is a miracle in itself.

The people I know who are world-class in this profession put in some serious overtime. I doubt I'll ever be that motivated, and there's ample question as to whether I have the talent in the first place. For

closing on two decades I've been content to maintain a casual average. I've had high points, sure, and many industry-common lows, as you'll see. I've watched the thoroughbreds race past, and I've trampled a few old ponies myself.

So I hail squarely from the center ranks, far from the rarefied air of greatness and equally distant from the hobbling stragglers getting picked off at the back of the herd. The vantage point is good here. It's just right to offer a peek under the skirt of a fascinating profession.

PART ONE

FRIDAY IS MONDAY

From the outside at 9:00 AM the tattoo shop always reminds me of a fun-house curio shack lifted out of an old Eastern European circus. The inside is dark behind the permanently lit neon in the windows. There's a sort of crouched, architectural discontinuity about the place, like an enormous mechanical bullfrog or a giant that just lumbered out of the fog. It seems truly weird just sitting there.

Like a lot of tattoo artists, I work weekends, so Friday is my Monday. I unlock the back door (the keys to the front were lost in the distant past and for purely superstitious reasons never replaced) and go in, careful not to spill my coffee into my bulging art bag, as I have so many times. After flicking on the overhead lights, I make my initial survey.

I can tell most of what transpired the night before without reading any of the notes left for me or looking through the incident log. The flash on the wall looks slightly out of place. My eyes wander over the surface and gradually focus on two slightly crooked sheets. That would be Neal's work. I make a mental note to bitch him out later, the first on the day's list. When the list grows to five, I usually start writing.

It's a summer Friday, and the morning is already warm and bright, with only a high smear of cloud to give the sky some character. A total

bloodbath is imminent. I glance at the clock and then go into the back to check the list Billy Jack no doubt left last night.

Billy generally takes stock at the end of his shift, as does Patrick. No matter how tired they are when they're finally done, at the end of their shift (often four or five in the morning) they usually glance over the supplies so that I don't encounter any surprises. I find that we're well stocked, but there are some long-range-forecast items I need to deal with. Medium ink caps, thermo fax paper, and the hand wipes Patrick prefers. We must have had a run of fat people this week, because Billy has noted that we need to place an order for another two dozen XXL T-shirts. Our current screen-printing guy is good in that he lets me place orders of this size and delivers a quality product, but bad in that it often takes him a long time and many reminders to get him off his ass. Calling him is the first thing I do.

Next is my schedule, a red leather-bound book in my art bag. I fish it out and sit down at the desk to look it over. Booked solid. First up is this cryptic notation: "11:00 two girls, they have art, sm, 20, Kim(?)." Translation: two females between eighteen and twenty-one who already have their designs, which both described as "small," although people generally have varying definitions of size, so I have to be prepared for anything. One of them left a twenty-dollar deposit at some point, and "Kim" may have had a fresh tongue piercing, a crappy cell phone, or a lisp, because there is some question as to whether it's actually her name. It's also possible that they were referred by a customer named Kim.

Next is one-thirty. Good. Time to ram down some food in there somewhere so I can drink when I get home. The one-thirty is Dan, the marine dude with the demolition sleeve. All the hard stuff is done on this one, and I'm just putting in the gray wash in the background. There is a notation, "11," next to his name: the size of the shader I plan on using. So no huge planes left. So far so good.

Last appointment up, after the three hours slotted for Dan's arm,

is a bummer for two reasons. The day seems a little less bright. Notation: "4:30 Lindsey, finish, pd, rst." This woman is a real crab cake, as I recall. I'm coloring in something that has already been paid for and can be certain of getting stiffed on the tip. The tattoo is also on her wrist. I try never to book similar body parts back to back, but here I've done just that, probably just to get this bitch out of my hair. So four hours plus spent hunched in the same position. Going to be murder on my lower back. Chances are very good the first two girls will be getting theirs in the center of their lower backs. I can only hope.

Out of curiosity I flip the page over to Saturday to make sure all the drawings are done and in place in my art bag's active file. I notice that my two o'clock tomorrow is the aerobics-sculpted lesbian real estate developer getting the fire filled in on her absolutely bald crotch piece. I guess I'll have to find time to beat off before that one. Professional detachment and all that. Sigh.

Next I check my supplies. Everything is set, but I decide to toss some extra liners in the ultrasonic cleaner just in case. One of my appointments could cancel and then I could swoop in on the easy walk-ins. I might be able to knock that last one out really fast, as I am already tempted to do, and then help Neal bleed some of the pressure out of the lobby so the night shifters don't arrive to find themselves utterly buried. I check the supply of the enzyme we add to the ultrasonic fluid as I pour some in with my tubes. Good for another month. I add it to Billy's long-range-forecast list.

It's nine thirty. I go out front and light up a cigarette. Across the street there's a flower-dappled beater of an RV parked in front of the East Bank Lofts. The flowers are the kind you put in the bottom of the bathtub for traction. There's a woman on the roof of the RV who appears naked at first glance, except for a pink hat with a bright blue feather. I squint to get a better look. She's dressed in tight tangerine. An interesting omen.

Rick, our crazy guy and my part-time assistant, got stabbed pretty

bad in the lobby about three weeks ago. Cops, ambulances, the whole nine yards. He had to have surgery on his arm to reconnect some tendons and is just now coming around the shop again. I'll have to find something for him to do before he rolls in around noon. Maybe I'll set him up to spy on the tangerine woman, divine the meaning of the bathtub flowers, and generally discern her place in the cosmos. He loves that kind of thing.

I have the door propped open as I smoke, and the sunlight is streaming into the lobby. I check to see if the vast bloodstain in the gray carpet has dissipated. Amazingly, it appears to be almost gone. I guess our customers have been grinding away at it, tracking minute flecks of Rick's dried blood around the city. I have no idea what that carpet is made of, but I'm repeatedly amazed at its stain-repelling resilience. We're all glad Rick's going to be OK physically. He's a lunatic the shop has adopted and often believes he's Batman. The long-term psychological effects of popping his Batman bubble remain to be seen.

At least that mess seems to have resolved itself for now. There are only two other potential crises demanding my attention, two hot topics to keep on my radar screen through the day. I'm sort of on the fence about both of them.

Two days ago I was sitting on my front porch smoking a cigarette when a bald, middle-aged man walked cautiously up the steps. He was wearing a beige jacket in the eighty-degree heat, and there was a kingly glint in his eyes. Cop.

"You Jeff Johnson?"

"Yep." There was no point in denying it. I was sitting next to my own front door. I cast a mental net over the last few weeks to dredge up the trouble spots. Nothing to attract the attention of the police unless they were here about Rick.

He swept his jacket open to reveal a highly polished badge clipped to his belt.

"Federal marshal. You know Dave?"

Flashing the badge must have been a cue of some kind. Two groups of feds approached from either side. In less than ten seconds there were, count them, seven grim, sweaty, overdressed guys staring down at me. Three more waited at the foot of the stairs. Two more flanked the house.

While Detective Hard-ass interrogated me about Dave, an old friend of mine, the rest of them gave me that cop X-ray look, as though they could read my every thought and did not like what they were seeing. One big jackass kept his hand on his gun holster the entire time, in case I decided to mount an attack with my mechanical pencil. He really seemed eager to go Wyatt Earp, and in fact my mirror neurons were sending me the signal to take him first by jabbing him right in one of his muddy eyeballs.

When was the last time I saw Dave? What was he wearing? Who was he with? Did he have any facial hair? Of course, if I lied I was in "serious trouble."

Naturally, their ham-fisted interrogation went nowhere. I didn't have any answers, and I didn't want to get drawn into any long-winded lines of speculation. Finally, Wyatt Earp chimed in with his bright idea.

"Why don't you call him on his cell phone and set up a meeting, tell him you have a little something for him?" Like I was a drug dealer.

"Nope." Man, that guy was fucking stupid. The baron in the beige jacket gave him a "shut up" look. Even high on smack and in full-blown zombie mode (an unfortunately likely scenario), poor Dave would have understood instantly that such a call meant that I was surrounded by an army of feds and that he'd better drop whatever he was doing and blow town. It struck me that these guys probably didn't have a high success rate.

The head detective gave me his card, a surprisingly elegant Ro-

manesque on textured taupe, and they split with a few parting glares, as if to say they would be back. I went inside and cracked a beer. It was early, but it was my Saturday, after all. In an ongoing attempt to stay off Al Gore's shit list, I tossed the card into the recycling.

So as I stand in front of the shop on this bright Friday morning, smoking and casually studying bloodstains and the tangerine woman, I wonder if it is time to start burning release forms. It occurred to me last night that these guys might put two and two together and realize that other customers of mine knew Dave. Their addresses and home numbers were on those forms.

I shake my head. I'll cross that bridge when I come to it. The second item concerns one of the newer guys, Scott Ramsay. Not a big issue, but one that has to be handled carefully. Not long ago I heard he was back in the market after spending a short time at CalArts finishing an animation degree. He'd been working at Erno's in San Francisco for years, and I guess Erno's final, grisly downward spiral had prompted him to return to school and leave the life for a while. He's good. My latest, and hopefully final, night hog, a part-time hack who knew she was doomed, even though she tried pathetically hard, panicked at the news of his coming and had to be prematurely jettisoned.

Here is the problem. There are nothing but Trojans left. The saintly Billy Jack, who never errs, even in his nightmares; the bloodthirsty Patrick Spatters, a guy we still know very little about even after two plus years, but who has never been late or remiss in any way and is the kind of guy you'd want at your back in the event of an alien invasion; Brian the Kid, an affable boy-man with sharp moves and a reasonably good attitude; and Neal Sterling, the porky little hobbit guy who worked with Scott years ago and was instrumental in luring him back into a tattoo shop with rollicking tales of money and spring beaver. This is a lean staff for a place like the Sea Tramp. Including myself, that's only six active artists, plus Rick, who answers the phone

and does his best to help out, and Don Deaton, my business partner and mentor, who tattoos very rarely these days, now that he's entered his seventies. We have Wayne Smith, a guy I tattooed with in the mid-nineties, around when we need him, and sometimes another unusual young fellow who does great tattoos but is poorly groomed at times, plus a handful of other stand-ins I won't hire full time or whom Don boycotts for reasons known only to himself.

All of them picked up slack for a few weeks to cover the night hog's shifts. None of them said anything, but I knew they felt leaned on. Why couldn't I have waited a few weeks so they didn't have to work overtime? They had all known this was coming for months. Hadn't they done enough already? We'd just won the Best of Citysearch. Was this their reward?

So Scott's arrival has been greeted with a general sigh of relief. Even with guys coming in from Salem and elsewhere to fill in for a few days, it was a long haul. Scott fit in right away. Everyone liked him, even Patrick, who is a discerning, often almost telepathic judge of character. Month one: good. Month two: smooth as silk. I barely had to run the place. Month three: the shit hits the fan. Scott had an art show in New York. He needed to miss a Friday, Saturday, and Sunday. Double shifts for everyone.

After a quick powwow, we arrived at a solution. Scott would work like a slave upon his return to restore balance to everyone's sleep schedule, and while in New York he would venture down to Mott Street and retrieve four gallons of red sauce from Vicente's.

He agreed to this. The four gallons are now in a freezer at his cousin's, as they would not let him on the plane with them. Big mistake. Errors of protocol such as this can snowball easily, especially among the current crew of veteran ass kickers. Scott will have to be careful. I will have to watch his back for a while.

It's time to check the restroom.

The presentation of the restroom is of vital importance. In a busi-

ness where hospital-grade sanitation is required, a wrecked, mossy, filthy restroom can send the wrong signal. I go in armed with gloves, sprays, and a desire to get this job done fast.

It's not that bad. I wipe down the sink, tinker with the toilet until I'm convinced some daisy-assed pantsuit could feel safe and secure about rubbing her cheeks all over it, and head back to the front, mission accomplished. I look at the clock: 9:55.

Neal rolls up in his glistening black Acura at 9:59, Ray-Bans shading his bulging eyes, a jumbo Starbucks something-or-other in one hand. He cruises through the door and immediately charges the radio, clipping short my Butthole Surfers CD and cranking NPR. I've managed to get him hooked on *Science Friday*.

"How you doin'?" he says cheerily, slurping coffee and looking over the shop to see what remains to be done.

"Good."

"I'll vac. How's the blood spot?"

"Almost gone."

Neal shakes his head. "Fuckin' miracle."

Neal is the walk-in man today. He will soak up all the random street traffic. He still breaks a sweat sometimes, but he's hard-core, commando-grade stuff. He talks fast, he draws fast, he works fast, and he leaves like a hurricane at the end of his shift, after which I gather he takes his girlfriend to some nice place for dinner, where he no doubt eats and drinks fast. I like this guy. His drawings are done on time. He takes no shortcuts and is never ill. He shows up at least one minute early and leaves only when the job is done and never before. His workweek can stretch past fifty hours easily, but I've never heard a complaint. He's a pro.

Things pick up almost as soon as he arrives. The phone starts ringing. Neal fields most of the calls while he lays out the portfolios and sets up his station. I transfer my tubes from the ultrasonic to the autoclave and then wander back into the art room, where we house our

grinder, the needle-making station, the jumbo light table I built out of a drafting table, and the wall-to-wall bookcases. Like all ancient shops, we have a reference library that contains an uncounted number of books on an endless list of topics. A few years ago we acquired some antique evening chairs and a sofa, period pieces of carved lacquered wood and crushed red velvet. I lined the walls with old framed Horiyoshi prints, weird Buddhist erotica, and peacock feathers. It's got a nice bordello vibe. This room leads to the sanctum sanctorum, the boob-and-ass room, an entirely self-sufficient shop within the shop, which we use as a fourth and very private station.

I don't need to make any needles. Normally I have to make some almost every day, a tremendously lazy habit on my part. Most people just sit down and pound out a week's worth and get it over with. I can't bear it. But on my Monday I generally have enough stock left over from the week before to get through one day. There are at least a dozen outlets for premade needle configurations these days, but I don't use them. The product isn't bad, it just isn't personal. The curves are off, the mountings not right; it's just not what I'm used to. I argue that the only thing lazier than making needles every day is buying them premade.

At this point, I honestly have nothing to do. I tinker with my station and wait. No sign of the woman with the RV when I smoke another cigarette. Neal is set up and pacing like a caged cat.

My eleven o'clock appointments arrive with the first walk-ins, so we're both busy at the same time. Neal took station number two, so he is closer to the door. At a street shop, you absolutely must make contact with the customers as they come in. He does a good job of this as the flow begins. I take up the slack from my more remote location as needed, calling out greetings and inviting questions.

My two girls are charming. They show me some pictures of what they want, two black and gray birds with a rising sun behind them. A symbol of their friendship, though readers should bear in mind that

this is very rare. Most of the time people choose a tattoo because they like the image. It seldom "means" anything, though we won't get into that until the end. Their research is good, and they have a pleasant demeanor. We get to work.

Noon comes and goes, and I prepare for the second of the two. Rick has not yet arrived, and I'm getting a little worried about him. (I will later learn that he was in jail after breaking into an apartment he'd lived in two years ago because he thought he still lived there. He was incensed that they had redecorated.) Neal is blistering away at his crazy pace, gabbing with customers and their support people, drawing, and generally being both affable and efficient; essentially the perfect walk-in man. He's not doing hard designs today. He's doing the easy, whimsical stuff. A kanji with a good brushstroke on a foot, a name inside a rippling banner, a small blue star.

At one o'clock my first two gals saunter out satisfied, embarking on a great quest for the perfect margarita. Neither of them was named Kim. I have half an hour to kill, and I'm starving. The lobby has thinned out for the moment. A couple of browsers and three guys in basketball uniforms are smoking cigarettes out front. Time for lunch.

Neal blasts off to the deli around the corner for meatball sandwiches. I can't go anymore, as I've been banned from the place after an unfortunate smart-ass incident.

A few months ago I went into the place and discovered a strange equation posted on the wall. The owner is an ardent Republican, and after years of patronage I was still greeted with suspicion by the staff. The math in the posting attempted to show how raising the minimum wage would destroy the world. Around it was the art display of a first-grade class, little-kid pictures in Crayola on brown paper, depicting scenes from their lunch outing to the deli.

"Those kids need to get better math instructions," I commented to the guy taking my order. He gave me a stern look and glanced at the

owner, who was sitting on a nearby stool reading the newspaper and monitoring the register out of the corner of his eye. The owner looked up and actually snarled.

"My boss posted that," the preppy kid shot back.

"He isn't back there, is he?" I looked over the sandwich counter with a furrowed brow. "I don't want anyone that stupid touching my food."

It got ugly, so Neal goes now. I've been kicked out of many places, as you will read.

I guzzle some water and watch the street. The phone rings. This time it's Pat Spatters, gathering intelligence for the night shift.

"What's the future?" he asks.

"Bloodbath," I reply shortly.

"Hmm. I can't take walk-ins till ten. I don't know about Billy."

"He's clear, plus Brian the Kid will be around."

So far Neal has forced very little back into the next shift. He will try to leave them free and clear, but there are never any guarantees.

"Good," Pat replies. "Six." His shift time. He hangs up.

Patrick is a strange man, as I've already pointed out. There's a bit of the mad dog about him. He's a solid guy who talks tough and at the same time is tougher than he lets on. I consider him dangerous. Often I hear stories about him like, "Yeah, we went out drinking last night. Jesus, the last I saw of Patrick he was wrestling with some security guard and knocking over tables at such-and-such bar."

I asked him once why he never works out. He's tall and thin, obviously strong in a wiry, bobcat kind of way, but not a bulky guy. He shrugged.

"You don't have to be He-Man to kick some psycho stripper's head out of her ass. For guys . . ." He made an expansive gesture. "Guns, pipes . . ." He shrugged again. That was it.

Pat Spatters. An enigma, but he's on my side at this point, and I'm on his. I know as much about this guy as I do about my new cell

phone, but I trust him, and we've forged a bond out of respect and camaraderie. Other people love this guy, too. Women seem to instantly adore him, though he brushes them off gently. Guys see their best in him: a bizarre animal that danced down the yellow brick road with a drink in one hand and a blazing torch in the other. He's a supersolid tattoo artist and can be velvet-smooth when a light touch is required. He gives more gift certificates to charity raffles than any artist I have ever worked with. He's my friend.

Neal makes it back in record time, and we eat in the back while watching the front. Neal eats so fast it's like it never happened, so he's back out there almost immediately. I take a few more bites, and then my one thirty arrives, a few minutes early.

This dude is a U.S. marine. Like all people, they come in different shapes and sizes, both mentally and physically. They are nearly always well-behaved customers. Courteous, disciplined, intelligent . . . and these days a little sad.

The next three hours are pretty fun. Sure, this guy talks about fishing sometimes, but fishing is something I have always thought I might like to do, especially when he describes it. This is a good piece, and after several sessions it's almost finished. He takes good care of it. He's a customer with good taste who has done a great deal of research. His sleeve begins with a detonating claymore on the inside of his wrist. Layered above it are versions of historic bombings, ending with Hiroshima: a play on history and his role in it. A big skull presides over all of this at the top of his inner arm. On the front stands a transition of machine guns, muzzles facing down into old, worn boots, with helmets on their butts. This blurs into a slanted perspective view of Arlington National Cemetery. His beautiful blond girlfriend is pregnant now, and they're getting married. I hope he lives out this cycle and doesn't have to go back to Iraq, but he says he gets calls every day after two tours. This man is not a coward in anyone's

book, but maybe he's done enough. Sad marines are a bellwether not to be ignored.

Neal is blazing away, watching the currents and keeping up a running banter as the lobby fills. Still no Rick. I take a cigarette break while my customer calls home to check on his knocked-up sweetheart. The street out front is alive with activity, but the RV is just sitting there, the tangerine woman nowhere in sight. I look at the clock. It's two thirty. If I'm going to get a last cup of coffee at the J&M Café across the street, now is the time, as they are about to close. I drink mostly decaf now, and I don't really want to encourage Neal (he drinks too much coffee as it is), so I pass.

A young woman and her mother arrive looking for Scott, who rolls in just behind them. The mother waits while Scott disappears into the back with her daughter. I guess he's handling her breast back there, and the mother's feeling a little uncomfortable. Neal notices and engages her. It doesn't take long before she's swept up in the carnival atmosphere, laughing, her shoulders relaxed, looking ten years younger.

The tide ebbs and flows. At moments like this I can't help but wonder if my business model is right. I run a lean staff because I want them all to make money. I could easily have ten full-time employees, but with the oldest shop around I want the best people, and I don't want them crowded. It's better to lose a few jobs and send them over to friends at other shops than to have four good artists queued up and treading dead water on a slow day in January. Maybe we lose a little dough this way, but it's good payback for a job well done, and it's the old-school way of doing things. I'll stick with it, but I'm greedy, so it's hard.

Pretty soon Scott finishes and they reappear, the girl beaming, the tip of a bandage sticking out of her low-cut shirt over her right breast.

"You didn't tell me how to take care if it," she says. Scott hands her an aftercare sheet.

"Just take the bandage off after a few hours and wash it gently with soap and water," he says. "Softly, in a clockwise motion." Here he starts rubbing a light circle around his nipple. "And then get some lotion . . ." More rubbing. Laughter all around.

Four o'clock hits, and in walks my last appointment, a real handful. Today she's obviously dressed for work. Slender, early thirties, a white ruffled shirt and razor-creased black pants flared at the ankle over sparkling, slightly clunky boots, with a fitted black torso-hugger jacket and black Gucci briefcase to match. Her hair is so blond it's a single shade from white. She's talking on her cell and flicks a jade-painted index finger at me to indicate that she has not officially entered my business yet and is not to be approached.

Neal is burning away full bore, deep in some rocket job on a hippie woman's shoulder. He looks up briefly at my incoming, sizes her up instantly, frowns at me, and then carefully ignores her. I drape my arms over the tip wall, a signal of irritation only Neal can read. He sucks it up and takes on all the walk-in slack as I grow more and more . . . peaceful. By the time she's finished with her call, I'm brimming with so much slimy, fake humanity that my toes are curled for purchase lest my feet shoot out from under me.

"Mr. Johnson," she says finally, clipping her phone shut.

I smile. "Let's see the arm."

She shucks her jacket, rolls up her sleeve, and reveals the coconut-white skin of her forearm. There is the outline and shading of a Chinese dragon, almost blue against the translucence of her skin.

"All my friends kind of like it," she says, casually tossing off this half-compliment. Snarky cunt. "I was thinking maybe a blue theme, but I don't know. Maybe red is better."

We talk it over, and against all odds we start to hit it off. Neal is rampaging through the waiting crowd, separating the people who

have brought five support staffers with them and are thus clogging the lobby, establishing a complicated waiting list in his head. And still no Rick.

I get to work on Lindsey, and she is unexpectedly charming. She holds her shit together as I plow color into her dragon. We chat, and after a few minutes I change my mind about her. Maybe she was in a foul mood last time. She's a high-strung bitch, no doubt, but not really all that bad. I pity the poor fool who falls in love with a cold, hoof-in-mouth business assassin like her, but in small doses I can handle her. We talk about the failing real estate market, and then we're done.

It's five thirty. As Lindsey leaves, Billy Jack arrives, early as always. He looks over the crowd, nods at me, and then goes into the back. Billy is a big guy with a shaved head and looks like a younger Michael Ironside, but for some reason he's not that scary unless he blows his stack, which is rare. He's the hardest worker I have.

Neal takes a short break to outline the waiting list. The objective now is to get rid of the customers who brought five people with them to watch them get tattooed. Those five people are just going to mill around and generally take up space and also give the impression to anyone just arriving that the line is hours long and there is no way in hell they're getting anything done today.

There are two time-honored ways to go about getting rid of these people. One, Billy goes out and makes them an appointment for later that night, by which time half the group will have gotten bored and peeled off. Two, I go out, say I can fit in a small job before I leave, and knock out the girl who wants the butterfly and brought her five best friends to help her pick one out. This won't offend anyone who has been waiting longer than her because they have already established a relationship with Neal, and they don't really have any idea what the time factors are for any given piece.

So this afternoon Neal goes back out, and I follow a minute later.

"I can fit in something small before I go," I call out.

"That young lady wants a butterfly," Neal says, pointing her out. I zero in on her. Billy comes out a few minutes later, and Neal makes a few introductions. Billy chats quietly with the customers Neal has hooked him up with, the other big-posse people. He takes down their ideas and makes appointments with them for later that evening. Half the lobby empties within minutes, everyone headed for the neighborhood bars, from whence only the tattooees are likely to return.

I set up and get the butterfly girl started on her release form. While she's doing this, I smoke a cigarette out front. There are two unoccupied lawn chairs on the roof of the RV across the street. The tangerine girl has changed pants and is now wearing a red sequined mini. She's industriously beating a brown throw rug on the side of the loft buildings.

It only takes a few minutes to put the butterfly together. The girl dances out on a cloud with her friends in tow. I break down station one at high speed so Billy can set up. We have this down to a science, Billy and I. His station looks exactly like mine, for one thing. If a customer were to look away for a moment they might never notice the turnaround.

I take all my crap back to the boob-and-ass room and stow it there. After one more glance at tomorrow's schedule, I recheck the supplies and then go sort out the lobby. By now it's in shambles. Empty Big Gulp cups, a burrito wrapper under one of the wooden chairs, magazines strewn everywhere. The portfolios are scattered far and wide. A few reference books have been left out with their spines folded back.

I put everything back in order, and then I head back to the restroom. No big disasters here. Less than a minute's work. Then it's back into the shop for a final sweep. This usually entails cleaning up around the Xerox and thermo fax machines, where piles of confetti have formed. Billy has already dealt with it. Patrick has arrived and is busy hypnotizing people in the lobby. He barely notices me. Neal is

scrubbing down tubes in the back. Billy is already working on his first tattoo. Scott is drawing something at the light table. Brian the Kid ostensibly has the night off, but he'll roll in around eight o'clock to pitch in if they need him.

I gather up my art bag and split. It's a little after seven now. My back is not so bad, a two-drink fix. The RV across the street is gone.

Across the country today things have gone differently at other tattoo shops. Many had days just like mine, as my schedule is very common. But many didn't. At my old friend Matt Reed's shop, for example, there were eight artists working six- to eight-hour shifts. They listened to weird metal from Norway all day, and things went exceptionally smoothly. The shop manager there is not a tattoo artist. He just manages, and he does it very well. Over at Peter Archer's old place they probably sat around listening to strange zithery Indian stuff and gabbing about chakras and biodiesel, and everything was as calm as a mountain lake.

Don will be in later to tell stories, make any emergency supply runs, and swing his sword around. I take one last look back to make sure the outside lights are on. The place is ablaze with neon and twinkling gold, just as it should be, the huge windows like lamps, the door a bright gateway to dreams. I'll pop in after dinner and a few drinks, just to breathe the air and watch the mystical steam engine in shuddering motion. I love this place.

2

IMAGES

There are four generations of artwork under the roof of the Sea Tramp Tattoo Company, comprising four distinct eras that span nearly a century. Looking at it all early this morning, in that quiet period before the rest of the gang arrived, I could trace a number of continuous threads running through the collection. In some ways it seems as though we've come full circle, that at least some of the artists appear to be curling back into the past instead of moving forward. Somehow this strikes me as unhealthy.

My little shop is a microcosm in the wider world of tattooing. Looking at the art is like studying the arc of a rocket. If you can see the entire contrail you might be able to guess where the rocket will wind up next. But in my shop and many others I sense that the rocket may be headed back to the location of the people who fired it in the first place, hence my uneasiness. Let me explain.

Bert Grimm was the original owner of the Sea Tramp Tattoo Company, then called Bert Grimm's Tattoo Shoppe. Born in 1900, Bert originally started tattooing in St. Louis at the tender age of sixteen and kept going right up to his death in 1985. He's a legend today, a larger-than-life figure who's become part of tattoo history. From his association with Buffalo Bill to his run-ins with Bonnie and Clyde, the stories and articles about him and the artwork he left behind are all captured remnants from the dawn of modern electric tattooing.

Bert's flash still figures prominently in our shop. It's ancient now, of course, and much of it is slightly water damaged and randomly singed from when some asshole blew up the Sea Tramp and most of a downtown city block in 1989. In spite of this, it's held up well and may even have a little extra character as a result.

Motifwise this stuff is straight from the old-school catalog. Crude, half-naked, cross-eyed women, lumpy eagles, superbasic skulls, primitive crosses, lots of navy designs, some evil-looking bunnies, and an odd profusion of skunks. It's all done in a narrow range of watercolors, with bold outlines. The colors are faded now, but they show what the artists of that period had to work with. Rio Degennero, a stand-in employee at the Sea Tramp who is now in his late sixties, worked as the puke boy for his father, Lou Louis, in those days. The puke boy stood ready with Lysol and a mop, swabbing the vomit trails of sailors on shore leave. He says about the colors of the time, "They had black, red, and green, and they weren't too sure about the red and they weren't too sure about the green."

Next up in the timeline is Don Deaton. Don started tattooing in 1972. He's in his seventies now, as I've mentioned. Most of his flash was destroyed in the bombing, but the differences between what survived and what he's made since show interesting progress.

Don can really draw, for one thing. The motifs are similar to those of the previous era to some extent, but the lines are finer, and the watercolor shading is layered and precise, the range of colors broadened. National Tattoo Supply was making a variety of stable colors when Don began working.

His half-naked women are voluptuous, showing contrapposto and gravity. Their full bodies are straight out of seventies *Playboy* with a jiggling dash of John Buscema, the brilliant artist behind most of the early Conan comics. Genuine expressions have been captured in the faces, ranging from Viking fury to the Madonna's mute grief.

The navy stuff is still there, this time exhibiting perspective. Here

we also see the rise of the wizard and a proliferation of Harley motifs. The eagles are more realistic. The leaves on the roses are more natural. The introduction of pencil shading, colored pencils, and various inks adds vibrancy. The edges of the flash boards are tattered because they've been taken down so many times. These designs have been tattooed hundreds of times.

Then there's my stuff, a whole whopping shitload of it. I've drawn lots of flash over the years, more in the last five than in every previous year combined. But it was with my generation that the value of flash began to change, even diminish. People look at this stuff and they get ideas. Then you draw them. They increasingly don't want anything off the wall if they can see for themselves that you can create what they're after.

Even still, like Bert's and Don's, mine is similar to the work of other tattoo artists of my time, those who began tattooing in the early nineties. Like theirs, it reflects the customers' interests with a few random stylistic deviations and personal tweaks. In this way it retains the aspect of a news archive, recording for posterity the tattoo trends of the day.

There are no skulls here. No navy stuff or any military iconography whatsoever. The half-naked women are all geishas or winged angel chicks. Lots of flowers, but no roses. Hummingbirds, but no eagles. Mechanical dragons, anatomically correct butterflies, suns and moons. No panthers, skeletons, skunks, or peacocks. No wizards either.

And no watercolor. Today there are hundreds of colors on the market and they can be mixed to make hundreds more. I use colored pencils and blenders to try to approximate the variety.

Then we have the last contribution, the flash of Billy Jack, all of twenty-two years old. He is a perfect example of a large group of new tattoo artists, the so-called tattooers. Billy is a hardworking guy who's really into machine craft, and he's fully immersed himself in tattooing's rich history rather than its present or its frighteningly complicated future, which would trouble me to no end if I had any doubt in

the drive to succeed and grow that sets him apart. He and his peers have gone all the way back to the beginning, to Bert Grimm and Sailor Jerry and the like.

Billy's flash is all watercolor. Skulls, navy girls, anchors, cabbage roses, and spiderwebs. Essentially Bert Grimm revisited.

Except his flash is better. Billy can draw almost anything. His images are deliberately flat, echoing the old high-speed outlines. Classic images with more color, designed more thoughtfully, rendered with better tools and an eye educated by hindsight.

Some tattoo shops today are utterly choked with lesser versions of this rebirth-of-the-bell-bottom stuff, this "traditional American" pap. I can see the appeal on some levels, especially for the newcomers who can't really draw and find themselves employed for the moment because we really need people. But in the end, there's one glaring downside.

It doesn't reflect what people are buying, or where this art form is going. This retro art doesn't really make all that much money and is largely useless as a touchstone to describe in a visual sense the range of possibilities, so the archival flash trail ends here. It's not a reflection of what Billy is generally called on to do. So why draw this stuff? In most cases it's so easy that a motivated monkey could do it, but is that really it?

There are two ways to look at it, one good, one bad.

Like so many creative types, I live partially in my imagination. I grew up primarily in Houston and L.A., but I've always considered my hometown to be the one I superimposed over my early surroundings. It's a futuristic sort of place, with shady men in black suits I plan on killing when I get around to it, provided I can find that goddamned sword. The skyscrapers in the distance look a little like space ships. There are cavemen here, Atlanteans and the odd full-breasted princess. My brother Mark lives in a hobbit hole just around the corner.

As an adult, not much has changed, so it might not surprise you to

learn that after looking at the art on the walls all morning long and
analyzing what it might mean collectively, I find myself missing again
a place I've never been to, a phenomenon that existed in an era not
my own, and even lusting after the simpler times I know will never
come again. I am far from alone here. There are artists all over Amer-
ica and beyond who cherish their vision of this magical place in time,
a second- or third-generation hand-me-down memory as dog-eared
and worn as a favorite paperback.

It's a place that finds its purest form in slowly blurring minds and
fading snapshots, in aging faces that are monuments to hard booze,
sunlight, and a life well lived. I'm talking about the Long Beach Pike
just outside of L.A., the breeding ground of a generation of tattoo art-
ists now retiring, the generation that passed the torch to mine. This is
where Hollywood got its image of the industry, where so much of the
stereotype was formed.

The Long Beach Pike was a type of permanent circus. Tattoo shops
came and went along the midway. The ringleaders of this bunch had
names like Captain Jim, Colonel Todd, and Bert Grimm. The mad-
men and buccaneers they employed were characters like Piggy, Flame,
Fat Mike, Rio Degennero, and our own Don Deaton.

The faces are younger in those snapshots. The clothes are patently
ridiculous. The cars in the background have fins. Everyone is smok-
ing and their hair is wrong. But if even half of the stories are true,
these guys were having *fun*.

Crazy women with big hair were giving out blow jobs instead of
paying for the cherries and sparrows they got in areas tucked away
from all but the most intimate viewer. If you were born in the sixties,
I hate to say it, but you might be calling these sirens grandma. The
foggy nights were alive with laughter, the smell of cotton candy, knife-
wielding hoodlums, and packs of sailors on leave from boats in from
around the world. Here you could find real human mummies, navy
LSD, and beatnik jazz dorks. The red wine was flowing, and there was

mystery afoot in every neon-lit night. Heaven had stretched down and for a moment touched the surface of the world.

I like stories. I like telling them and I like hearing them. Over the years, I've heard hundreds of people reminisce in my chair, but none of them get that faraway, dreamy look like the old men from that time and place. It's probably the same expression Neil Armstrong gets when he rhapsodizes about dancing on the moon.

Every profession has its anecdotes, its codes and superstitions. The far-flung descendants of the Pike have a lot of commonalities, not the least of which is that we all carry a picture of it.

But in every real sense, that was a long time ago. Why are the Billy Jacks of the trade bringing the primitive art of those early days to the surface again? We all romanticize this era, but very few artists have been interested in re-creating any of the images from it until relatively recently.

I read an interview with the science fiction writer Robert Sawyer a little while ago. I had the chance to meet him while I was living in Toronto. I took a workshop he was teaching on short-story writing and found him to be a stand-up guy.

In the interview he talked about something called memes, and the reason for the end of the archival trail of flash in so many shops may lie there. Robert Sawyer and his wife have no children and thus have not perpetuated their DNA into the future. Instead, he says, they have transmitted something of themselves through time in the form of ideas.

It sounds a little like French science until you consider it. I've never been to the Pike, but an image of it exists in my mind as clearly as a memory formed by my own senses. Somehow this place is still alive, drifting down the decades like a live organism that exists in our heads and breeds through language.

Sometimes late at night, just after closing, if you're there at the right time, if it's been a fantastic shift, if you listen with your head

cocked just so, you might imagine the sound of the surf through the pier, an echo of high, hysterical laughter, the distant voices of sailors singing a foreign dirge, whispered pleas, seagulls, and under it all the steam trills of a calliope. Billy Jack can hear it. I think the best of the tattooers can.

It seems entirely possible that our memes are dying as tattooing emerges as a higher art form. The projections of places like the Pike are dimming, fading into obscurity. That might be why Billy Jack and his generation are reviving the old stuff—because they can hear the last strike of a distant, resonant bell going silent for all time. They are our historians, preserving something that would otherwise be lost in time. I hope this is true, and I hope they grow up to contribute to real progress as well.

FLASH IS GOING the way of the dodo in any case. Looking at my stuff, I realize I drew most of it out of some misguided sense of duty. Today it's little more than excellent wallpaper. Tattoo shops are supposed to have it on the walls, and it's a mark of amateurism if it's bought out of the back of a magazine. So I keep drawing, and, in one way at least, keep the record going. Flash will always be useful as a guide or touchstone, but the era of the all-custom shop is at hand.

Like it or not, this industry is now being driven by consumers, and their perceptions are formed at the industry media's cutting edge. There are several good magazines showing interesting work from around the world. Picture books are coming out all the time. People can see fantastic work all around them, in every bar, in every café. This comes as hard news to many, and a percentage of my peers have gone into ostrich mode to ignore this unsettling truth. This is the darker interpretation of revisiting the era of Bert Grimm and Sailor Jerry, that it's the secluded kingdom of throwbacks, a dreary Monaco of paranoid cowards.

There are tattoo artists now who can do almost anything, and that single fact has changed everything. If the only limit is the imagination of the consumer, then control has shifted out of our hands and a new Darwinism is afoot. We can't pick and choose what people get anymore because they'll just go somewhere else. We can act as guides, as advisers, but not much more. So flash is dead, though no one can really put a date on the headstone. The era of the skilled artist for hire sneaked up on us. If you can't draw, if you know nothing about art, then you better move your huckster ass to a seedy backwater like Reno or some other shitscape, maybe Snuff's Landing in New Jersey, and try to stay off the real-world playing field.

ONE MEASURE OF a modern tattoo design, a standard that may become paramount in the very near future, is conceptual creativity. Does anyone else have this design? How much consideration went into its development? Is it singular, as unique as the wearer?

The designs are getting bigger, the tools better, and the stronger artists are throwing tradition to the wind, rewriting the rule book with every tattoo. Shitty cartoon drawings have given way to carefully composed paintings in one generation. Everywhere I look I see good artists digging deeper into themselves, pulling fantastic notions from the bottom of their creative wells, and I see the rest slowly getting picked off or running back to the shelter of the Golden Age.

I don't really traffic in classic images, and I haven't tattooed any flash at all in two or three years, even though I still draw the stuff for the stated reasons. People arrive with elaborate ideas, and I figure out how to make them happen. And it's not just me this has happened to. It's happening in every city, everywhere.

How do I feel about this? Like everyone who ever found themselves at a crossroads, I'm of two minds, and I can say for certain that reminiscing along these lines has done nothing for my sense of well-

being. By day I know that I will sally forth and destroy all in my path. I've kept up with things. I know the score. I'm going forward, not backward.

But at night, when it's dark and I'm alone with my thoughts, I confess I worry about slipping, losing the pulse of the images, about being a name on a wall somewhere with all dynamic vitality lost, and then I'm as paranoid as the worst of the tattooers. At times like this, looking at the rocket trail and where we're headed, I think the future may be for the drunk or the insanely bold. So I drink.

3

WHAT TO LOOK FOR

Not long ago, my cat, the fearsome Mr. Peepers, got a big ol' sore on his tongue and started drooling all over his mighty chest. It was time to take him to the vet for some torture. He has since wisely concealed any hint of illness from me.

I hadn't been there since I had his balls chopped off, and I knew from the rumor mill that there was a new tattoo shop in the area. It turned out to be right next door, so after I dropped the poor cat off I decided to have a peek inside.

The day was rainy and cold, so I had a jacket on, thus hiding any big tattoos on my person. There was nothing to give me away as a tattoo artist. To the unbelievably inept guys behind the counter, I was a potential customer. I quickly understood why the place was a graveyard and accurately predicted its imminent demise.

The interior was undeniably swank. Someone's mother or girlfriend had dropped a lot of money on the place. Lots of buffed stainless steel, recessed halogen lighting, and old-school flash from floor to ceiling. The two artists were sitting behind a wide counter facing the door. They looked up when I came in with hard, tough-guy expressions, like two frat boys trying out for a TV show about San Quentin.

I smiled. They stared back blankly, either stoned or utterly uninterested in doing any business.

"'Sup," one of them finally managed.

"Hey," I replied. "Nice place."

One of them snorted, as if to indicate how stupid I was for pointing out something so obvious. His partner attempted to stare me down, his expression slowly morphing into an exquisite distillation of disdain. How utterly precious, I thought. This wasn't a business at all. It was their clubhouse. They looked back down at their magazines. I half expected the vibe of this place to rise up and shank me.

"My cat has an abscess on his tongue," I continued. This got their attention, at least to the point where they looked up again.

"A great big one. Drooling like a faucet. Never seen anything like it."

They said nothing.

I introduced myself and immediately they turned into real people. They were friends with one of the kids who works for me, so they knew who I was. We chatted pleasantly for a few minutes until their territorial hackles went up. I left, pleased that they would never be any kind of competition. If either of those surly dipshits worked for me, I'd can them on the first day, probably in the first hour, maybe even the first few minutes.

IT USED TO be that in any given city of a million or so there would be a small handful of shops. When Don Deaton took over the Sea Tramp in 1976, there were two parlors in Portland. Don hatched a novel scheme for the time, one that other people were going to pick up on later.

"How can we distinguish ourselves from the competition?" he wondered, pacing back and forth. "There must be a way to rise above the norm, to set ourselves apart. I know! Let's treat the customers like *customers,* like this a real business!"

This act of marketing genius was both a revolutionary form of mu-

tiny against the prevailing code of the time and a breakthrough on the same scale as the advent of the automatic transmission. It's amazing that there are still tattoo shops out there that haven't figured out what Don did all those years ago. Here's your first pointer.

Is the artist pushy, morose, arrogant, or brooding? Were you greeted with the same level of courtesy you might expect at the police station, if you were covered in vomit at 4:00 AM? Go somewhere else. The field is wide enough not to have to deal with some princess with a dirty diaper trapped in his or her blowhole. Hashing out ideas is part of the job. Listening to the customer is important. It's the very first step in a long sequence of events that leads to a quality product. Your prima donna won't hold your hand for a minute, rolls their eyes at your questions, and has all the charm and character of your new cell mate? Hit 'em where it hurts. Right in the bank account.

Doing your homework is a must. Every experienced working artist has something they're excited about, a style they love above all others. Your modern tattoo artist is one of many talents, and for small jobs a reputable shop is an all-service operation, meaning anyone there is qualified. But if you want something big or complicated, it's your job to find out who really rips it up in that category. You wind up with a happy artist if you do this, and you can be sure it will be reflected in both the work and the price.

Portfolios are a must, but it's far better to see something in real life. If you see a piece you like, ask the wearer where he or she got it. Most of the time they'll tell you. People are proud of good work and generally happy to refer someone to the mind behind it. Consider looking at what an artist is working on when you come in to look around. Be a pain in the ass (sort of). It's your money and your skin.

Don't let them draw on you. This, I predict, will lead to some fist-fights and a few death threats, but it's true, so fuck it. Direct to skin is the playground of some lazy, lazy fuckers. I go around and around this issue with some of my old cronies, but let's get real and admit the

truth. No one's first draft is as good as a second or third draft, and when someone draws directly on you with a pen or (gasp) a toothpick dipped into their previously pure pigment, it's a first draft. They didn't take the time to figure out how to do it the best way. They never even did a sketch to consider the compositional options. The use of transfers is an industry-wide practice today. There *are* times when you have to draw directly onto the skin, like when you're putting in a wind or a smoke background on a sleeve, or adjusting the area around a knee or an elbow, or when doing a cover-up, but these are exceptions to the rule. Direct-to-skin drawing, at its very worst, is a pressure sales tactic. People can be cowed into getting something they don't feel sure about if the artist invests enough hands-on time in the transaction.

And for God's sake, pay attention to the toilet! Restrooms are easy to keep clean. All that shit you never see, the complicated backroom world of autoclaves, enzyme baths, ultrasonic tanks, and so on? Not so easy. The same goes for the artist. If they look dirty, you can logically infer that they place little value on cleanliness.

The A team and the B team.

With very few notable exceptions, every shop has artists of varying degrees of competence. The A team is generally booked up well in advance, but there are always cancellations. The B team is not. If you want a dolphin or a name, it doesn't matter, but if you want something hard, wait for an appointment unless your research has led you to an up-and-coming B teamer.

And you, dear customer, who pays my bills and empowers my kooky lifestyle, there are things you should never do, and I see them all the time. Every tattoo artist will recognize this and gnash their teeth.

I personally don't like sports. Some tattoo artists do, but not me. A bunch of grown men chasing around a little ball . . . I don't know, it's embarrassing. So don't jabber on and on for three hours about the home team, or any team for that matter. I just don't care, and it's

powerfully irritating. Sometimes I look at my schedule and my heart sinks when I see you're on it. Driving to work on those days is like driving to an appointment for a prostate exam.

And don't bother giving me any kind of line like, "I'm a lawyer. Here's my card if you ever need any advice." You know what? Fuck you. You know who you are, and we know what you're up to. If we ever call that number, you're surprised, even shocked, and then evasive. It's like your Mexican gardener calling you at the office looking to score weed. To the very rich, we'll always be to the left of your waiter and a step above the poor soul who details your Hummer. I'm not part of your servant class, which is part of the reason I got into this game. You can take that card and stick it up your powdered ass.

And sweetheart, touching you is not my reward at the end of the rainbow. It's my job. Someone with a nicer rack than yours will be in soon, and they might actually give me a blow job. Sitting around after work griping over tequila with my colleagues, I hear it again and again. Beauty translates for some into a bending of the rules, a "lucky you" mentality so trite and common it's ugly. No tip, demanding of special treatment . . . It's tiresome at the very least.

Vegans smell like fried chicken when they sweat. And they tend to pass out. For heaven's sake, can't something be done about that?

"I'm from out of town." What kind of witless rube would utter this sentence in a tattoo shop? With the exception of world-class shops that attract international attention and responsible tourist venues in places like Vegas or New Orleans, this is a business that relies on returns, word-of-mouth, and people seeing what can be done. That tattoo is my business card. What? You mean no one is ever going to see it except your church group in Oklahoma City? And you think this means you don't need an appointment? B team, you're up!

4

SHOP TALK

Almost every industry develops its own jargon over time. While researching the provenance of the predictably colorful slang used around the shop and in the tattoo world in general, I came across some interesting stuff.

Big business has some understandably stale lexicological grass turds. "Mission critical" means very important and probably crops up in water-cooler commando moments. "Leapfrogging" apparently refers to the time-honored corporate practice of chopping the legs out from under everyone in front of you. "Offline" has no doubt found its way into the government culture by now, as it means you're about to lie about something and don't want any record of it. "Special sauce" is apparently a proprietary secret. Yuck.

New York City waste management workers, also known as garbage men, refer to maggots as "disco rice" and to a generously filled used condom as a "Coney Island Whitefish." These guys clearly have a superior imagination.

Surgeons refer to inept surgical interns as "007." Hmm. A license to kill.

Any shop that's been around for a while develops its own patois. Some of it overlaps with that of other shops and geographic locations to form an industry-wide language. The West Coast version found at the Sea Tramp Tattoo Company has spread far and wide as former

employees and apprentices carry our code language to the far corners of the world. Some of the terms are unique to us, others we imported and adopted. Some terms and phrases have their origin in the distant past, hailing from Bert Grimm and Don Deaton's old stomping grounds on the Long Beach Pike in the late sixties and early seventies. They change over time as well, sometimes mutating into something unrecognizably new and occasionally falling out of use altogether.

"Bloodbath" has no clear point of origin. Essentially, a "bloodbath" describes a point of extremely high tension either behind or just ahead of you. Your schedule is jam-packed. So is everybody else's. It's 10:00 AM and the phone is already ringing off the hook, a line is forming at the door, and the people in it are not getting along. It's just been discovered that the toilet is broken. A cop car pulls up across the street and just sits there. At this point you might glance over at your equally apprehensive crony and say something like "Uh-oh, dude. Blood-bath."

Similarly, I might arrive early in the morning to find the shop torn to pieces. The carpet in the lobby is a field of ground-in Cheetos, spilled drinks, and gum wrappers. Chairs are scattered everywhere. The main desk is littered with a pile of reference books five deep. The Xerox station is in ruins, buried under scraps of paper, some of which are mysteriously wet. The thermo fax machine is radiating a cloud of superheated long-string polymers. Even the plants in the window look exhausted. A smell hangs in the air, a rich, dense potpourri of nervous sweat, fried chicken, and dangerous chemicals. Maybe I'll find a note like this one Patrick once left me. His hands were obviously bloated ham hocks when he scribbled this expressive missive and taped it to my locker. "Four AM. Bloodbath. Need strong drink. Mess. Sorry."

Trojan. A solid, no-nonsense, business-oriented tattoo artist. A Trojan is never late and never breaks. They will always arrive early to get

a jump on any potential surprises. They take the job seriously and can be relied on to fix any sink, change any lightbulb, or wipe the floor with any scumbag. They do these things without being asked and don't brag about it. You can rely on them to arrive, set everything into professional working order, and then get to the job at hand. They don't need a babysitter, a boss, or anyone to hold their hand. They're never afraid to ask for help or advice, because their ego has taken a backseat to their desire to get it right every time. They are passionate about everything and have learned every lesson in this book and more. With a few notable exceptions, it takes a minimum of five hard years in a very good place to become a Trojan. You have to be smart and motivated. Morons and trust-fund kids need not apply.

Tattoo psychosis. A condition that affects some tattoo artists, wherein they become territorial egomaniacs who believe they have divine powers now that they are finally making actual money doing art. These people are usually really, really into it, often claiming they eat, sleep, and breathe tattooing, or some other cliché, and woe to the philistine who offers a view contrary to their own. Sometimes they're brooding little beady-eyed cocksuckers, sometimes gun-toting apes, but they're never very popular. Trojans often make short work of them.

Taco valve. You've just witnessed your cohort's one o'clock appointment snarf down a jumbo supersized fast-food buffet. Shortly they will be in pain, their body tense, their system ratcheting into high gear as age-old biological reflexes kick in. Time to lean in and say, "That 'TV' show is coming on at two." Translation: Cut this one short before we wind up tattooing in a cloud of mustard gas. It's true that we advise eating before a tattoo. It helps to stabilize your blood sugar, for one thing. But if there was ever a time to eat something healthy, this is it.

Bunny or a total bunny. A customer on pain pills, et cetera. This one is pretty old and stale and has fallen out of general use except in describing extravagant pharmaceutical abuse. Interestingly, "bunny" shows up in sport biking as a reference to an attractive woman, sort of like Playboy Bunnies. Women generally take tattoos better, so our bunnies are more often men.

Pee-pee truck. Whoever coined this reference to the aggressive, my-vehicle-makes-my-dick-bigger crowd deserves a medal. I think it was Matt Reed, a local icon we will hear much more about later. The most recent permutation is "Dee Dee called." This is a general heads-up, a sort of vague, sinister warning. Someone has pulled up in a planet-frying monster truck with fanatical Jesus/homophobic/war stickers all over the glistening chrome bumpers. Said person may be wearing a cowboy hat in some of the darker scenarios. It extends far beyond that, however. Say you've just overheard the lady in the impeccable gray Prada power suit in the lobby bitching out a subordinate on her tiny cell phone. You gather she's a recently divorced public prosecutor who has just joined Alcoholics Anonymous and fired her psychiatrist. Mouth the words "pee-pee truck" to the doomed artist as he or she goes in.

Packer. Someone who is concealing something on the medical portion of his or her release form. Recently I was tattooing a woman who revealed halfway through her tattoo that she suffered from debilitating arthritis, caused, her doctors said, by an unknown virus. There was nothing on her release form to indicate I was working on a person with an unknown virus. That was a rush job. If she had been honest, I might have asked her to consult her physician first. I just don't like the "unknown" part of the whole thing. It gives me the Fear (see chapter 11).

Pork chop. This is just an easy tattoo, something the more experi-

enced artists usually pass down to the newer ones to cut their teeth on. These tattoos are usually a little old-fashioned and, you guessed it, no bigger than a pork chop. This term seems to be industry-wide.

Night hog. A crappy tattoo artist, the weak link in the chain. This one is pretty much a Sea Tramp term, though like "proactive," an increasingly popular and dubious word, it seems to be making the rounds.

Scratcher. A convict dipshit with a "gun." This is someone with no formal training, a type of ghetto/graffiti low-water mark. And a stinging insult to hurl at a professional. A "gun" is what a scratcher calls a tattoo machine. These terms are also industry-wide, although some of the newcomers seem a little confused about the semantic nuances of "machine" versus "gun."

Boy butter. This colorful name for petroleum jelly originated on the Pike.

Chud or Chudder. A customer that barfs.

Tramp stamp. A tattoo in the center of a woman's lower back. Also referred to as a "California bumper sticker." The Germans refer to this as "arschgeweih," which translates as "ass antler." Bravo!

Clean. A technically flawless tattoo.

Time fighter started in San Diego and was unfortunately imported into our midst. This is a somewhat cruel moniker reserved for the pushy, face-lift BMW crowd. I have banned this one on the grounds that using it is a symptom of nascent tattoo psychosis.

Sidebusting. Putting a tattoo in direct contact with another artist's work, often used in a pejorative manner. I do this all the time. It simply means you can't claim the piece as your own without a long disclaimer. That's fine with me. We are hired to do a job, so sidebusting seems entirely reasonable. Imagine if you commissioned a painting but the painter refused to do it on the grounds that it might integrate with another's work on display in your

home or gallery. You are generally accused of sidebusting by artists with tattoo psychosis.

Bonus hole. A customer with an allergy to latex, the stuff condoms are made of.

Dain bramage. This comes from huffing in too many solvents and/or hazardous chemicals and was coined by Don Deaton decades ago. The dementia associated with breathing toxic fumes is never to be underestimated.

Swamp panther, or occasionally **snow leopard,** depending on the season. A full-scale bloodbath has just been successfully navigated. Whoever seized the rudder and guided the situation away from seemingly certain disaster is a swamp panther. If this person made a crushing amount of money at the same time, worked some serious magic, diffused a Dee Dee bonus hole bomb or two, or did a lesser combination of these on a solo shift, then they have earned the much-coveted title of "pussy-eating swamp panther" and may ride high on the esteem of their colleagues for at least a week, or until they are deposed by someone else in the next bloodbath.

We need some new terms these days. What would be a colorful code name for a passed-out vegetarian? If I ever get a really pasty, scrawny person with the clothing and affectations that peg them as an idealist ready to wind up on my floor in a drooling pile, I shudder. What to call these people . . . "Mushrooms"? You can see how hard it is.

And what about our health inspectors, those inept little dudes with their clipboards, an eighth-grade education, and their impossibly feckless support staff, those rude, ignorant fat chicks in the state capital basements? "Blowbots"? Maybe an acronym for piece of shithead . . . "Posh"? Enough.

Here is a story told with bloodshot eyes and hoary stubble on a

grim face: "Dude, it was a *Dee Dee* on speed dial unholy *bloodbath.* No *pork chops,* a mid-shift seismic *California bumper sticker taco valve* explosion, a fucking parade of drunks brimming with *Chud* potential and I ran out of *boy butter* after the second fight in the lobby. *Bonus hole* city to boot."

This, my friend, is a *pussy-eating swamp panther.*

BIG FAT MOTH

No one is always right, not the artist, not even the customer.

RECENTLY AN ARMY recruiter brought in three potential soldiers. All three had matching kanji symbols. This was an actual government official, a stern, inflexible moron in full uniform. He lined up his prospects and had them display their symbols, then motioned for Neal, the artist on shift, with a chop of his callused hand.

"I need to know that these tattoos aren't gang related," the recruiter said in a stentorian voice.

"I don't really read Chinese," Neal said after a cautious examination. Neal is an affable guy, a pro, so he thought he'd at least politely glance at them. The recruiter frowned.

"It's Japanese," one of the would-be recruits offered.

"Hmm," Neal replied. "I can't read that either. Sorry. You mean you guys don't know what symbol you got? Can't you just tell him?"

The recruits rolled their eyes at each other behind their shepherd's back, as if to say *thank god*. The recruiter snorted.

"I was under the impression that this is what you do," the recruiter said, obviously suspicious now. "Are you telling me that you don't know what you're doing?"

Neal shrugged. "You can try to look it up if you want. We've got some good books."

He dug out the kanji folder and watched as the recruiter slowly went through it, occasionally holding it up and comparing a symbol against the three before him. Eventually he slapped the book down on the counter and turned to Neal again, his eyes smoldering.

"You realize I'm on official business," he said evenly.

Neal nodded.

"What's your name, young man?" He whipped a small pad out of his pocket and clicked his ballpoint pen.

"Sam Spade," Neal answered. This name was duly recorded.

DO I KNOW what a Patagonian liver-spotted lilac looks like? Nah. If you bring in a picture, I hope you researched it. I'm serious, because we see countless images a year and only remember a fraction of them. In all honesty, I cannot at this time remember the difference between a daffodil and a lilac. I just never bothered to shuffle the information into long-term storage. There is no such thing as a human Google image bank.

The kanji symbols drawn on napkins, the weird foreign writing from some guy in a bar, the standard of Croatia scribbled on a coaster . . . These are dangerous waters. You aren't sure what any of it means. We aren't either.

Image confusion happens. If you ask your tattoo artist to do the research for you, sure, you might pay a little extra, but you will get the goods. If you do the legwork yourself, do it well. Trust is a two-way street. It's your tattoo, but it's forever attached to the tattoo artist's reputation.

Case in point.

An old pal of mine was working outside Fort Lewis, Washington,

hoovering up the easy money always found around military bases. The GIs get homesick, so one of the things they do is get a tattoo of their state flag, something to remind them of home. These are Southern states, mostly.

A guy came in and said he wanted the Texas state flag.

"I don't really know what that one looks like," my friend said, envisioning something with a star on it. "Go find a picture and I'll be happy to do it for you."

"I can draw it," the guy said. "Shit, I'm a Texan."

His drawing was pretty convincing and the tattoo went well. A few weeks later he crashed through the door, scarlet with fury and spoiling for a fight.

"This ain't the flag of Texas, and I ain't no fuckin' Portuguese!"

This happens.

IF YOU BRING your own design into a shop, chances are it will kick around for a few days before it finally gets purged. There are copies, transfers, et cetera. Usually at the end of the week I clear out my folder and toss all the completed stuff into the recycling so it doesn't clog my admittedly crappy filing system.

Occasionally a customer will see the last few designs I've done while I'm rifling through my stack. Sometimes they have interesting comments.

"Eww. Someone got that?" my appointment asked, pointing at a drawing. I held it up.

"Yeah. I just did a small set of these on a group earlier." It was a Xerox copy of a picture of a curiously chubby butterfly. Underneath the image was some italic Latin nomenclature, of course not part of the actual tattoo.

"A moth," my appointment said, pointing at the writing.

"Moth?" This was news.

"Yeah. Look at the writing. Who would get a big fat moth?"

My Latin had failed me again.

A FEW YEARS ago, one of my regular customers brought in her mother's family crest. She'd gotten a Celtic image representing her father's heritage months ago, and now it was time to get something for her mom and grandma, the Italians. Eventually she found the crest, and I put it on her upper back, a nice, swirly thing with brilliant greens.

The masterpiece was unveiled at a family get-together a few months later. Her mother smiled at first, but then leaned in a little closer and frowned. She pointed out that her maiden name was misspelled. A single letter was off. They got back on the Web, went to the site she had originally used, and punched in the correct spelling, holding their breath, hoping that it was just another spelling of the same family name.

An entirely different crest appeared.

Is this my fault? I never tattooed this person again. Somehow, this cranky bitch's head was so far up her ass she couldn't spell her own mother's name, and in her mind it was my fault. Go figure.

It's amazing how many people can't spell their *spouse's* name. As a safeguard, I always have them write it out themselves before I make the fancy version. If they look even slightly pensive, I suggest they call and make absolutely sure. It blows the element of surprise if they don't handle it well, so we have a convenient list of lies they can fall back on.

"Honey, I'm at the mall and I'm entering us into a free car give-away. I put in one entry for me and I want to put in one for you to double our chances, but I'm drawing a blank. How the hell do you spell your full name and does our street name have two e's or one?"

Or if they think that won't work, there's the more dramatic:

"Hey, baby, I'm seriously fucked. This cop wants to know I'm actually married and that I'm driving straight home and giving you the keys. He wants to ask you some questions. I'm handing over the phone. . . ."

Is that so hard?

This system was put into place after a truly tragic tattoo I put on just before a wedding. One minute we had a giddy bride-to-be on our hands, and a few hours later a wretched creature from *One Flew over the Cuckoo's Nest*.

This stunningly beautiful young woman with finishing-school posture was also impossibly sweet, the kind of perfect creature who generally winds up with a bland, generically handsome would-be bit actor who's kicking ass in some accounting firm and has a natural golf game.

Her fiancé's name was Al, and she wanted to surprise him by getting his name tattooed on her upper arm where it would show below the strap of her wedding dress. She was absolutely on a cloud. Such was her magnetism that all of us were swept up in her bridal glee whether we liked it or not.

"Al is short for Alphonsinino," she said as I set up. "Do you think that's better than Al? I mean, his mother doesn't call him Al. They're Greek."

"Get his birth name," someone suggested. "Al could be anyone. It's like a nickname."

I didn't care. In fact, getting his whole name may have struck me as more intimate. And also more expensive.

"I don't know how to spell that," I cautioned.

"Sheesh, I practically know Greek after all this time. We've been together since our freshman year in high school."

I think she was in her early twenties.

She wrote it out. I used our script book to draft up the name and

got down to business. When I was finished, her large, soft eyes watered up.

"It's beautiful," she whispered between delicate little sniffs.

Two hours later she staggered through the door with a wild look on her mascara-streaked face. Her perfect cascade of rich, foamy brown hair had been yanked into thready clown wings. Her formerly cute outfit hung on her quivering frame like a moist burlap sack.

"Noooo!" she wailed, and broke down in a spasm of body-wracking sobs.

It was later in the day, and by this time the shop was reasonably full. Everyone froze. It was apparent to every potential customer that whatever had gone horribly wrong for this distraught debutante involved us, the tattoo shop, and more specifically me. Several people took one look at her and then gave me hard stares, the kind normally reserved for the stoned guy that accidentally drops a lit cigarette into a passing baby carriage.

I took her aside and tried to find out what had happened, pretending she was my girlfriend or sister by hugging her and holding her clammy hand with feigned familiarity.

"His mother," she gasped, "I showed her . . . his name (hiccup) . . . not right . . . SO STUPID!" She wailed again, a piercing in-labor-with-twins shriek of raw agony.

"No problem," I said quickly. "We can fix it. I can change it." I wanted to stick an ice pick into her eye and scramble her fucking brains. People were walking out! They would certainly talk about this later.

"Really?" She shifted gears into cautious hope, looking at me through teary eyes, her glossy lower lip quivering. "Are you sure?"

"Of course."

For the next hour I wracked my brain trying to find a way to deal with her. In the beginning it seemed hopeless. The *ph* was supposed

to be an *f.* The mother-in-law had pointed it out at the rehearsal. We were out of time.

I drew dozens of different things on her with a ballpoint pen. Everyone I was working with took a shot. A customer or two offered suggestions once they got a bead on the situation. During the entire process I was distracted by my efforts to stave off another emotional eruption on her part.

I was in hell.

Eventually I had no choice. I threw in a few sparkling black stars and some shading and filigree. She lurched out like a zombie with her fiancé's name perfectly done. Assuming he was a stilt-walking, ex-convict accordion player in a Mexican circus.

SOMETIMES YOU DO the research and you still get it wrong. Most of the time it works out, though. Customers take tattoos seriously, and so do the artists. The opposite occurs as well. It's possible to fail as a customer in more ways than one.

I WAS VISITING an old pal who'll remain unnamed for reasons that will become clear. When he discovered he was destined to burn in hell for all eternity, he didn't take the news very well. The tattoos covering his arms are all Asian-influenced, with some demons and warring monkeys and whatnot. Abundantly hell-worthy, apparently. The grim prognosis concerning his immortal soul was delivered by two young evangelist women.

The shop was laid out in standard fashion, with one major stylistic exception: all of the artists there had their own section of the wall to hang their art and flash, but at eye level, running through the entire lobby, was a continuous band of photographs in glossy black frames.

They were all well done, beautiful pieces by the artists in the sections it ran through, highlighting their finished style. The band had an overall unifying effect.

"Hell bound," one of the young women said, clicking a long fingernail on the first photograph. Her friend nodded vigorously. They were both smiling, apparently delighted at the vast potential for suffering laid out before them. They went along the wall like this, ticking the photos off one by one. Everyone in them was damned, and presumably the artist as well.

My buddy and I exchanged glances. What were they doing here?

"Can I help you?" he asked.

The two of them approached the counter, briefly surveyed the smoking-orb tattoos on the backs of his hands, and had a whispered, snickering conference. He waited patiently with his hands flat on the counter in front of him, which I found sort of surprising. My friend is a bit of a hothead, and the hands-flat-on-the-counter routine is code for irritation.

"We don't want anything like any of this," one of them said, her gesture encompassing everything in the place. "We want matching crosses. Tiny. With a little flower in the center and some little leaves. Right in the center of our lower backs."

"Let me draw something special for you," he said smoothly. I picked up a magazine and settled down to wait while he dealt with them.

"Have you accepted Jesus Christ as your personal savior?" one of them asked sweetly. Both of them smiled with their mouths, but their eyes mapped his expression with the intensity of cats studying an aquarium.

My friend looked up from his drawing. "Well—" he began.

"Our church is always accepting new members," she interrupted. "Is your family already a part of the Lord's community?"

"We sort of—" he started.

"All of this is the devil's work," she continued. "He works through agents, whether they know it or not. But the penalty is always the same."

"His instruments grow numerous as we near the End Times," her friend intoned. "Imagine an eternity of anguish."

They continued in this fashion until he finished their design and showed it to them. They squealed in delight. Something about his smile made me queasy.

It took less than half an hour for him to do both tattoos. They left with a final admonishment, to which he nodded with great humility and reserve.

"Does that happen a lot around here?" I asked. Maybe there was a church camp nearby.

"Never," he said. "It probably won't happen again, either." He handed me a copy of the design.

At first I didn't see it. A cross with a flower and some leaves off to either side. There were more leaves than were stylistically necessary, I thought, and then it hit me.

The flower had six petals. There were six leaves on either side.

Ouch. He'd marked their tender little backsides with the number of the beast.

Do I think this was right or wrong? I wouldn't have done it, but I reserve judgment.

YOU CAN EASILY be in the wrong place at the wrong time in any situation. "April Fool's Is Artist's Choice Day" is a prime example. A free tattoo from a bona fide master of the craft can be a real keepsake. But don't piss him off.

A well-known artist from the South took up residence in the Pacific Northwest some years ago. He brought with him some of his kooky traditions, chief among them a free tattoo day on April 1. It was

and is a great publicity stunt and a way for him to explore new styles and techniques and generally do whatever *he* wants.

In the first few years, people were still getting to know him, but his place was never slow. He had a big name from publishing great, innovative pieces in the industry magazines, all of them with a dark, cartoony slant. I've met him several times, and he was always polite, but in the end this dudeboy is nuts, and I'm talking brave crazy. I tip my hat to him. Here's one reason why.

On year three of the April Fool's Day gig, a pack of skinheads found out about the free tattoo day and thought it sounded like their kind of deal, as the only money they likely had was the fiver stolen from one of their grandmas' purse. By the time they showed up, a long line had already formed, full of sweater-wearing hipsters and skater kids who knew a good thing when they heard it.

This pack of bald assholes pulled up and, naturally, barged right to the front of the line, led by their fearless leader, a massive Aryan nightmare with scarred hands and a hard and ready glare. His Docs were buffed to a mirror shine, his hairless head as smooth and empty as a hollow chicken egg.

Their arrival did not go unnoticed. When the shop opened, this monster was allowed in first. Things were about to go very, very badly for him.

A wooden screen with a hole in it was set up in the operatory. The recipient of the free tattoo stuck his arm or leg through, and then it was tied down with a leather belt. You never got to see what was going on, and you couldn't withdraw until the tattoo was done. That was the deal.

The enormous skinhead hunkered down and rammed his meaty forearm through the hole.

"Make it good," he ordered.

The tattoo artist, a sort of small man with the heart of the most

psychotic banty rooster, buckled the guy's wrist down and went at him.

Everyone waited. Usually the tattoos were small and took mere minutes, but this first one dragged on and on. Had our artist hero pussed out? Was he noodling away on some Nazi dream tat? Impossible. Had he lost his focus?

An hour or so later, he finished and released the wrist binding. His old gray face appeared above the screen.

"There you go, champ."

The skinhead withdrew his forearm and beheld it in awe. There, in stunning, perfect glory, was a huge-assed African woman in a loincloth. She had an enormous Afro and was winking, her full lips stretched in a come-hither smile. A chicken bone pierced her nose, and she held a dripping watermelon wedge missing a generous bite from the center.

The skinhead roared and swept the screen aside to find himself staring down the twin barrels of a sawed-off shotgun. The artist holding it had a very no-nonsense expression.

I'M ONLY THAT brave when I've been drinking. Some months later I saw the tattoo in person, and looking at the craftsmanship I knew the mind behind it was utterly sober and as sharp as a bucket of broken glass. The tattoo was flawless, a stunning portrait of an African fertility goddess, part R. Crumb and part something else entirely.

"I need this covered up," the guy said. He was twice my size, a scarred, muscle-warped yeti, but there was a hint of defeat in his pale eyes.

"Can't be done," I replied. I felt high right then. High on another man's bravery but soaring nonetheless. There was no way I was going

to have a hand in undoing that masterpiece. It would have been like splattering avocado house paint over the *Mona Lisa*'s smile.

He strode out without looking back.

LET'S REVIEW. ONE artist cannot write in Chinese or Japanese because of his humble, monolingual Philadelphia origins, one is ignorant of Italian family crests, the spelling of Greek names, and Latin in general, another of the differences between the flags of Texas and Portugal, and yet another is apparently unaware of the fate of his immortal soul and somewhat shaken by the news. And last, we have a dedicated professional with a sense of humor when loyal customers are treated poorly.

It seems almost rude to tell stories about moths and damnation, but it really drives the point home, doesn't it?

PART TWO

6

THE DRUGS

'm racing toward the Oregon border in some kind of bright red Japanese sports car. I have no shoes and no driver's license, and I've been smoking gooey Mexican heroin and snorting piles of coke off a switchblade for three days straight. Most of this has run out, so I've moved on to the impressive constellation of pills in the Spider-Man lunch box on the seat next to me.

We ran out of heroin in Wyoming, of all places. Unfortunately, the guy intermittently vomiting in the backseat has been on a full-blown tar binge for longer than three days and, due to a grave miscalculation, he's going through withdrawal. It's one of the ugliest things I've ever seen.

The stereo blares a Butthole Surfers double-live CD to drown out his retching and moaning. Every once in a while I look back to make sure he's still breathing. At some point in the past few hours he had a wet dream and tore his pants off and threw them out the window. He's naked now except for a sweat-soaked New York Dolls T-shirt, his flaccid penis gummed to his skinny thigh. The car is littered with licked-clean scraps of the foil we were smoking off of, beer cans, and bags of an amazing volume of bile and phlegm. A thin veneer of coke covers everything, and we're almost out of gas.

I'm in deep shit.

The trip to Yellowstone seemed like such a good idea a few days

ago. I had just worked a few months straight and had some time off coming up and a little money set aside. Everyone was wondering what I was going to do. In those days I would fly off to Paris for a week of wandering around, visiting museums, and chasing Dutch women. Sometimes I'd hare off to Southeast Asia. But this time I had something different in mind.

"I think I'd like to go to Yellowstone," I announced. It was the location of one of my few almost-pleasant childhood memories, and I wanted to see it again.

Most of the other tattoo artists thought this was just as offbeat as the rest of my vacation choices, but one voice rose over the grumble of "shithead" and "idiot waste."

"Is that where them bears live? Shit, I always wanted to go there. I got a new sports car and I can't even drive the fuckin' thing."

It was Dave, who would bring the Federal Marshals to my door years later.

Understanding this unique, criminally insane specimen has remained beyond me. Dave was a lapsed Jewish gangster, heavily tattooed and always interested in getting more, preferably for free. He did people favors like a young Godfather and dressed like Elvis before his bloated sequin period. He worked as a part-time assistant to some stoner who worked at the shop at the time, not because he needed the money but because he wanted to be there to soak up the vibe. Dave had power, resources, and influence, and it all stemmed from the fact that he was a drug dealer extraordinaire. Rumor was that he had everything in any quantity and if he didn't, as in, say, an exotic South American root or a new chemical out of some college lab, he could get it for you, and fast.

Dave dangled the keys in front of me, a mad light in his eyes.

"What, you taking a bus? Teach me how to drive." Dave was from New York. It's entirely possible that he had never been behind the wheel in his life.

God only knows where he got that car. After an instant of consideration, I grabbed the keys. A few hours later we were roaring east listening to *Jesus Christ Superstar*, a drug-packed Spider-Man lunch box between us and ready for a rendezvous with disaster.

WHEN WE STOPPED for gas three days later, I only got half a tank before the poor redneck attendant spotted the half-nude and seemingly dead Dave in the backseat and went white in a single heartbeat. I slapped a bill in his hand before he thought to run and tore out of there sans gas cap. The next four hours were some of the longest I can remember, a hellacious stint of driving at the exact speed limit in the precise center of my lane with one eye on the rearview mirror. We reached Dave's apartment building running on fumes, with a moaning, thrashing zombie vomiting and gurgling in the backseat. If you've never seen a heroin junkie go through unmedicated withdrawal, take my word for it, it's immensely, powerfully disgusting.

I just left him there with the car windows down, parked on a crowded street at sunset in a bad neighborhood. A couple of crack dealers peeled off the wall as I walked away and peered into the vulnerable car, then jumped back, cursing and laughing and calling their friends over. A small crowd began to gather. I have no idea how the rest of his evening went. We never talked about it.

In those days it seemed like everyone was high and getting higher. There was a sense in my social group of artists and musicians that drugs were not only a time-honored part of our chosen lifestyles, but that they were actually *good* for us. They lent a certain crucial plasticity to the mind, altered perception in a purely educational way, and were generally to be sampled whenever they were available for the common good.

When I finally got home that night, I remember the empty quiet of

my little book-filled apartment. My head was the only source of sound, and it was ringing like a nightmarish game-show gong.

I had come to a crossroads and I knew it. The values of my subset were suddenly in question. *On the Road, Fear and Loathing in Las Vegas,* all the countercultural stuff I had read and absorbed, needed to be painstakingly reexamined. I think the entire process took about ten minutes.

I'm just not one of those people, those heroes I admired and sought to emulate in those days. Whatever fantastic subreality they lived in was not mine. I had my kingdom of dreams and superstitions, and that would simply have to be enough. The doors of perception quietly closed.

Looking back, I can't believe I took a right turn there. Introspection is often a sticky process for me. That moment shines brightly because it stands out in relative isolation. The truth is I've been more lucky than smart. My brand of slightly scummy charm has gotten me the rest of the way. Those things, and a paranoid unwillingness to live what Dave thought of as a life, have shaped my fortunes.

If I'm to be perfectly honest, I must admit to a certain cowardice as well. I hit the skids early on. After running away from a foster home when I was fifteen, I intermittently underwent periods of starvation that ended in mugging people. Then I got to visit a nice correctional facility. I have no safety net, you see. If I fuck up too bad, I die. The doped-out art shitheads of that time all had one thing in common: they could always go home. They didn't know what a certain kind of poor means. Call it common sense if you want.

I OCCASIONALLY RUN into two of the artists I worked with then and the woman I was dating at the time. They're "clean and sober" now, a phrase I despise for some reason. Their teeth are brown and cracked like they've been sucking on a tailpipe. They gained back all

the weight they lost and then just kept right on growing. I'm not sure if you can really consider that "recovered," but they're around, working for minimum wage somewhere.

Any remaining temptation to fall into that pit was eliminated by Dave weeks after our ill-fated road trip, when he called me out of the blue. He didn't work at the tattoo shop anymore, but we still kept in touch. He seemed genuinely desperate for something, so when I finished my shift I headed over to his place.

Dave buzzed me in instead of meeting me in the lobby, which was unusual. Normally he greeted all of his visitors at the door with a gun in his pocket and made any drug transactions in the elevator. I rode the elevator up and walked through the dimly lit halls to his apartment.

There was a big, dark stain on the shabby carpet outside his door. A segment of police tape dangled from the door across from his. I stepped over the soggy spot and knocked.

"Come in," he shouted.

Dave was sitting at his desk across the room, holding a stick with both hands. There were several lengths of twine tied to it, which led to various points on the walls and furniture. As my eyes adjusted to the light, I could see that he had duct-taped his collection of guns everywhere. Twine led to the triggers. All of them were pointed at the doorway, where I was standing.

"Close the door," he rasped, looking behind me.

Dave was greenish and sweaty, his bruised eyes glittering like a rat's. The trigger stick was trembling, like he'd been holding it in place for a long, long time. There was a mirror with a small mountain of coke on the desk in front of him. The room smelled like oniony sweat and ether. He'd been sitting there in the semidarkness for hours, as patient as a praying mantis.

Dave had come into a great deal of money through some shady deal and then translated it directly into the stash on his desk. The size

of the transaction had apparently rippled the surface of the local crim-
inal pond, and the larger predators had come to investigate. The
wrong somebody had found out where he lived and shown up the
night before.

When the guy across the hall opened his door to see what all the
pounding was about, he was promptly stabbed to death. Whoever
held the knife stayed outside Dave's door until the sirens eventually
drove him or them away. While the hallway filled with police and
meat-wagon personnel, Dave had been busy constructing his duct
tape/gun spiderweb.

It turned out that he just wanted me to check out his setup and
inspect it for possible flaws. He was also interested in how many peo-
ple I thought he could blow away with one pull of the stick in his
hands. I don't remember my evaluation or my estimate of the poten-
tial death toll.

He wound up robbing a bank and doing some time, but when he
finally got out I fixed him up with a place right down the street from
me. We palled around when I got a chance and we could agree on the
venue. He still preferred the pimp dives where he felt at home, plus
he harbored a foul fondness for what he referred to as "tweaker
pussy." Apparently meth addicts don't have sex very often and he
could tell the difference, plus the missing teeth did something for
him. The feds got him in the end, and he did another short stint.
When he got out he died in some shitty motel, a two-decade down-
ward spiral complete.

ANYBODY WHO SAYS they don't like drugs has never tried them.
They make you feel good. They wake you up when you're tired, they
calm you down when you're jumpy, they make you happy when you're
sad as hell. That's why people buy them. Until society is perfect and
everybody is content, drugs are going to be around. The trick is to

steer around them when you can. These two consecutive examples of stark madness really drove the point home for me in a big way. I'd like to say that I remember this period of time like I remember video games, with fond memories but no desire to play again, but the truth is I have to learn this lesson all over again every once in a while. It gets easier.

I can only think of two other fields where one brushes up against piles of drugs more often: the lost-and-found guys at the airport and the police. I assume both of these groups have treatment plans that don't involve the Salvation Army. They have low-grade Betty Ford asylums and HMOs to pay for them.

Need something from a graveyard at 3:00 AM? Gotta have a bike lock, three varied bottles of single-malt scotch, and a snow shovel, and they have to be delivered by a tall woman with a Mohawk within the hour? Trapped in Idaho with no pants and requiring immediate rescue?

These infernal powers can be yours as a tattoo artist, but look very carefully at the price tag. To use the preternatural ability to procure anything at any time is to flirt with soul-smelting disaster. Need some coke, a plumber, some Cambodian breast milk? It doesn't matter what time it is. . . .

That way lies madness. So what if you have the best connections? Burn the phone numbers and forget about it.

It's a formula played out again and again, a calculus with very few real variables and a narrow range of conclusions. I'm sure there are a few tattoo artists twelve-stepping their way through life out there, but I don't know any. Once you walk too far in that direction, you never come back. The temptation, the availability of things, the ease of procurement, is simply too much. You have to retire your machines and go back to the real world.

THE SECRET ARMY

She was big in every way, a knuckle-crawling, leather-wrapped, chain-festooned bull dyke exuding a robustly foul temperament. This human volcano erupted into the shop late one winter night just as I was close to finishing my last job of the day. Another artist was hanging around tinkering with a machine, working the rest of the night until 2:00 AM. The normal carnival atmosphere was subdued that evening, replaced with the sleepy mix of warm air from our antiquated electric-coil heater system and late-night jazz from one of the local stations bubbling through the speakers. All that vanished in an instant, as if a wall had been ripped away, leaving us exposed to the raging storm outside.

Grundy was standing in his usual place along the tip wall, where he had been staring at the same page of a magazine for the last hour. He glanced up at the sudden commotion like a nearsighted mule sensing change on the wind. The big woman stared back at him and sneered in open contempt. Grundy was her equal in size, a grizzled, chunky old guy with vacant, glazed-over eyes. Sometimes he claimed to be a Vietnam vet, at others a retired submarine welder. All we knew for certain was that he was a burned-out ex-boozer on heavy meds. Grundy could fix all kinds of things and was a font of esoteric medical advice. Maybe that was why we let him hang around. For whatever reason, he just showed up one day and stayed for years.

Grundy looked back down at his magazine, oblivious to the blistering alpha vibe being lasered at him, still contentedly surfing his personal twilight zone. His total lack of reaction seemed to faze her long enough for my colleague to take her aside and get to work on her.

For the next few minutes, it seemed like things were going to settle down again. The mellow ambience returned and seemed to have a calming effect on the restless newcomer. We didn't realize that she was building up a head of steam and getting ready to blow. What we witnessed next was truly spectacular.

Out of the blue, this gargantuan woman started ranting. She may have been trying to apologize for messing with our pet wino. I've never been sure.

"It's not men that I hate," she boomed. "It's the dick."

Grundy looked up, and his glassy eyes gradually focused. My colleague and I exchanged curious glances. My client let out a nervous giggle.

"It's like a snake or a bald worm or a fish tongue or something," she went on. "And the hair? Forget about it! It's a toupee with a big grub in the middle!"

Grundy's beady eyes widened ever so slightly. Her eyes narrowed.

"I've got this girl at home, and every night I pull those legs apart and eat that pink little pussy, and you know what? It's sweet. It tastes like sugar."

A lightbulb went on over Grundy's shaggy head, obvious to everyone. A signal had made it all the way through the rat maze of his wrecked brain and was loading for transmission. Both tattoo machines went silent. Even my customer looked on expectantly.

"You know," Grundy said thoughtfully, "I bet your girlfriend has diabetes."

. . .

CRAZY PEOPLE CAN add character to a place. If the ambience in your bar is off, or your lobby has gone inexplicably stale, consider picking up a lunatic. They're not hard to come by, and they often work for free. A lot of tattoo shops have one. Larger places might find it handy to keep two or three around.

The insane can be useful too, and surprisingly versatile. One night there was an altercation in the basement nightclub below the tattoo shop. One of the combatants drew a gun, but in an admirable show of restraint, he fired into the ceiling rather than into his opponent's face.

Grundy did a neat little shuffle as the bullets came through the floor around him. Amazingly, they all missed. He was later able to accurately identify the caliber based on what kind of insect noise they made as they winged past him. This was helpful when the owner of the bar tried to deny responsibility for any damage to our floor or ceiling, or to the ruined copy machine the bullets had punched through in the office above us. Grundy's forensic expertise was instrumental in banning all large-caliber handguns from that bar for years.

Grundy could also fix cars, although never quite right. He might get it running, but the turn signal would be stuck forever. He could lay tile, but you had to watch that he didn't start flagrantly sniffing the glue. He often turned up with surprising things, like a giant box of razors or several pounds of beef jerky. Once he produced a signed photograph of Patton. It couldn't have been authentic, but it said something about him that he so admired this war hero, astride a tank with his leather riding crop held defiantly to the sky, that he took it upon himself to forge a signature on the glass of the frame.

Grundy is gone today. No one knows what happened to this poor, sweet soul. One account has him working with a helicopter crew smuggling crank across the Mexican border. Another finds him drowned in a freak flood somewhere in Nevada. His most plausible

fate is the scenario that finds him hanging around a doughnut shop in Bakersfield, earning his keep by sweeping the floors and keeping the table legs straight.

Tattoo shops are approachable places. We don't find these people. They find us.

After Grundy came Roscoe, the enormous, one-eyed Navajo. A poet and a mystic, Roscoe was the darling wino favorite of many neighborhood businesses. He was a fierce-looking dude, but he had the temperament of a well-nurtured puppy. He was useful in helping us weed out the weaklings and princesses who occasionally slipped through the interview process. Roscoe was our final test, our litmus man. He eventually returned to the reservation to dry out. I'm glad he did, but I miss the guy.

Currently we have Rick Finamore, a.k.a. Batman. Madness first visited him at a Sepultura concert a few years ago, when he was in his midtwenties.

"Jeff, I need your help."

I recognized the voice. It was Rick, one of the Finamore boys. I'd been working on them for years.

"Sure, bud. What's up?" I assumed he wanted an appointment at an odd time or maybe some aftercare advice.

"I was at a show last night, and I heard something in the static."

Hmm.

"It was the voice of God, dude! He's trapped in a magnet at the center of the earth. We have to use the white smoke!"

At first I laughed, and then I realized he was serious.

"Really?" I asked.

"I'm kind of hung up at the hospital right now. I need you to come over and sign me out."

There was a brief commotion on the other end, a struggle really, as the phone was taken away from him.

It turns out that Rick is bipolar, and this was the first manifesta-

tion. He more than qualified for welfare, but unfortunately his born-again Christian mother was put in charge of the pitiful amount of money the government gives crazy people to survive. She took every last penny for her church in the pursuit of a position in the ministry, leaving Rick on the street, starving and beat up, carrying around a stick he had painted with nail polish. He thought it was a light saber and believed he was Batman.

It's common among the artsy intelligentsia to dismiss overly religious people as gullible and stupid. This may be true, but ripping off your own kid is just plain sick. That dumb bitch better hope God isn't real. Dudeboy has a dark side, if the literature is to be believed.

Eventually Rick wound up in a shitty downtown hotel surrounded by older, truly hopeless crazy people, staring down the dismal barrel of his future. He had just enough money to get a pack of generic cigarettes and a sandwich each day, or two sandwiches. His choice.

I've taken a personal interest in this kid, as have the rest of the artists at the Sea Tramp. Five days a week he's here, answering the phone and drawing pictures. We make sure he gets lunch and dinner, and someone always gives him a few bucks for his only hobby, karaoke.

Rick is bright. He's funny, insightful, and honest, the kind of guy you want to see have a chance. There are so many things he could have done. Sadly, the possibilities have thinned out for him now. He has a shitty résumé, bad credit, no education, and no prospect of changing any of it because he's Batman part of the time. At thirty, he's worse off than a blind high school dropout who doesn't speak any English, trying to build a life out of less than nothing, with predictable results. It says something about the world when Rick's only hope comes from the private sector.

I once dropped by my old friend Peter Archer's shop, back before he gave the place up. He was conferring with a grizzled old guy in an army coat over some detail on a sign they were working on. After a

few minutes, Peter gave him a few bucks, and the guy stumbled out holding the money in his palsied hand.

"Is he a sign painter?" I asked dubiously.

"Sort of," Peter replied. "He's our crazy guy."

IT'S HARD TO distance yourself from people when you're literally touching them for most of the time you're interacting. Maybe that's why so many tattoo shops have a secret army. I've seen some truly surly tattoo monsters perform great acts of tenderness that likely stemmed from this connection. Then again, maybe artists, even tattoo artists, are just naturally easy marks in this respect.

Either way, the secret armies are real. There are no tanks, just tenspeeds and skateboards, paper airplanes instead of fighter jets, light sabers instead of guns. So many tattoo shops have their Grundys, their Ricks, and countless others. The Snake Kid, Gorilla Biscuit, good old Roscoe. These are our ground forces, loyal and brave, asking only for kindness.

At my last physical I couldn't help but notice a near total lack of this familiar sensitivity in most of the medical staff. I mentioned it to my wife, and she suggested they were probably taught to maintain emotional distance. What an awful thing to teach someone.

Hopefully, my time will come when I'm old and half filled with organs grown in genetically tailored pigs. But I swear, if some doctor feels my nuts and looks up my ass and then tells me I'm going to die with all the compassion and feeling of an answering machine, like any self-respecting officer of the secret armies I will quickly close the emotional distance between us by stabbing him in the neck with his ballpoint pen.

THE KILLERS

pparently they're all around us, like spiders or dust mites or flecks of other people's skin. You never really notice them. I'm talking about the zero people, the ones who don't rate on any normal human scale. Killers.

I'd bet that some psychopath is getting inked right now, no matter what time you're reading this, somewhere in the world. Statistics would suggest I've worked on more than a handful. My personal suspicions seem to bear this out. There have been times when I've glimpsed the rosy pork blossoms of hell's flora crawling inside of people, brushed up against abominations poorly disguised as human beings.

You can learn a lot about a person after tattooing them for a few hours. Sometimes it's delightful and makes the time pass more quickly. Occasionally, during the course of tattoo chitchat, a customer will say something worrying. It's common for someone to let slip a comment that opens a corridor into their personal life, but sometimes what you sense in there isn't normal. Then there are times when you learn all you need to know in the first instant.

It was just after 1:00 AM, almost closing time. The door was propped open on a warm night, and I was zoned out, partially hypnotized by fatigue and the buzz of the neon. The four-lane, one-way street out front was empty.

In the distance I heard the roar of a big engine getting closer. When a car screeched to a halt out front, I stood up and looked out, wide awake. I didn't like what I saw one bit.

It was a white Cadillac with tinted windows, dusty and bug-encrusted. The engine was pinging angrily from a long, hard drive. The stench of smoking oil and radiator fluid wafted through the open door. Seven large black men in expensive suits were standing around the car, stretching and lighting up cigarettes, looking into the shop. They were a cliché from some kind of rap video, with gold teeth and impressive scars and whatnot. What bothered me was that one of them was angled just right, so that I could clearly see a gun in a chest holster under his tailored sharkskin suit jacket.

One by one they filed in, ignoring me. I smiled nervously, just in case one of them focused in my general direction. Over the next few minutes, I couldn't help but notice they all had guns under their jackets. Big ones, of the banana-clip variety. These guys were equipped to assault a police station, but here they were, in my tattoo shop.

The leader was the smallest guy in their group, about my size, which made him even scarier. He scanned the place while the others watched him and then finally turned to me.

"I want 'Shaniqua' across my chest. Big as you can fucking make it."

"No problem," I replied. I set up, drew out some basic letters, and we got to work.

What happened next wasn't entirely my fault. Let this be a lesson to everyone: do not go to a tattoo shop with a bunch of your gun-toting buddies. It makes the artist feel panicky, and panicky people make mistakes.

Things went fine at first, until one of them took out a cell phone and made a call.

"Yeah."

Silence.

"Yeah, we're at that tattoo place. He's getting Shaniqua's name. That little shit in there?"

Silence.

"Not too long. When you hear the car, go out the back door, 'cause we're killing every motherfucker in the whole fuckin' place."

Silence. He flipped the phone closed and looked right at me. I had stopped tattooing and was staring at him, stunned. He knew I had heard everything. There was a blankness in his expression, a total lack of concern, that turned my insides to cold mud. My testicles yanked themselves all the way up into my body. My tongue felt like it was coated in cave dirt.

My customer was waiting, a snarl of impatience curling his upper lip. He didn't care that I'd overheard their plans for multiple homicide. I got back to work.

What were they going to do with me now? Should I even bother to finish the tattoo? Was I going to die as soon as it was done? Maybe I could just keep working on it for another hour, say I had to take a leak, and then run for it.

These thoughts were thundering through my head at maximum volume, ripping through my sweaty skull at top synaptic speed. The transfer of the letters on the guy's scarred chest was shitty, and the whole thing was blurring with sweat. I lost focus.

SHANIQUA.

What had I written so far, in huge, bold letters?

SHAQU.

Ozone flooded my nostrils. I almost blacked out. A weird slide show flickered across my eyelids, a random montage of things from the past. My first bike. My brother Mark. My cat Bobi. Some girl I dated in high school named Beth Whirly. It was like a kind of seizure.

The ringleader started to look down. Cell phone guy must have sensed something, because he seemed suddenly alert.

"Don't look down," I said, smearing his chest with the paper towel. "You'll warp the transfer. We're almost done."

For the next hour, I prayed to gods I don't believe in as I turned the name into a kind of L.A. graffiti piece so complicated you could only make out half the letters. They were pacing up and down the lobby as I finally finished, clearly ready to leave, irritated that it had taken me so long and impatient to start gunning people down.

The guy looked down at his new tattoo and smiled, reached into his pocket, and pulled out a plastic envelope packed with bills. I hadn't given him a price quote, and he never bothered to ask. He pulled out a hundred and casually tossed it on the counter, grabbed his shirt and coat and shoulder holster, and walked out without a word. Seconds later, the car peeled out.

I locked the door, turned out the lights, and crouched behind the tip wall. A minute or two later, a big car rumbled to a stop out front, idled for a long minute, and then rolled away.

The next morning I read in the paper that they had wounded and killed a bunch of people less than twenty minutes later. A drug dispute of some kind. The police caught half of them. I called in sick for a week.

THIS TYPE OF encounter occurs, in general, about once a year, sometimes more. But none of them hold a candle to the human I've come to call the Collector.

It was early summer in the late 1990s. The door was propped open, and I was taking it easy, once again kicked back at the desk with my feet up, reading. I didn't really feel like working, and so far that day I'd managed to avoid it. Slow summer days are rare, and it's always irritated me that I can't seem to enjoy them.

He slipped in without my noticing. I became aware of a faint scratching sound, a rhythmic noise that had almost imperceptibly en-

croached on my attention. I looked up and discovered a tall, thin man with a pigeon chest and a prominent Adam's apple dragging his fingernails over an image on the wall in slow, almost caressing circles.

"Can I help you?" I asked sharply. It was creepy the way he had silently entered and then announced himself with that rasping noise.

"How much?" he asked. His voice was high and breathy, almost girlish. He glanced at me and then went back to running his nails lightly over the image, an empty banner with three slots.

"Hundred bucks," I said. It was ridiculously high for something so basic.

He nodded and withdrew his hand. I went back to my book. If I ignored him, he would probably drift back out.

When I looked back again, minutes later, he was standing there staring at me, as motionless as a scarecrow. I put the book down on the desk.

"Did you want to get that?"

He nodded.

"We take cash only," I said. He opened his wallet. I could see it was full of bills, so I set up, thinking, "What the hell." Fast, easy money, right? So what if the guy seemed a little odd? A slow day punctuated by a quick, overpriced job seemed lucky. I gave him a release form, made a stencil, and called him back.

There were red flags all over this play, but I ignored them. He wanted the tattoo on his chest, so I pulled out the body board (a paddle table) for him to lie down on. I couldn't have seen it coming, but his next move should have set off any final alarms that remained silent. This weird dude lay down on the body board and then shimmied out of his shirt like a molting snake. I waited patiently for the full minute it took for him to do this, not even wondering why he didn't sit up and just pull the shirt off. I was already resigned to the strangeness of the moment.

It took less than five minutes to tattoo the banner, and at that point I felt kind of bad for taking advantage of a crazy person, so I asked him if he wanted anything in the banner, no extra charge.

"Yes," he said in his high voice, and told me a woman's name. I've racked my brain over and over trying to remember it.

I dutifully tattooed it in and then asked him about the two remaining slots. He gave me a date, some time a little over a week before. I thought at this point that maybe he had a girlfriend.

"In the last one I want numbers," he said softly. "Nine of them."

He reeled them off and I put them in, and the instant I finished and sat back, a chill rippled up my spine. The last series of numbers could only be a Social Security number. I looked at his face and our eyes met. It was like looking into the eyes of an alligator. Somehow I could tell he knew what I was thinking, that he had been waiting for this moment. Everything changed in one violent lurch. I was not in control of this situation at all. I never had been. He was. On some deep, primate level it dawned on me that this guy was pure evil.

He sat up like a machine unfolding, and my breath caught in my throat. His *entire back* was covered with banners, some of them more than a decade old. The insane, haphazard sticker aspect was appalling in itself, as though tattoos had been thrown randomly onto his back from across the room. For some reason, one of them stands out: a faded black horse head with a three-strip banner crammed with letters and numbers, riding high in the collection. Every single one of them was filled with a woman's name, a date, and a Social Security number.

I dropped my machine and went for the nightstick behind my station. Something white flashed across the corner of my vision, and I cringed and threw my arms up to protect my head.

He was in the doorway. It was almost as if he'd teleported himself there. I never knew people could move that fast. He leaned forward

and the hundred-dollar bill pinched between his long, yellow finger-nails fluttered out of his hand and came to a rest on the counter. Then he was gone, his long legs pumping like stilts.

I ran out after him, but there was no sign of him. My heart was hammering as I went to the desk, and for the first and only time in my career, I dialed the police.

I looked down at the desk. The white flash I had seen was his release form. It was gone. So was the pen he had used to sign it. I checked out the transfer. An empty banner. I couldn't remember the name or the Social Security number. Only the date. I put the phone down.

There was no proof, no evidence of anything. The guy had done this before. I didn't even have a fingerprint.

A few years later, I told this story to a couple of cops I was tattooing. They were pretty quiet the entire time. When I was finished, they looked at each other.

"We don't usually hear stories like this," one of them said finally, shaking his head.

"You got lucky," his partner said. "Really lucky."

I was scared all over again.

OVER THE YEARS, I've developed a disturbing pattern resulting from my encounter with the Collector. Once a year, I sit down at the computer and look over Web sites devoted to serial killers to see if this guy has ever been caught. I do it on the day before my birthday.

The National Center for the Analysis of Violent Crime in 1992 identified a total of 357 serial killers operating in the United States from 1960 to 1991. The incidence of serial killing in the general population has been on the rise since then. This is not a contested point. There are more and more each year. By "serial killer" they mean something quite specific. A serial killer kills one person at a time.

There's very often a sexual component. Serial killing is distinct from business killing, as in the charming hit man with a version of "Shaniqua" on his chest. It does not describe the tragic, dipshit mass murderers that shot up Columbine.

A sociopath will say, "Sure I'll kill people for money. They all suck anyway." A psychopath will decide to kill everyone with red hair because they have the devil in them.

He's still out there. To date I have found no evidence that the Collector has been apprehended. But I'm watching, and so are a lot of other tattoo artists. And I'm talking legion.

9

ODDITIES

My second appointment today was a lovely young African American woman. I've tattooed her a few times, and I like her. She's a smart, funny, strong single mother with weird taste in cars. She has a really nice ass, too, like something out of a comic book. We were smoking cigarettes together out front and talking over the finer points of her design when I noticed something hanging off the side of her neck, something I'd never noticed before.

It was a wizened bulb about the size of a big grape or a small fig, dangling from a hair-thin strand of skin. It jiggled when she moved her head. It was slightly darker than the rest of her neck, but paled at the top like the skin over a knuckle. Apparently the bulb was dense and heavy, straining its tether.

There was a time when such a discovery would have made me consider her in a new light. Her ass would have looked different, its high roundness somehow off, her teeth too many and possibly brittle. My psyche would have superimposed an aura of biological malfunction over her. That time has passed.

Some three decades ago, as a graceless teenager, I noticed that a girl I had developed a fondness for had a strangely shriveled hand. It hadn't developed since she was a baby, I guessed. I don't know why I'd never noticed before, but there you go. She noticed my noticing,

and things changed between us. Maybe there was an expression of shock on my face at this startling discovery that she'd somehow kept hidden or that I'd failed to look at in favor of her generously budding breasts. I decided, as an open-minded bonehead of a kid, that I didn't care in the least. People would think better of me for ignoring the baby hand. It would make me a better person to fortify myself in this way. I would think more of myself. My period of deliberation was woundingly long, however. Things were never the same, and because she ignored me completely thereafter, and as I was young, I eventually forgot about her.

The average American probably rarely comes into hands-on contact with things out of the physiological norm, and most probably never develop any real skill in dealing with it, even as adults. I couldn't objectively speculate on the pedestrian frequency of contact with the unusual because I've been immersed in a fleshy, oddity-filled occupational subcategory for a long time.

As a tattoo artist, not only do I see these kinds of things far more often than normal, but there's an added dimension. The customer's psychic filters are often down. Any abnormality of design isn't hidden from you. A person's reflex to turn to a certain angle or disguise a certain feature is off-line. A kind of doctor-patient relationship is in play, and you get to see it all. Sometimes you can be called upon to decorate the very thing that sets a person apart. Sometimes you just tattoo right next to it and find yourself wondering if you can ask, for instance, "Hey, is that a vestigial nipple?"

It turns out you can. If it's on the skin you're working with, you sort of need to know. But you better be cool. Really, really cool.

Art classes in no way equate to psychology classes. An in-depth study of the role of the Pre-Raphaelites on modern posters in no way parlays into goiter sensitivity. It all has to be learned on the job, which is maybe not the way it should be. What I've seen to date of how the artists I've known and worked with over the years handle the presen-

tation of oddities is pretty impressive. As a whole, we seem to have risen to the occasion and handled it well.

I'm not talking about the countless skin tags, warts, and missing toenails, or even the more exotic yellow, scale-encrusted dimple of an old bullet wound, or a gnarly third-world surgical scar. Boils, lesions, psoriasis, eczema, folliculitis, active volcano acne, blisters, whatever. These are nothing.

I'm talking about black sponges growing off the skin, flippers, stumps, spines that warped to accommodate a third kidney, hairy purple square-foot patches of alien flesh, a secondary anus.

I MIGHT HAVE mentioned the totem pole hierarchy that exists in most tattoo shops. The new guy or gal generally gets the crap. That's how it should be, especially since I'll never be that guy again. You learn on the small stuff, and along the way you learn about people, and that teaches you something about yourself. I was working with Wayne Smith, a veteran tattoo artist I was often paired with in my first year at the Sea Tramp, when my first test came. I failed miserably, but it was infinitely instructive.

We were sitting around drawing when a tiny little woman and her tiny little husband came in. They were dressed like Mexican peasants or gypsies, with hairy moles and small, dark eyes. It quickly became apparent that they were Eastern European.

The struggle to bridge the language barrier began. Wayne indicated with a minute shake of his head that he didn't really want to deal with these short people who smelled like BO and goat hair, so I moved in for the kill.

It gradually became apparent that the woman wanted her husband's name. I gave her a price quote, and they talked it over in their Slavic language and finally nodded.

"Where do you want it?" I asked. She looked puzzled. The man stared into the distance with a perfectly blank expression.

"On your body," I continued. I pointed at my arm, my chest, my shoulder. Her eyes lit up.

"Da!" She struggled with her parka for a moment and then produced her arm, thumping it out onto the counter.

Sometimes I worry about all the acid I took in the eighties. I had to do a double take to make sure that what I was looking at was real and not a trick of the light or a random misfire in my head.

It was . . . a flipper. There were ridges at the terminus that could have been metacarpals and a bony knob halfway up that might have been a partially formed chunk of elbow. A few thick black hairs curled out of the tip.

"I got this," Wayne said, shouldering me aside. I staggered back, my face as empty as I could make it, and watched him work.

Wayne sat her down and, after carefully shaving the hairs off, drew out a perfect name and heart design on the flat part where the hand would normally be. He held that flipper like the queen of England's royal appendage, delicately, with a gentlemanly reverence. When he finished, she showed her husband and they smiled shyly at each other and exchanged a few quiet words.

When they left, Wayne stared at the door for a moment and then sat down and went back to drawing. He never said a word about that flipper.

The lesson I learned that day is difficult to put into words. Wayne went swamp panther and took over when he sensed me stalling out, but why did he never mention it? Why no lecture? I got bitched out all the time in those early days, especially by him.

You can teach someone to drive. You can teach them how to perform brain surgery, or fly space shuttles, or tattoo living beings. But you can't teach character. I was going to have to learn how to navigate

this region of primate superstition myself. There was nothing instructive he could say, so he remained silent. Wayne was tutoring by example.

THE WOMAN WITH three kidneys was lovely. I was tattooing her lower back when I noticed the radical curvature of her spine. When I commented on it, she smiled and told me that she had a fully functional extra kidney on one side, and her spine had bent to accommodate it. When I was finished, I asked her out. I liked her candor, her style, everything about her, and wanted to see more. She said no. I did have sex with the woman with two butt holes more than once on the desk in the back room, but I never touched either of them. You can read whatever you want into that, but they were both memorable women, even without their oddities.

So you get used to the unusual, even comfortable with it. At least while you're awake.

THE SLEEPING MIND finds its own oddities, and there is no escape, no professional detachment, no eerie supernatural swamp panther grace when it does. The imagination is akin to a muscle. When it's been worked and sculpted and beefed up, it tends to tick and quiver while you're resting. Some things are just plain spooky, and there's no getting used to them. Invariably, there's a psychological component.

An obese woman came in years ago and got a portrait of herself as a little girl on her pale, bulging stomach. She insisted that there be no mouth in the portrait. She lumbered out with a tattoo of a young, pigtailed girl with smiling eyes and a flat expanse below the nose, a harrowing image when seated in its context. Every artist there that

day had nightmares for months, possibly years. At some point the topic became taboo.

In the waking world, the black sponge grew from the bony back of a petite Asian woman who spent most of the time I was tattooing her viciously berating someone on her cell phone. Maybe that's why I dream of her the most. That black sponge has migrated across many customers in my dreamscape, mostly over their scalps. When I notice it, the world generally slows, and there is an instant of calm before spiders foam out of the shadowed holes.

What could test the steely nerves of today's pro? What, for instance, could make the wicked Trojan Pat Spatters scream like a four-year-old girl? There is an answer to this question, but sometimes the more you learn the less you wish you knew. The test readers of this book made me take it out, claiming it was as if someone had whispered the recipe for madness in their ear.

SCAMS

The speed at which information travels these days is as amazing as its modes of conveyance. One day at work my cell phone rang. It was my wife, talking unusually fast. I was just getting set up for a tattoo, but I stopped after I'd listened for a minute, completely awed by her news.

"Aw, man," I told my client, ringing off, "the vice president just shot some rich dude."

"What?" He looked at me like I was crazy. The lobby was full of people. My announcement silenced them all.

"Shotgun," I went on. "Right in the face."

A few people laughed nervously. Then, in a spooky domino effect, their cell phones started ringing. My phone rang again. This time it was my brother with the same news.

FUNCTIONAL SCAMS PROPAGATE at a similar speed through branches of the tattoo information superhighway. If you ever come across anything new or potentially successful, you place a few calls and the information is downloaded into the wider system. In my personal stratum, points of interest can travel from Portland to L.A., the hinterlands of Kentucky, and parts of Spain in less than a day.

What could be better than a free tattoo? Many enterprising flim-

flammers have tried to answer this mythical question. My personal favorite: two tattoos!

Why anyone would trot this haggard dinosaur into a tattoo shop is beyond me. We've all heard of it, even if we haven't seen it firsthand. The operators always fit the same profile. One big-haired older woman and a frosty, predatory younger one in training. They work as a team in what's called the Two-Tattoo Rub. The last time this trailer-park judo was whipped out on me, I wrote the entire thing down to use in an article. It went like this.

"Ooh, I love it," the young woman cooed when I showed her the stencil, a butterfly and a flower with "Bucky" scripted underneath it. The older woman gazed over the top of her tattered magazine with eyes like gas station slot machines. Her posture made me guess she had been a repo clerk or a security guard at some point, something that bred confidence without really building character.

"Here's the other one," I said. The young woman gave a cursory glance at the second tattoo and nodded. It was a lurid, wiry tree frog from a picture she'd brought in. Probably poisonous, but we were too far along for me to start pointing these things out. I brought her around the tip wall and got to work.

Their scam was intended to unfold like this: Two women come in, and one of them wants two tattoos. The other one is just there to watch. The artist draws everything and does the first tattoo, at which point the customer lets out a theatrical squeak and gasps something like, "I wanted the butterfly on my breast and the frog on my ankle. You put the frog on my boob! It's in the wrong place!"

If they're really good, they get more than just a couple of free tattoos. Show any fear whatsoever and the threat escalates to a lawsuit. I've heard of this being played out into three tattoos. But of course this was not my first day at school, and I wasn't on the short bus.

I took the money up front for both tattoos, claiming it was shop policy. This made the older woman suspicious, but she dug around in

her purse and came up with most of it. She snapped something at her younger friend, who reluctantly gave up thirteen moist, wrinkled dollars from her purse with a confused expression, as if saying, "Wait, that was my dime bag and candy money. . . ." They were actually short a few bucks, but I agreed to do a simpler version of both tattoos, playing the rube.

I applied the transfer to her breast and leaned back. It said clearly on the release form "Tree Frog–Breast," "Butterfly/Flower/Bucky–Ankle."

"What do you think?" I asked, slogging through my part in the script.

Neither of them responded. They were deep in some conversation about Bucky, who apparently had no end of colorful problems.

"Are you ready?" I interrupted. The young woman nodded. At this point she was refusing to even glance down at the transfer, no matter how hard I tried to make her. It was in plain view of her companion, who also studiously avoided looking.

When I finished the first tattoo, the girl stared down at the skinny tit draped over the top of her bra and shrieked.

"Ahhh! Oh my God, no! Jesus Christ!"

The older woman leaped up and leaned over the counter, then leveled her gaze at me and narrowed her eyes. She'd probably practiced this expression in the mirror. Her big blond hair stayed rock steady while she trembled with volcanic rage.

"She told you where she wanted that frog five times. I heard her. You better have a good lawyer."

"You mean it's your word against mine?" I sighed.

The young woman's hysterics ground to a dead stop and she regarded me uncertainly. Her mouth hung open, revealing a tongue stained blue from something she'd been sucking on. The older woman didn't reply, but the stern set of her face blurred ever so slightly.

"Who told you idiots how to run this burn?"

The one I had just tattooed sat up straight. The older woman reeled back as though she'd been maced.

I put the machine down, slowly peeled my gloves off, and picked up the phone.

"What the hell are you doing?" the older broad snarled. Her young friend pulled her shirt closed and glared at me.

"Extortion. Fraud. More shit, probably." I leaned back in my chair. "Everything is clearly marked on the release form."

"We didn't do anything!" the older lady shouted, staring at the phone in my hand. I almost cringed at the parade of expressions that rippled across her leathery face. Fury, realization, fear, morbid resignation. The younger one burst into tears.

Clinging to each other, they walked out five minutes later with one tattoo. I kept the money for both. The girl with the poison frog on her tit cried the entire time.

THAT'S AN OLD scam, one with a prepared antidote. It works in my favor now, as you have seen. It probably will again, too, until this book is published.

Another one that gets played often enough is the timeless, sophisticated blow job routine. This one stung one of my young associates quite recently. We all laughed at him and made slorping sounds for days whenever he came in.

My young friend was tattooing a kind of good-looking woman. Something really small. She went on and on about how she wanted this and that added to it and then promptly segued into her improbable dick-sucking skills. Apparently she was amazing, really world class, in the Olympic Hoover category. She could write endless educational pamphlets on the topic, maybe even teach a class for disgruntled housewives and newly awakened gay dudes at the local community college.

Young artist X found himself sweating and smiling too much. Light-headed, even. It was like a dream come true, a fantasy scenario that always seemed to happen to other tattoo artists, but never to him.

"How interesting," he probably said, or maybe something inane like, "Everyone should have a hobby. So, you wanted what added to this?"

Hook, line, and sinker. At the end of the session, after making numerous free additions, he said something like "So, let's hear more about these blow jobs. . . ."

She looked shocked, indignant. "I'm not a whore, you sick animal!"

"Uh, no, I mean, you said, I thought . . . aw, shit."

"What the hell kind of business are you running here?" She was appalled to the point of stamping her foot.

Yep. It happened again. I think my poor buddy was so embarrassed he let her go without paying anything extra at all.

The most common new trend is people taking cell-phone pictures of the flash. Someone will come in, ask for a price quote on a picture on the wall, and then wander around until the artist is distracted and surreptitiously snap a few quick pictures of it.

Imagine their surprise when the artist snaps a picture of them in return.

"What the hell are you doing?" cell-phone guy will ask.

"Taking your picture," the artist answers, and then maybe snaps another one.

"Why?"

"Well, you're stealing from the shop. I have to turn your photo over to the owner so he can feed you to the pigs after he butt fucks you to death."

Yep. Taking pictures in this case is illegal.

They go on and on. Personal checks. We don't take them, ever, even from our own families.

"We're all paying together." This is a good way to get burned. By the time you finish the last job, the first ones are gone, and the customer left holding the bill will occasionally deny he or she had any idea they were paying as a group. You can't hold people hostage these days. Or cut all their hair off. It used to be easier to deal with this. We have a ponytail hanging from a hook in the shop that was separated from the greasy skull of its owner for this crime.

The other guy's price quote routine: "What do you mean this costs fifty bucks? My buddy got the same tattoo from the other guy here a week ago for twenty!" Nope.

"I need to run to the bank machine. I forgot to pick up cash on the way here." The tattoo is already done. We generally go with them. All of us.

Some of these burns seem to have finally retired. It used to be common for people to request custom art and then insist that they needed to take it home to think about it. Then they take it around looking for a better price quote or have Cousin Lester do it for beer, thus ensuring you've drawn for little or nothing.

This last one has no foundation in consumer logic. You don't take a car home for a few days when you're on the fence about buying it, nor do you take a plate of sushi with you so you can stare at it from various angles to decide if you should eat it. It's true that tattoos are highly personal and deserve appropriate consideration, but time is money. Take all you need, but always remember that the art stays in the house. The copy of it, the eventual tattoo, is what's for sale.

A few years ago, a short-lived variant of this cropped up. We had a rash of customers get all the way up to the point where the transfer was on their skin before backing out. Sometime later, they began returning with crappy versions of the tattoos, begging to have them

fixed at any cost. We'd been drawing for some dork who had gone under and was working out of a nearby hotel.

And then there are the trades.

"Hey, man, I can fix this floor up for you. Me and my bro do it on the side. We just finished up an eight-hundred-square-foot job in the West Hills."

These transactions go bad about 30 percent of the time (a conservative estimate). As a rule, I try to avoid trades, occasionally passing up some great deals that have good odds of going through. This after an incident involving a customer who worked part time as a mechanic. He wound up stealing a Bel Air I was restoring. Fortunately, he was not the only criminal I knew at the time, so I found myself in the awkward position of having to trade someone else to steal it back.

I explain it like this to the guys who work for me: if someone is any good at what they do, be it cars or floors or dentistry, then as a rule they are prosperous enough to pay for a tattoo like everyone else.

Don't get me wrong. Most of the time, day after day, everything goes fine. But tattoo shops are businesses, and as in every business in the world, there's always someone who thinks they can get what you sell for free.

I do have a free tattoo, one I'll give out willingly. It's on the fingers, where "love" and "hate" would normally go: "Star Trek."

PART THREE

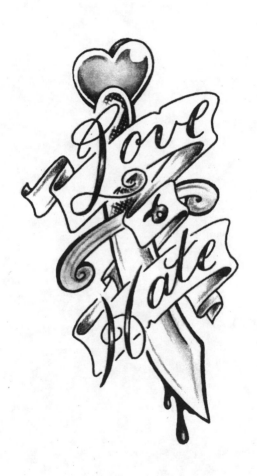

11

THE FEAR

It's 4:00 AM.

Some nights are darker than others, and this one is as black as the inside of a rock. Without concentrating in the least, I can sense the exact shape of my liver. My mind skitters across the surface bulges and puckered seams and maps it out as something shaped like an old man's shoe. I groan and turn onto my side. The gland in my armpit feels like a walnut.

I drink too much, I know. The cigarettes don't help, but unfortunately these are the least of my problems.

I must have huffed in at least a teaspoon of the exotic chemical we use to sterilize stainless steel surfaces. And that was just today. I have no idea what this stuff is, but I know it can't be good for me. It's a hellish liquid designed to dissolve living things, to break them down into inert, no-longer-biological material, and I'm breathing it in all day. And what the hell was up with the soldering flux yesterday? I must not have washed my hands well enough, because when I stepped out for a smoke part of my tongue went numb. Must have gotten some on the cigarette. The label on that tiny white flux bottle is one long, exclamatory warning sign.

Maybe it's just my imagination.

And maybe my liver and kidneys are black and purple, straining to contain the flood of toxins they have absorbed over the years. I con-

sider turning on the light and reading for a while, but I don't want to wake up my wife, a poor sleeper at the best of times. Her breathing is soft and regular. The cat is purring next to me. I'm not purring. I feel a little feverish, in fact. My breath is sort of whistly, and there's an ominous gurgling in my chest.

It generally occurs to me at this point that my stringy, discolored viscera may have utterly failed to filter or restrain this toxic payload, and that the angry clouds of electron-heavy chlorine particles dumped on a daily basis into my failing system are rearranging my DNA even as I lie there, giving birth to a heretofore unknown variety of virulent and gruesome cancer, the type that will be met with genuine shock when diagnosed. Perhaps a unique hybrid of Tasmanian face tumors and an unknown scourge of the monkfish.

"Where have you been?" the doctor will ask, wiping sweat from his pale forehead and pressing a panic button under his desk to summon a secret wing of the military. "Snorkeling through the sewers of Chernobyl? Drinking airport toilet water?"

Oh, yes, let's not forget all that nasty biology I've waded through. There are things they can't test for, you see. Like mad cow disease. That wicked fucker could drop on me at any time, or one of its freaky cousins. On NPR's *Science Friday* they said that prions could lurk in your system for years. Decades. The death toll will be unspeakable, and I and my kind will lead the charge right over the cliff.

When I was tattooing that girl from Thailand, did she sneeze a few too many times? Remember the lawyer who contaminated a plane-load of people with drug-resistant TB so he could go on his honeymoon? Some jackass lawyer customer of mine sneezed right onto the back of my neck just last week. TB, SARS, the Great Undiscovered. Oh, Jesus, no. Not me. Not yet.

I'm a ticking time bomb of chemical waste and contagion, living on the front lines, sure to get picked off in random, deadly sniper fire. And soon. Man, my pulse is really racing. Left arm is a little numb,

too. Shit. I wonder if something has eroded a critical valve or membrane in my heart.

I get out of bed and go into the living room and sit down. Anything is better than this, even early morning TV. Maybe I can decompress by watching some ultraprimitive kid show designed for prelanguage toddlers.

The Fear is real.

Professionals try not to talk about it too much, but it's there in nearly all of us. The thing we fear the most is the artist who never experiences it. That will be the ignorant shithead who kills you.

A tattoo artist has to put a great deal of trust out into the world. We have to trust that you will be truthful on your release forms and honestly disclose your health status. We have to trust the artists we work with not to pick up a phone with bloody gloves on, or touch a doorknob or any of the other hundred things that can be cross-contaminated and jeopardize our health. After years of worrying about these kinds of things, I've developed a sensible strategy, something I think about at times like this.

I don't trust anyone. Ever.

No way am I going to believe what's on those release forms. And the people I have working for me? I would trust any of them to break me out of a Mexican prison armed with nothing more than a sharpened stick and some discount fireworks (and they would), but to trust that they are perfect, that they will never make a mistake, never touch something they shouldn't? Not gonna happen.

In 2001, I had to undergo a physical examination at the behest of the Canadian government. My wife is Canadian, and we were considering moving there. I dutifully jumped through all the paperwork hoops and eventually found myself at a clinic in Portland with a Canadian doctor on staff, appointed by her government as its medical representative.

My examination went well at first. My eyes are good. I've never had

a cavity. I lied about smoking. Heavens, no, I don't drink. And then came the naked part of the exam.

This poor lady (infer the worst kind of bitch here) fell to pieces, clutching at the crucifix around her neck. Apparently the dragon that covers more than half my body brought up images of orgies involving senators and spurts of baby gore with Satan himself capering on a lube-slicked stage. The old knife scar on my ribs suddenly stood out. I hadn't noticed it for years. My right arm is a testament to poorly conceived design and application, possibly denoting more street cred than I merit or needed at that moment.

"Mr. Johnson," the doctor said in a quavering whine, "I will have to recommend the most thorough possible physical examination for you. . . . People like you . . . You know what I mean. . . ." I shit you not.

And thus began a NASA-style, eight-month ordeal, punctuated by random and frequent urine tests, all of which ultimately turned up absolutely nothing. I understand that I had some bad luck drawing this particular doctor, as the Canadian immigration people, other than this one, were far nicer than the ones my poor wife had to deal with on the American side. I hated paying for the entire thing, but I gleaned something useful from eight months of suspicious urine handovers, humiliating blood draws, a lifetime's worth of X-ray expo-sure, and general dick probing.

These people, this shithead doctor and the much more hospitable nurses, all presumably educated, were not nearly as careful as any artists I have worked with. Why? Because doctors and nurses know what they're doing!

Can a germ crawl five feet? I doubt it. Three? No way. It's so small. I think. One? Hmm. What if you smear it a little, give it a head start? Fuck it. Nuke the entire area and move on. Should you pick up that needle without gloves on? I saw this during my personal medical witch-hunt period all the time! Toss it into the sharps container, cur-

sory hand wash. Your garden-variety tattoo artist would never dream of doing that. How the hell are you going to pick your nose if there is some question as to what's under your fingernails?

We take classes, sure, and every one of them is devoid of real, quantifiable knowledge, the raw brass tacks, if you will. People will argue about this, but trust me when I say they're full of shit. There is no "Pathogen A has a motility rate of blah blah blah" and "Such and such will live in an oxygen atmosphere for said amount of time provided that the ambient humidity and the suspension medium meet said requirements." In other words, they pale in comparison to the years of higher education health-care professionals undergo.

It's better to just convince people how dangerous the situation can be. A simple set of rules can protect everyone, and that's what the best of these classes teach, with a broad overview of the dangers and how to avoid them. I support this. I'm ready with my sprays and general paranoia. I sure as hell don't want to go back to school for years to learn how to handle dirty things with any measure of specificity. I'll take the easy way out.

And suffer the occasional bout of the Fear. It doesn't breed anything but total, rigorous vigilance. Bear that in mind the next time you feel like bitching about the price of a tattoo.

I look at the clock. My throat feels raw. What the hell is that electrical smell? Is that my fingernails? Time to go back to bed. . . .

THE FEAR STRIKES at all hours, but at night, when your head is on the pillow, is when it runs rampant. It is the swamp panther in your late-night pantheon of thoughts. Part of living with it is developing a close relationship with its useful but much less powerful sidekick, the Doubt. Far from an equal and opposite force, the Doubt sits quietly in the corner wearing a tinfoil hat, patiently deluding you, always helpfully deceitful.

Case in point: a random civilian encounter with poison, which I doubt had any lasting effect.

My wife and I had gone snow skiing. It was a beautiful, sunny day, so we lathered on the sunscreen. At the end of the day, with the car packed and the sun setting on the mountain, I glanced into the rearview. Sure enough, my lips were a cracked, peeling mess. There were flecks of blood on the filter of my cigarette.

That night I put on some ChapStick, had a few painful shots of bourbon, and crashed into bed, blissfully exhausted. My lips were still burning, especially after that nightcap, so I decided to root around in the dark on my wife's nightstand for her lip balm. My fingers settled on something the right size and shape. I took the cap off and sniffed. Soothing . . . medicinal . . . just what I needed. I smeared on a generous amount and went to sleep.

I woke a few hours later drenched in sweat. My mouth was a numb chemical slick, my stomach a sack lined with electrified nerves. I staggered into the bathroom and heaved my guts out, feverishly reviewing everything I had eaten. Eventually I wound up on the cold tile floor. Some time later I made it to the couch.

When the first light slanted through the window, I awoke, sore and sick but measurably better. I padded into the bathroom to take a leak and caught my reflection in the mirror.

My eyes were bloodshot and my face generally haggard and puffy, but there was something horribly wrong with my lips. The skin had turned gray and in places had peeled away entirely, leaving patches of baby-smooth, incredibly tender pink flesh. I looked closer.

I was molting.

Within a day or so, the process was complete. I was left, for some months, with the unwrinkled, artificial lips of a mannequin. My wife runs marathons, one of her many difficult hobbies, so she has a little trouble with her feet. The substance I had rubbed onto my sun-fried, wind-ravaged lips was her callus remover.

Did I go to the doctor, even after reading the dire warnings on the label? Nah. I've read such labels before. Reactionary doggerel, said my doubting side, the whispering imp on my shoulder. It can't be worse than the time you got formaldehyde in your eyes, can it? You can still see, can't you?

Such is sanity.

RECENTLY, THE FEAR took an unimaginably sinister turn, which is why one Friday morning I found myself speed-dialing NPR over and over again, forty-five minutes behind schedule and trying to avoid eye contact with my increasingly impatient customer.

I already knew that tattooing had changed my brain to some extent. The pattern-recognition software in my brilliant wife's visual cortex is crap, for instance. Mine has developed because of sketching, which essentially involves picking the good lines out of the random garbage you've drawn on a sheet of paper. It's a simple and very useful side effect of my career. So she's in charge of the computers, and I'm in charge of finding her shoes and her car keys.

If you don't believe in the concept of a soul, as I do not, then its closest and most precious analog is the brain. Dumping complicated pharmaceuticals into the poorly understood chemical dance of this organ is, for me, a no-go. Booze wears off. Even the drugs from my experimental phase wore off, distressingly fast in most cases. I like who I am. Sure, I have problems, just like everybody else. Maybe I score a little below average on basic thought hygiene, but it's who I am. I'm sure there's a pill out there to lessen the late-night bouts of the Fear, but the idea of taking something that will change me scares the hell out of me.

I kept getting a busy signal, and my customer was now staring at me with a nervous look on his face, the worst possible thing he could do. That look was altering my brain chemistry as surely as any pill. It

was even changing the expression of my DNA. Sound crazy? Keep reading.

We get up to some nasty shit as a species, but it's been my observation that lots of raw bad news also comes out of the rat and monkey populations. I don't like rats, so of course I know lots about them. For instance, it you were to affix the incisor of one of these little plague machines to the tip of an arrow and fire it from a compound bow, it would pierce a bulletproof vest. The tooth is that hard. Monkeys . . . well, who cares unless they throw a handful of Ebola-packed feces into your hair.

Amazingly, it seems that in the distant past our common primate ancestors did just that, but it wasn't Ebola they were throwing, it was mirror neurons, and they didn't throw them into our hair, they chucked 'em right into the operating instructions for our brains.

I finally got through to an NPR screener, only to discover that the program I was calling about was a repeat, so I had to go buy Dr. Daniel Goleman's book *Social Intelligence* and read it. Goleman confirmed my worst fears.

It turns out that the human brain is packed with mirror neurons. These little bastards, in the prefrontal cortex and elsewhere, handle the image that forms when we talk with others about something we both recognize, like tattoos. They spring into action while we watch the body language of the people we're talking to and help us with our body-language response. Mirror neurons help you understand tone of voice and what you should do about it. We can all understand another person's state of mind to some extent, and we send messages back in response, linking some parts of our brains together for this social task and others for that, and mirror neurons are a key player in all of it. This horrifying text had plenty of information about what goes on in the brain of a tattoo artist.

The evidence is in. Dealing with customers who are nervous and in pain, and undergoing a moment of transformation, has apparently

done something to my identity, my brain/soul. Of course your brain learns. It even redesigns aspects of itself to be better at its job. If you repeat a social interaction over and over again, your brain will grow horns, do hula dances, manufacture new and better land mines, and generally settle into a different shape to suit your needs. But remember, before you elect to do anything too many times, that this brain is *you*.

Epigenetics is the study of how our experiences alter the way our genes operate. Some of our genes are as dormant as fish on the bottom of a frozen pond. Others are smoking along at top speed, leaving trails of instructive proteins. Experience can alter which genes are doing what. So what we do over and over again, especially in regard to active mirror neuron involvement, can affect us on a fundamental level, right down to our temperaments and spectrum of behaviors. The person behind your face.

So the expression of my DNA has been altered as well. The exotic combination of mirror neuron interactions, found nowhere else, is like an untested psychotropic drug I've been taking without knowing it.

This job has changed me. The Jeff Johnson who started tattooing all those years ago, that kooky stoner kid, is dead. His brain/soul never knew what hit it. I have his tattoos, his cauliflower ear, his scars, and a mutated version of his memories. But then, I also have his wife, his job, and all of his money.

PUSSY-EATING SWAMP PANTHER
TO THE RESCUE

The instructor surveyed the group assembled before him and nervously licked his lips. Twelve heavily tattooed people sat in a semicircle with their arms crossed, staring at him. This was evidently the first time he had ever been in a tattoo shop, and the environment seemed to have set him on edge. He glanced repeatedly at his CPR dummy, a naked pink torso thing that seemed somehow lurid in its new surroundings, like a teaching tool that had a newly discovered history of doubling as a dildo.

"Well, today we will be going over CPR and emergency first aid," he began, wringing his hands. "Before we begin, does anyone have any questions?"

The room was silent. A chair creaked.

"What about snakes?" someone finally asked.

The instructor looked startled. "Snakes?" he asked, almost to himself.

"Yeah, snakes. Is it true that you can neutralize rattlesnake venom with a jolt from a car battery? I saw it in a movie."

People nodded approvingly. I was sort of curious myself. Maybe he could solve the question of Gram Parsons' overdose if he knew the answer to that one. Apparently the junkie who was with him at the time of his fatal heroin overdose attempted to revive him by stick-

ing an ice cube up his butt. Urban myth, or time-honored scientific fact?

"That's a very good question," he said with a tight smile. He looked down at his loafers and then glanced at his pink porno-dummy. "Let's go ahead and get started."

AS PART OF our licensing requirements, we take classes like this every three years. This was the second or third round for many of the artists in attendance because Red Cross classes conveniently expire every three years. It was my first time.

We blew in the pink dummy's mouth and pressed on its chest. I remember it had a blond wig Velcroed to its head. The instructor loosened up after a while and actually began to enjoy himself. The class took on a subtle party atmosphere, as many of the artists were old friends who rarely saw each other.

The class was for nine credit hours, but after three we were running out of material. The instructor whipped out a baby CPR doll and showed us how to Heimlich the tiny thing. At one point its head fell off.

By the end of the class, I noticed someone had drawn an anchor on the big CPR dummy's arm. We paid the instructor, and the group broke up.

Afterward I was smoking a cigarette outside when another artist approached me for a light.

"That wasn't so bad," I said.

"Yeah," he agreed. "Except I feel jinxed."

"How do you mean?"

He shrugged. "It's like when you get health insurance. First thing you do is break something."

I had the same bad feeling.

· · ·

THREE WEEKS LATER, I took a few days off to spend with the young woman I was dating at the time. We decided to go out to Hood River, a picturesque little town in the Columbia Gorge and the wind-surfing capital of the world. There's a great hotel there, restored from its origins as a turn-of-the-century railroad stop. It has a brass bar with an old-West-whorehouse feel and a pretty good restaurant. The rooms facing north have a view of the river.

That first morning, slightly hung over and full of coffee and eggs Benedict, we decided to explore. The day was already growing hot, so the plan was to drive around and find a scenic spot to go swimming.

We drove east for a while, smoking cigarettes with the windows down. The terrain transition is pretty sudden in that area. One minute you're in a misty coniferous forest, and then you abruptly climb into a high desert of rock and long, gold grass, crisscrossed with green-rimmed streams. For some reason, we decided to take a small highway that led up into the dry hills. It was almost noon when my companion slowed and then stopped on the gravel shoulder of the road.

"Look at that," she said, pointing.

I followed her finger. More than thirty feet down, at the bottom of the streambed running alongside the road, was a station wagon. It was battered and coated with dust and appeared to have been there for years. It was curious, though. The stream it sat in ran through such a pristine area. You'd think someone from the state would have pulled the wreck out of there at some point, if only to keep the partially submerged gas tank from fouling the water.

"Maybe you should go look," she said hesitantly.

"It's been there forever," I objected. I was wearing shorts and flip-flops, not even a shirt. There was no way I was going down into that thorn-choked gully to satisfy her humanitarian curiosity.

She turned off the engine, and in the distance I could hear a faint buzz. It was coming from the wrecked car at the bottom of the ravine. We were all alone on that road. I hadn't seen another car for more than ten minutes.

"Shit," I said.

The first ten feet weren't bad, but then I got into the long grass and shrubs close to the water. Hungry deer ticks were literally bouncing off my face. I struggled through the last twenty feet to the car holding my breath.

There was a man inside. It looked like a grenade had gone off in his lap. The inside of the car was splattered with blood, and he was very pale. Camping gear was strewn everywhere, slick with bright red gore. Most of the windows were gone. Flies were everywhere. I reached in and felt his neck for a pulse.

He was alive.

The first thing that occurred to me was that there was no way all this blood could have come from one person. I backed away from the car.

The station wagon had missed the turn some fifty feet up and tumbled end over end, ripping a swath through the shrubbery and low trees that was now visible from where I stood. I scrambled up onto a rock and looked over the wake of destruction. Glass, a few shirts, and a tire. I peered back at the car. Something was pinned in the clear water underneath it, possibly a sleeping bag, possibly a person. Checkered cloth fluttered in the current.

I scrambled back down and looked around, my mind spinning through wildly improbable scenarios where I levered the car around with fallen branches like something out of a *MacGyver* episode. I realized I was panting and that my hands felt cold, even though I was sweating heavily. I shook my head. If there was someone under that car they were dead already. They had a car on them, and they were under two feet of water.

I felt the man's pulse again, and this time he moaned when I touched him. More than anything in the world I wanted him to open his eyes and say something. His pulse hadn't changed. I went around to the other side of the car and half crawled through the window to look him over. No serious wounds were visible. It was possible he had simply suffered thousands of cuts, which could easily be life-threatening given the amount of blood he had lost, but there was nothing I could apply direct pressure to.

I got back out of the car. I needed help. That fucking class had certainly not prepared me for anything like this. All I could remember was the anchor on that goddamned CPR doll.

I bombed back through the brush and up the steep incline. The woman I was with was pale as a ghost, staring at me. I was covered in blood and scratches and dripping with sweat.

"We need help," I shouted, even though she was standing right in front of me. She nodded and slumped against the car. Neither of us had a cell phone.

A car was approaching. I stepped out into the road and waved my hands. It slowed for a second and then gunned it, racing around me.

"Fuck you!" I screamed.

Another car was following it. I stood directly in front of it. The driver had to either stop or run me over.

It was an old man and his wife. He rolled the window down an inch and peered out at me. Another car stopped behind him.

"There's been an accident," I yelled. "Drive to the nearest phone and call for an ambulance. Hurry!"

He didn't move. The guy behind him opened his door and half stepped out of his car.

"You OK?" he called. Another old guy.

"No!" I yelled. "Turn around and go to the nearest phone and call for help. There's a seriously injured man down in the ravine."

By this time, two more cars had stopped, then three. All of them were filled with old people. A mob was forming.

"Listen to me!" I commanded. The shoulder of the road wasn't all that stable, and there was no guardrail. One of these codgers was going to fall into the ravine and break a hip, and then I'd have two problems. The important thing was to get an ambulance, and no one was doing anything. It was time to take charge.

"I am certified in emergency first aid. I just took the class to renew my tattoo license. Go call for help. I'm going back down there!" I started slapping people's hoods, and the cars finally started pulling out.

The woman I was with was sitting sideways on her car seat with her head down, trying not to pass out, so I left her there and went back down.

The man in the wreck was still breathing. His pulse was strong, though it seemed faster. His skin had turned very red for some reason. For the first time, I noticed the smell of booze. He was drunk as an Irishman at a bar mitzvah.

It seemed important that he not move. He moaned a few times, and then his eyelids fluttered and opened. He couldn't seem to focus on anything.

"Easy now," I said. "Don't move."

"Gotta pee," he whispered.

"Do it in your pants," I told him. "You've wrecked your car. There's no telling what shape your insides are in, not to mention your spine. Are you alone? Was there anyone with you?"

His head lolled to one side. I reached in and gently held it in place.

"Is there anyone with you?" I asked again, thinking of the cloth shape under the car.

"My friend," he said breathlessly.

We just sat like that for a while.

Eventually I heard sirens. Two highway patrolmen skidded down the embankment and pushed through the brush with a stretcher. An EMT was with them. I staggered away from the car, told a trooper that there might be a body under it, and slowly crawled back up to the road.

My hands were shaking so badly I could barely light a cigarette. A matronly EMT came over and swabbed me down with some antiseptic towelettes.

"You did great," she said calmly. "You might have saved that man's life." I felt like crying. That class . . . that fucking anchor . . .

They got him into the back of the ambulance and drove away. The two state troopers watched them go and then turned to me, smiling for some reason.

"Is there anyone under the car?" I asked.

"We don't think so," one of them replied. He looked at his buddy and they both chuckled.

"What the hell is so funny?" I asked sharply. Standing there sweating and bleeding and stunned, I was in no mood for any cop humor.

"Relax," the same officer said. "It's just that we don't get calls like this every day."

I glared at him, unable to think.

"Dispatch got eight calls in a row," the other cop explained. "There'd been a bad accident, but a tattoo artist was on the scene administering first aid."

They both laughed again and patted my shoulders. The woman I was with laughed too. I felt light-headed.

After I gave them a no-doubt-incoherent statement, the woman and I drove back to the hotel in silence. She parked, and we went straight into the bar and sat down.

It was cold inside, and oppressively dark. The uniformed bartender was the same one from the night before. Thank God I'm a generous

tipper. She took one look at us and skipped over the fact that I was wearing no shirt, focusing instead on the streaks of blood the EMT had missed, the scratches all over me, the wicked sunburn and swelling ticks and the ghostlike, vacant countenance of the woman next to me.

"What the hell happened?" she asked. God bless her, she was already pouring a double Jameson for each of us.

"Bad car wreck," I said, wrapping my hand around the glass. "We had to help."

"Good for you," she said. "This one's on the house."

Like an old epileptic, I raised the glass and had to lower my head and ram it into my mouth, then tilt my torso back to dump the drink down my throat. The bartender watched me and then immediately refilled the tumbler when I brought it crashing down on the bar. I repeated the process a few times, and then I suddenly knew I would throw up soon.

Gradually my eyes focused on my reflection in the mirror behind the bottles across from me. I looked terrible, an older, clay-faced version of the person I had been that morning. My hands and feet were blocks of ice. But I smiled weakly at myself anyway. I had taken command of the lobby, if nothing else.

Stupid and jinxed to be sure, but in spite of it all, today I was a pussy-eating swamp panther.

HUMILIATION

There have been many low points in my career. Some, if not all of them, will be recognized by professionals reading this. Things the average reader suspects might go on behind the scenes . . . well, sometimes they do, and at one time or another I have done them all.

Every one of these moments, or in some cases a continuous string of them, is clearly visible in the otherwise murky depths of my memory, like half-melted orange warning buoys on a black surf marking the icy location of plague rat migrations, swarms of radioactive jellyfish, and hellacious toxic slicks.

You will find humiliation on the mental key ring of a wide variety of artists. The metal has been shorn of most of its bulk from frequent use but is still curiously weighty and substantial, like the ignition key of an ancient tractor. Self-loathing, despair, the grim certainty of ineptitude, awful periods of bleak revelation . . . all these black doors open with the same key.

At some point every artist takes that first step and creates a body of work. You draw, paint, sculpt, whatever, utilizing all the skills you acquired over a childhood of sketching Boba Fett and Spider-Man and combining them with whatever else you learned in college or from books. Then, if you're really lucky, you step back to behold what you

have done and have that all-important artistic awakening. It is the firm, soul-vacuuming realization that you utterly suck.

I've endured countless episodes like this, and they've generally resulted in moments of growth. But my postgraduate degree in humility came in the much broader context of a big, long, splattery decline that was, in retrospect, entirely of my own design. I was fortunate enough to have a day in my life when all my shortcomings were chopped up and displayed on a blank porcelain plate for me, like a tumor version of sushi.

I HAVE MISSPELLED things. I have put symbols on upside down or even backward *and* upside down, and let me assure you that is no small feat. I have done things to young punk chicks in the bathrooms of various tattoo shops that would make German pornographers flinch. I've been vengeful on occasion for all the wrong reasons. I've felt bad about all this occasionally. Most people would feel worse, I know, and that doesn't help either.

The longest period of utterly stale behavior on my part began one night a decade ago, when I was standing outside the tattoo shop I had been working at. Things had gone badly for me in that place. I'd broken my hand and wound up sidelined, then was replaced altogether. I was bitter.

I didn't have the energy for arson. I was spent, out of gas, burned all the way out. Standing there in the rain, staring through the brightly lit windows of the tattoo shop at the prosperous artists politely ignoring me like the embarrassing Dickensian hobo I'd become, I felt poised to swan dive into a period of wallowing and pitiful debauchery.

Luckily, there was a part-time opening at the Sea Tramp, where I had begun my career. My old mentor Don Deaton was happy to have me back.

I made just enough money to scrape by. I found an incredibly cheap, roach-infested studio apartment next to the impound lots under the freeway and proceeded to decorate the place with empty beer bottles.

I don't think I've ever been depressed, at least not in the clinical sense, but I was certainly close right then. I spent huge amounts of time watching kung fu movies, entertaining hairy punk girls who brought their own beer and never spent the night, and generally being a worthless burnout. My hand hurt all the time, even after doing one small tattoo. I wrote a few short stories that I never sent to anyone and eventually lost. I drew some flash that centered on broken glass and then lost that too. I grew some weed with some Mexican guys and sort of halfheartedly dabbled in petty crime.

An entire year passed like this.

I don't know how long it could have gone on. During this time some Apache girl broke a window over my head. A pipe in the wall broke and soaked my entire book collection. The kid down the hall got his head cut off one night. Some asshole robbed me at gunpoint in the stairwell and stole my six-pack of beer and a roll of toilet paper. I threw up on some guy's motorcycle parked in front of the building and had to hide out for a week. You can get used to almost anything, I guess. Fortunately, my head was about to be yanked out of my ass by another employee of the Sea Tramp.

His name was Matt Reed. This quiet, shy dude had been getting better by leaps and bounds while I was licking my wounds. I was only peripherally aware of his stunning progress, as we never worked together and I didn't really give a shit. Essentially, I was working the dead shifts he wanted to take off.

One spring day he showed up on his day off to talk to me. As usual, I was doing nothing, mentally fixated on urging the clock forward and scheming to flake out early.

Looking back, I can see that this must have been a difficult conversation for him. Amusing at the very least. Matt was going on a working vacation to Europe for three months, during the summer, no less, traditionally our busy season. After raising the standard of the shop in a spectacular run of hard work, he was going to leave a cranky, womanizing burnout in his place. Matt was throwing me to the wolves.

He could have replaced me with someone else and I probably wouldn't have noticed, but he didn't. It was time to show some dignity and at least shoot for average, he explained. The slow, patient way he described this to me, like someone talking to a slow child or a bright ape, was almost my undoing. I was about to go from barely working at all, and certainly never doing anything difficult, to maintaining at least a semblance of his standards, seven days a week, through the busy season, alone. But what really shook me out of my funk was that *he believed I could do it.*

Matt was better than I was. If it had been a foot race, I might have been able to see his dust trail through a telescope designed to study the craters of the moon. He was everything I wasn't: dedicated, motivated, ambitious, and focused. His was the face of the future, a coming period of spooky samurai artists. I was close to being one of the chewed-up, unidentifiable chunks left floating in their wake. It would have been easy for this budding titan to trample me into oblivion, but he didn't. Instead, this quiet, unassuming man became one of the biggest influences in my career.

I may have started tattooing a few years before, but this is where it really began. It was time to sink or swim. I flopped into the pool and set forth with a furious chain-smoker's doggy paddle. By the time I reached the far side, I was half porpoise, and I have Matt to thank for it. In hindsight I must admit that I was still lazy and distracted, but Matt pulled me into the next era in tattooing. I was under no illusion

that I was one of the pioneer set, but at least I now had the skills that would allow me to continue working professionally.

This very same challenge was slapping a lot of red faces in the industry right then. Guys like Matt were popping up all over the place, taking things to an interesting new level. They were doing things everyone suspected could be done but that no one had ever gotten around to actually doing. A new door had opened while I was making beer can sculptures and meditating on the most obscure distinctions between Sonny Chiba and Bruce Lee. With all the humility we could muster, I and a significant portion of my peers bowed to our new masters. They had succeeded where we had failed.

All the dreamy notions of gray scale that we thought about experimenting with but never did? These guys were doing it. Really large displays of gravity and dimension, the warping of perspective, the infusion of classical ideas? Done. Nailed.

If you look at a stack of tattoo magazines, a continuous archive from 1980 until the present, you'll notice an abrupt shift sometime in late 1995. Names like Guy Aitchison and Paul Booth appeared. They began to show what was really possible, putting theory into practice. This leap was occurring up and down the West Coast and in places like Austin and Chicago. Jack Rudy did that portrait of Jack Nicholson and struck terror into the hearts of everyone. It looked like a painting. The tattoo renaissance was at hand.

But in all things, for every force there is an equal and opposite force. Some of the repercussions of the revolution were going to be seriously fucking boring. The terrible resurgence of old-school design motifs, for instance, is still the most wearying to this day. As a direct reaction, a significant portion of time would now be spent aping tattoo history, the Sailor Jerry crap from our cartoony, Scooby-Doo–coloring-book past. Only this time we would render the images with machinelike precision, a much-touted advance. This sad glorification of history is a slight to the field's progenitors at the very least, a witless

slap in the face of the artists who dedicated themselves to progress in their period with the tools at hand. It's easy to be a perfect mimic, but it's exposing and exhausting to be an innovator.

There is a terrible logic in selecting measuring sticks you may never match up to. Sure, it can be humiliating. Even your best moments dim when it hits you that there is always someone better and brighter. I've had fun chasing Matt over the years. He's like a massive truck sucking me along in his vacuum wake. You can be sure there's a bigger vehicle in the darkness in front of him, and it's square in the center of his crosshairs. I'm not alone in this view. All the good artists I know, even *painters*, for heaven's sake, are frequently stricken by healthy moments of abject self-revulsion.

Humiliation finds endless expression. Right when you think you're at the top of your game and are feeling invincibly smug and self-confident, something shitty happens to bring everything back into focus.

A well-known actress recently sashayed into the Sea Tramp Tattoo Company, an actual famous person! And she was looking for me! Apparently she was in town doing some kind of film activity and the guy she was with decided to get a tattoo. She made a few calls, and my name came up.

Well, what an ego booster. I was on my way out after a long day, so I turned the guy over to the night shift after making the sale. The actress was sort of leaning in the gate in the tip wall as I tried to slip past. I rocked my hips forward to clear the door just as she arched her butt back. My crotch slammed into her ass with a resounding smack. I tried to pull away, bounced back in, and slammed her again.

Excellent. To everyone's amazement, I dry humped the famous person. So high, and then so low.

· · ·

AS SELF-MOTIVATING MANTRAS go, mine may seem like a bummer, but believe me when I say it works and is probably more common in the art world that you'd think. It's not a narrow view, so it could work for anyone, no matter what you do. Consider the schlocky, half-baked alternatives first:

Don't worry, be happy? Put a gun in your mouth, cream puff.

Every day in every way, I'm getting better and better. Right up until you convince yourself to rampage through a shopping mall in your underwear with a high-powered rifle.

Real beauty is on the inside. It's on the outside! The outside! I'm sorry. We're all bad and I know it.

There's a light at the end of the tunnel. That's the gateway to hell, moron. BYO lube.

Goals are dreams with deadlines. If you don't die soon, I just might murder your ass myself.

It has to get worse before it gets better. If you work in a tattoo shop, then you, my sweet delusional fucktard, are fired.

I am the master of my own destiny. With the small exception of the world that exists outside your head.

Need to really motivate yourself? Then tell yourself the honest truth. Look into the mirror and repeat after me.

I am a sorry-ass boob of a fraud who'd better get my shit together before someone notices what I'm doing. And you better believe it every day from now on.

PART FOUR

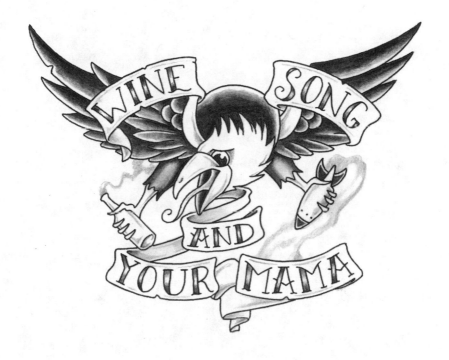

14

POCKET FULL OF CASH

t's bad to fuck the customers, no matter how tempting the situation is, no matter how easy and fun and perfectly natural it may seem at the time. I know this from experience, of course. Like the hilarious joy of playing with fire, it's a lesson learned only after you suffer your first really wicked burn. Or after you accidentally torch your house. Perhaps a combination of the two.

There are many fine things in this world. Warm, lard-impregnated drop biscuits, single-malt scotch that tastes like the blood of shurikened cherubs, smoggy methane sunsets, and the resplendent creature who sashayed into the shop one rainy day. They all have something in common, too: not one of these beautiful things is at all good for you.

This utterly delightful urban pixie arrived with a shabby, greasy-haired monster in a snot-streaked army coat whom I took to be her unfortunate choice of a boyfriend, and together they waited around in the lobby for an opening. I finished the job I was working on, pulled a wad of cash out of my pocket to make change, and then swaggered over to the tip wall. I'm sure my smile was a toothy one.

She was short, slender, and impossibly curvy, punkish and just a little torn up, with dark hair and milky skin. . . . I don't know, I was salivating right away. She wanted something around her wrist, she said, something pointed and sharp, yet delicate, with a hint of mad-

ness to match her character. I found the right design, modified it a little just to show off, then brought her back and got started. The boyfriend waited out front, smoking cigarettes in the rain and talking to himself. I'd already convinced myself that she could do better.

I took my sweet time, I'll admit. We talked quietly about bands, local bars, that kind of thing. The intimacy of being physically close to her combined with the easy chatter to make for a pleasant, relaxed, flirtatious vibe, much like a perfect first date. At one point she mentioned that the guy she was with was just a friend of hers. My heart leaped right into my pants. When I'm that horny I'm utterly fearless and painfully stupid, mostly, I suspect, because I have low blood pressure and have to fuel any organs with a blood demand one at a time. IQ-wise, I was on par with a baboon.

"I just got out of a shitty relationship."

"Me too," I replied. I probably had.

"Fucker hit me."

"What a dick," I said sincerely. "I would never do that."

She smiled at this and lowered her face, keeping her eyes on me for that conspiratorial look. "I don't know," she said sweetly. "I'm just looking for a little fun right now. Nothing too serious."

Sounded like the preamble to a memorable night to me.

"I like you," she whispered, leaning in closer. "You want to get a drink when you're finished tonight?"

She gave me her phone number, and I called the very instant my shift was over. We agreed to meet at a bar I'd never heard of. I took a cab.

The bar turned out to be this weird, shitty dive in some old cinderblock replica of a Swiss chalet. She was already drinking when I got there, so I settled into the booth facing her and ordered another round for both of us, well bourbon and pints of beer. She'd changed into something more revealing, a tight, faded Black Flag T-shirt with a fist-

sized hole in the abdomen and a short plaid skirt. She got up to get cigarettes from the bar at one point and then sat back down on my side of the booth, in direct contact with me, and put her hand on my leg, saying she was cold. It was raining like hell outside. The bar was almost empty by then.

We drank more, lots more, and I marveled at how this gal could really put it away. Pretty soon the kissing started, hot and passionately sloppy. I was drunk when she said the magic words.

"I live a few blocks from here. Want to go over to my place?"

"Hell, yes."

The walk through the rain seemed like more than a few blocks. For some reason, she wasn't wearing a coat, so after a block or so I naturally noticed she wasn't wearing a bra. Her clinging T-shirt had gone as transparent as wet Kleenex, revealing dark, chill-hardened nipples and a flat abdomen. It seemed like we circled around forever, zigzagging through alleys and parking lots. I was hopelessly lost and beginning to wonder if she could find her place in the rain when we stopped in front of an apartment building.

I think the building was white. I'm reasonably sure the carpet in the hall was red.

We stumbled up some stairs, down a long hallway, up some other stairs, around a corner, and down again until she finally stopped in front of a door. She took a single key from her tiny purse, and the heavy door groaned open on a dark room that smelled like old beer and garlicky leftovers.

"You want a beer?" she asked, motioning me inside.

"Sure," I said.

"Have a seat," she said, gesturing at the couch. She flicked the light switch on the wall and a bare bulb lit up in the center of the ceiling. There was something wrong with her door, apparently. She couldn't get it all the way closed or something. I crashed down on the

sofa and watched her struggle with it for a minute. She finally dropped her key and some kind of metal bulb back into her purse and disappeared into the kitchen. I heard the clatter of pots and pans.

There was something odd about the placement of her furniture, I dimly realized. At first I couldn't figure out what it was. The place was a real shit hole, but that wasn't it. The arrangement of things, however dirty, just seemed off. It was then I realized that the couch I was sitting on was sort of far away from the wall. My shins were touching the coffee table, a heavy thing covered with overflowing ashtrays, beer cans, and old Chinese take-out cartons. I glanced down, and there, looming out of the darkness to my left, just poking out of the space between the couch and the wall, was a pair of enormous, muddy combat boots.

Amazingly, I had no immediate reaction. I was drunk and horny. If someone had left his boots here, too fucking bad. I could always go out the window if the giant that wore the things ever came back. For some reason, I leaned over to see what else was back there.

The shabby monster from the tattoo shop was lying between the couch and the wall. The boots were on his feet. He stared up at me, his face fish-belly white and beaded with sweat. For a split second neither of us moved.

I jumped up as he rose to his feet. He was even bigger than I thought. There was no way I was going to fight this guy. Seizing the moment, I sprang the three steps to the door and in a flash realized why it had taken her so long to close it.

The sneaky little bitch had removed the doorknob.

It wasn't looking good. The guy came at me with the confidence of someone who had already won the fight. He didn't even bother to put his hands up. I was just drunk enough to have the wrong reaction. Rather than yell for help, try to defuse the situation with diplomacy, or use my head in any way, I got mad as hell and drove the heel of my boot into the pit of his stomach as hard as I could.

It was like kicking a car. I should have gotten my ass kicked right then, but as fortune would have it, the step backward he took to absorb my kick sent him into the coffee table, neatly clipping his legs out from under him. I take no credit for this. It was the luck afforded to drunks and fools everywhere, both of which figure prominently on my résumé. The beautiful punk girl stood right behind him holding a cast-iron skillet, snarling at me, almost totally unrecognizable. As he fell, he knocked her back into the kitchen.

There was just enough of a nub of metal sticking out of the door for me to get a grip. I lost a good chunk of thumbnail opening the door. Once in the hall, I slammed the door and ran. The outside portion of the doorknob and the metal rod attached to it came off in my hand, so I took it with me.

I couldn't find the goddamned door to the street! I sprinted up and down the halls like an idiot, envisioning running past their door again and being yanked inside. I jogged up and down several flights of stairs, feeling like maybe it was a good time to throw up. I lit a cigarette, smoking laws be damned. Once I calmed down a little, I finally found the exit.

"Wait!"

She came running down the stairs just as I opened the door. I paused, thinking I still had a chance. We could go to my place. Maybe I was imagining all of this. Such is the power of lusty self-deception.

She dashed up, arms wide, as if to throw herself into my crushing embrace. Instead, she savagely bit me on the cheek.

So I punched her. Getting that bobcat off me was hard. I staggered out into the rain just as the guy appeared at the top of the stairs. I didn't look back.

I wandered around for a while, completely stunned, unable to get any wetter. I should have seen it coming. The money she had seen in my hands, going straight to meet her after work, eager to get laid, putting the bank drop off until tomorrow. Her hand on my thigh in the

bar, feeling the roll in my pocket. I wondered what they had planned on doing with me after they got the money. None of the scenarios that came to mind were very appealing. If everything had gone their way, I might be rolled up in a carpet at that very moment, pathetically trying to chew a hole in it as I slowly asphyxiated.

Eventually I found a bus shelter and stood under it, smoking and wondering where the hell I was. A bus appeared out of the downpour and I got on and rode it all the way downtown.

There was a bar called Fellini's in Portland's Old Town in those days. It seemed like the right place, considering the tenor of the evening so far, so I stopped off for one last drink before hitting a cab stand. After I downed most of a beer and a shot, I noticed the bartender's eye stayed on me. I went into the bathroom to check out what he was staring at.

There was a bite-shaped welt on my cheek. The damn thing eventually turned blue and yellow. It took almost two weeks to go away. My lower lip was hideously swollen, for reasons still unknown to me. I went looking for that apartment a few times over the next week with a hammer in my jacket. Thankfully for everyone involved I never found it.

A few years later I heard through the grapevine that an old buddy of mine had gotten married. I hadn't seen him for a while. Rumor had it that his wife was some kind of ex-junkie bombshell who used to rob people. Sort of a bad-news punk chick he had manfully plucked from a fast-moving gutter.

When I finally ran into them, I shook her hand and pretended I'd never met her before. She mouthed "thank you" at me behind his back. That was in the late nineties. They have three kids now, and they're still going strong.

. . .

ATTEMPTED ROBBERY IS only one of the possible outcomes of fucking the customers. Artists I have worked with have been stalked for years. Some of them had to sell their cars because they were afraid they were being followed, and at least half the time they probably were.

Some years ago, I worked with an artist I will refer to as G. He was a tall, muscular guy with wavy blond hair and big, white teeth. He was so charismatic that to stand next to him in the presence of women was to be invisible. In the two weeks we worked together, I literally never spoke to a woman in the tattoo shop.

He left with a different woman every night. On his last day with us, two women came in at the end of the night, took one look at him, and it was on. They were powerfully slutty looking, with cowboy hats, glittery makeup, and painted-on Levi's shorts. G spoke with them for perhaps a minute and then approached me.

"OK if I split a little early, little buddy?" That's what he called me, "little buddy." I don't think he ever committed my name to memory. He tossed his head at the two women, busy blowing bubbles with their gum and running their eyes up and down his body. "Want to get out before the bars close." He winked. "Gotta catch last call."

I shrugged, and he bolted out with a woman on each arm, a triumph even for him, I assume. This meant I would have to do all the end-of-shift cleaning and close up myself, but I was getting used to it.

G and I both had to work the next morning. The shop opened at noon, and he never showed. At first I was irritated, then worried. Don came in and, after questioning me at length, grew furious.

"That goddamned playboy dumb-ass!" he shouted.

By two o'clock the shop was full and the phone was ringing off the hook. I was navigating a bloodbath solo and was justifiably upset when the phone rang for the hundredth time. It was G.

"Don't tell me," I said. "You're too fucking hung over to make it in."

"No, little buddy. I'm in Idaho."

G woke in the backseat of a car in a remote truck stop with a vicious, snakebite-style hangover. It was not his car. He had no shoes and no wallet. We wound up having to wire him money for a bus ticket. Don canned him when he got back.

That was fifteen years ago. If only I knew then what I know now.

I usually look the other way when I catch one of the guys sneaking off with some customer of theirs. It's none of my business until some jilted lover throws a brick through the window. Occasionally, however, if we have someone new, someone who might need a little advice on the subject, someone I might be able to spare a little terror or discomfort, I just might tell them a helpful story.

"This was one fine-looking woman. Short, curved, punky. I don't know, I liked her right off the bat. . . ."

15

TRUE LOVE AND OTHER POSSIBILITIES

"I've got good news and I've got bad news," Matt Reed said.

"The good news better be that you can cover this up," I said.

There was a pause on the other end of the line.

"That is the good news," he replied. I sighed in relief.

"The bad news is that it's going to be a shark biting an anchor."

"Nooo!"

A few weeks before, I had given Matt a Xerox copy of a woman's name on my inner arm. It was the deluxe version, meaning the first and middle names spelled out in florid script with a gauzy, satiny *I Love Lucy*–style heart behind them.

Some background may be necessary here to understand the depth of the situation. Every tattoo has a story. Every cover-up has two.

Two months before, I had gone on a trip to Vegas with a woman I had known for a few weeks. It was the end of summer, and we had a room reserved at one of the hotel casinos. I've never been much of a gambler, but on that trip I threw caution to the wind and rolled the dice in a grandiose, shortsighted way.

The next morning, still blazing drunk from a night of Bushmills (which now smells like rat poison to me), we wed in the splendor of the Graceland Chapel. This was, of course, not the richly complex Canadian genius woman I was to find matrimonial bliss with years later.

It was early, and the King had not yet arrived, the first definitively bad omen. I have one unclouded memory of the event, that of standing outside the chapel in the blistering heat hailing a cab. I couldn't help but notice how the boulevard was lined with sun-bleached plastic bags and faded scraps of porn handbills, and everything was powdered with a fine filth blown in from the surrounding desert and made sticky by car exhaust. I have since formed a more favorable impression of Las Vegas, but right then, at that moment, I saw a glaring parallel between my life and this gaudy, half-dead dump.

Things would have been fine if we had just stayed there, never spoken to each other about anything of consequence, and continued vacation-style drinking, but the plane tickets were round trip, so a few days later I found myself landing in Portland in the rain, hung over, sitting next to some slumbering woman with bad breath whom I knew next to nothing about, and we were husband and wife.

You may be tempted to predict what happened next, but no one could have guessed.

Her parents apparently worshipped some "master" from India, if my understanding is correct. They were devout in the extreme. There were weird photos of some guy I took to be her uncle or grandfather scattered all over her apartment. He vaguely resembled the guy from those early-nineties Doritos commercials, but he was in fact their messiah. Naturally, I didn't fit in. I never would. Possibly no one ever would.

This was made very clear to me.

I guess we both tried halfheartedly for a few months, hence the tattoo, but we were unable to overcome a single one of the strange obstacles set by the cosmos before us. I am, after all, a tattoo artist of no denomination, with no family other than my brother. She was an aspiring actress/secretary from an amazingly peculiar, claustrophobically entangled family that demanded conformity, a notion that filled

me then and now with the urge to break and burn things. Eventually she took half of my pitiful savings and moved to L.A. I still haven't seen her in any movies.

Matt was aware of the situation, of course. When I handed him the Xerox of the tattoo, he looked skeptical. It was kind of big, for one thing, and dark. Not exactly a cakewalk of a cover-up.

"You know you can do it," I said.

He didn't reply.

"I don't care what you put over it," I went on, pleading now, giving him some leeway. "Just none of that Popeye coloring-book shit. You know I hate that stuff. Something tasteful."

"Give me a few days," he replied.

GETTING A NAME is always a gamble, but the odds that it will pay off, at least in the short term, are much better than you'll find in any casino. It's a get-out-of-jail-free card and retains some of its initial power in this regard for later use. Consider putting it off until you've done something really bad, or you know you're just about to.

How many of the names that go out of the shop each week will wind up on ancient, wizened cadavers, kept faithfully through a long and happy union? Perhaps this is a question best left unasked, though statistics show that 49 percent of marriages now end in divorce. And who can say how many that make it to the end are really happy?

Eight years ago I made a much more sensible choice and married a truly excellent woman. Laura and I have been very happy. I have her name tattooed on my arm, and I plan on keeping it until I die in a heroic gun battle with crooked cops in my late nineties or I get a new robot body, in which case I'll scratch it into the shiny new arm with a nail.

Beware the meathead dork who won't tattoo names. Art is an exer-

cise of the imagination. If an artist can't imagine that a perfect stranger might have a chance at happiness, then I doubt they can imagine very much at all.

"I don't do names. Trust me, you'll regret it," is a judgment from the mouth of an amateur dumb-ass hack who would be better off leaving his or her miserable personal life and broken home out of the workplace. There is no faster way to get on my permanent shit list. In my shop, this is a first-time-firing-with-wrathful-prejudice offense.

Let's ask the burning question: do most people regret getting names? It depends entirely on when you ask them.

Take my case, for example. At the time I got the tattoo underneath the shark biting the anchor, it seemed like a good idea. My mind recoils from any deep probing of that period, like a tongue poking around a shattered molar hole, but a hazy overview summons up a feeling of general well-being and happiness associated with that time. I was having fun then. It was a lighthearted period eventually made sober by fanatics and by growing up. I was that young person. Things change, but history is real and permanent. I can lie to myself all I want, but there on my arm is a shark biting an anchor, a memento of failure and poor judgment, impermanence, and the worthlessness of personal fiction. Maybe we all need such a totem. I certainly need mine.

PANTHERS ARE A time-honored easy fix when you need to cover a name. Roses . . . Peacocks . . . There are lots of stories under these tattoos, good and bad, funny and tragic. And every one of them is a manifestation of secret personal growth.

A good cover-up is like a crossword puzzle: it just takes a little while to figure out. Drawing a perfect cover-up is like solving a Rubik's Cube blindfolded, operating from a single one-second glance. It can be done, but this is obviously not easy.

A name is still one of the most common tattoos. After doing a countless number of them in countless ways, I feel confident in saying that I have no idea if it's a good thing to do, and I likely never will, but some vague intuition compels me to continue. Like string theory or the first nanosecond of the big bang, the wisdom of tattooing for love alone seems destined to be one of the great mysteries of our time.

Hegel wrote that Minerva's owl flies at dusk. The owl is, of course, the totem of wisdom. It will come as no surprise to you that I don't know exactly what he meant by that. It may be that wisdom comes at the end of a bad streak, or maybe not until the very end of it all, when all your streaks and rolls are behind you.

Either way, that's a lazy fucking bird.

ART + LOVE = MOJO

I n the summer of 2000, I found myself in a small Spanish restaurant, seated across from a woman of exceptional beauty. She wasn't my type personality-wise, but there I was. She looked like a college cheerleader, a group that collectively spurns men of my description. She drove a brand new silver Lexus with a Dave Matthews bumper sticker. I had no car, of course, not even a driver's license. She taught first grade in a Montessori school. I was a champion delinquent of long standing. On the ride to the little place where we faced off, she had mentioned that her favorite meal was a potato, which I found repulsively ascetic.

The waiter approached, and I ordered a glass of wine instead of my traditional bourbon. Her eyes narrowed.

"You're ordering wine?" she asked. "It's Thursday."

"Right," I said slowly, trying to pinpoint the meaning of this cryptic statement. The waiter looked back and forth between us.

"Water," she said primly. "No lemon, please."

He gave me a sorrowful glance and went to fill the order.

"I haven't had a drink since last year, I think New Year's Eve," she said, wrinkling her nose disdainfully.

"Problem drinker?" I asked politely.

She laughed like a starlet on camera and shook her luxurious cascade of red curls. "No, silly. It's a purity pact I made with my mother

at church. We're really close, almost like sisters. I talk to her every night."

Well, shit.

The tenor of the situation had abruptly changed. I abandoned my normal set of motivations and slipped neatly into escape mode. First priority: how to get out of there without ordering dinner.

I flipped out my cell phone and looked at it.

"Work," I announced. "I'll take it outside. Please excuse me."

I went out and had an animated conversation with myself in front of the massive windows while she looked on expectantly. Through hand gestures and posturing, I conveyed a studied visual of growing outrage. After a suitable length of time, I went back in with a harried expression.

"I'm so sorry," I said. My wine had arrived, so I tossed it back in two swallows. "There's been an emergency at the tattoo shop. Explosion in the restroom, maybe Mexican dynamite. Toilet's ruined. We'll have to reschedule." I gave her my sad, hungry mask and a painful sigh.

Fifteen minutes later I was home. It was still early, so I decided to head over to the hipster bar around the corner. My luck was about to change, though I had no idea at the time. It turned out that I had just returned from the very last crappy date I would ever have.

Beulahland is still, to this day, my favorite bar in the world. As I entered, I immediately felt better, like a fish that had been thrown back into the water or a bird that had just found its way out of a snake-filled cave.

The interior of the place was semidark and filled with a nutty, haphazard collection of secondhand bar furniture. The bar itself was made from an old church pew back, a stylish design metaphor I've always admired. There was a stuffed mountain goat on top of the ancient beer cooler.

The usual suspects were all in attendance: bald, punk union dudes

(nice guys all, especially in a bar fight), skanky hipster chicks (all crypto art critics and knife fighters), drunks in training, and all the rest. The lesbian pool sharks saw me come in and waved me over for a game of doubles. I grabbed a Jameson and joined them.

"What's up with your hair?" one of them asked.

"I combed it," I replied. "Had a date."

She squinted at the clock over the bar. "Ended early, eh?"

"Not early enough."

It was around that time I noticed a powerfully attractive young woman reading at the bar. I'd never seen her before. She was extremely fit, with short blond hair and high cheekbones. On the next trip to the bar, I glanced at the book she was reading, a battered copy of Wilfred Thesiger's *The Life of My Choice*. Hmm.

"I love that book," I said.

She looked up and smiled, the Cheshire grin that is her signature. Even in the relative darkness I noticed that her eyes were a unique greenish blue, a calm Mediterranean.

"Don't tell me how it ends," she said.

I went back to the pool table, where my buddies were all staring at me, aghast.

"You're an idiot," one of them pronounced.

"Dude," her girlfriend chimed in, "even you had to see that smile."

"Go back over there and invite her over," the third suggested.

So I did. I went right back over, and the woman with the Mediterranean eyes looked up.

"Hey," I said. I pointed back at the table. "My friends want to know if you want to play pool with us." What a chickenshit.

"Oh, sure," she replied, closing her book.

She was better than all of us at pool, and that's saying a lot. It turned out that she was visiting from Canada, where she was a fourth-year student at Queens. The two of us closed the bar that night, sing-

ing along with Tom Waits songs, talking about books and what the world would have been like if Ezra Pound and Groucho Marx had somehow been roommates in college or at a prison work camp.

It was like nothing I'd ever experienced before. We were old friends after three or four hours. We'd read the same books, we liked the same music, and so much more. We agreed to meet the next day and catch the new Jim Jarmusch movie, *Ghost Dog*.

We spent every night together after that. At the end of her two-week visit to Portland, she decided, what the hell, let's make a summer out of it. This pleased me to no end.

Laura fit perfectly into my life, which was amazing. At that time, almost every aspect of my existence was under continuous fire from any woman I came into contact with. They had their reasons.

I lived in a small apartment with my best friend, Moses. He was a bartender at a swank hotel and looted the kitchen there regularly. Thanks to Matt Reed, I was doing good work at the time, but not that much of it. Some of my customers were chefs who paid for their tattoos with boxes of pilfered items. We lived off stolen duck, crown rack of lamb, filet mignon, anything we wanted.

Our friend and landlord spent half the year in Mexico, where he owned a beach house. We did routine maintenance on his Portland properties while he was gone, so our rent was dirt cheap. We worked as little as possible, spending our time reading on the porch and frequenting the bars where our friends worked, soaking up free drinks.

In short, we lived like kings, enjoying lives of art, literature, and good food. We barbecued every night, rain or shine, and hit every gallery opening that boasted free snacks and booze. We hit so many of these functions that an improbable rumor began to circulate that Moses and I were exotic rug merchants.

This carefree attitude quickly wore thin on any woman Moses or I got involved with, but we'd been at it for years and had no intention of changing. Moses was also a part-time underwear model in those

days, a six-foot-plus, rippling superman with tremendous, dastardly charm, and I was no slouch at meeting women and enjoying a few pleasant weeks with them.

Our problem with the fairer sex was keeping them around after they had discovered more about us, namely that we were happy bachelors of the stripe I've just described.

None of this fazed Laura in the slightest. She happily grazed through galleries with us, fit in immediately with our eccentric group of friends, and quickly became adept at barbecuing stolen meats. Walking places instead of driving didn't bother her. She was (and is) a tremendous athlete and enjoyed the exercise. No amount of misbehavior on my part shocked her. In fact, she took great delight in my continuous string of antics, laughing and clapping with earnest enthusiasm at some of the high points.

She thought it was nice that I had an art job and was unconcerned that it occasionally involved half-naked women. I blew off work a lot that summer, something I still did anyway in those days. We went rafting, cruised around town, invaded private swimming pools, and shot BB guns. We took up archery, which she mastered to an impressive degree in less than a week. Time seemed to fly by.

The day inevitably came when she had to return to Canada. Her car was in long-term parking at the Chicago airport for reasons neither of us can remember. In the week leading up to her departure, I grew more and more pensive. I knew I would never see her again if she left, so I asked her to stay. A friend of ours from Australia picked up her car and drove it back to Portland, happy for a chance to see the country.

We married less than a year later. The immigration people were sort of a hassle, but we took our time, in no hurry to jump through the hoops. We had a ton of money after the wedding in Toronto, thanks to her large and generous family. We were cruising down easy street with the top down, the Doobie Brothers on the stereo.

September 11 changed a lot of lives in America, mine definitely included. Like many Americans, if I were ever to find bin Laden living in a resort in Switzerland, I would step on his tongue and kick his head backward, and then I'd get nasty. I saw the footage from the World Trade Center for the first time while standing in a convenience store on the Oregon coast. We'd been riding recumbent bicycles on the beach all morning. At first, I thought the clerk was watching a shitty made-for-TV movie. When I realized he wasn't, I knew that a part of my life was over. Nothing would be easy from then on.

The federal immigration process instantly locked up. It was a bad deal to start with, staffed by utter morons too dull and aggressive to merit employment as prison guards, but with the keen new national hysteria, lives were ruined, couples separated, and families destroyed. My wife would soon be a fugitive, hunted by oafish, vehement badge boys. I went to the best immigration lawyer I could find and, at one hundred and twenty dollars an hour, got the bad news. We were fucked, just like all the other green card applicants. The forecast was bleak.

I had to abandon everything, I soon realized, if we were to stay together. My life as I had known it was over. I would have to change in an all-encompassing way. It was time to live up to my potential, and even that might not be enough. People were being deported left and right. We lived in a state of terror. A new Berlin wall was proposed, this time the size of Texas. The "home of the brave" was perhaps not a suitable accolade for us anymore. The war on terror was a short one, lasting about as long as a softball game. America lost.

The lawyer bills were staggering. Already, the Canadian side of the immigration process's medical bills were through the roof. Fees of every kind were around every corner. Our meager finances were drained virtually overnight. I needed money.

We fled to Canada for more than a year. There we eked by, waiting for the U.S. immigration process to clear up. It never did. It was a

rich-kids-only-need-apply scenario now. There was only one thing to do in the end, especially after talking to Don Deaton and realizing that my aging mentor was about to lose everything and badly needed me to return. It was time to go back, where I would engage in pitched economic battle to the death.

I realized something critically important around that time. Something unsavory about myself, a factor I'd never looked at, a part of my being that was broken. My lifestyle, my career, my concept of ambition were all screwed up at the very foundation. At thirty-two years old, I realized that I had been camping inside my own life.

MY PARENTS HADN'T really wanted kids. I can only guess that they had them to impress their own parents. They had three boys. We were often split up in their endless maneuverings to pawn us off on anyone who would have us. We had no possessions that weren't robbed from us at the end of the shadowy custody arrangements, as with our prized, painstakingly acquired comic book collection, stolen by some shitty offspring of a morbid, violent floozy my drunken father had dredged up. We grew up with no permanent place to live, were put to hard labor, and when that work was done, we were free to do whatever with what remained of the day, as long as we stayed far away. Two meals a day was lucky. Beatings were routine and savage. My sweet mother spent her time in the soap-opera land of a local nuthouse, but was thoughtful enough to bankroll my early efforts as a drug dealer when I was thirteen for a cut of the profits, and my father spent his time boozing with the aforementioned violent beast-woman, who despised her own children and would have eaten them if it were legal. You can imagine how we fared. These were the kind of people you wanted to send a Ouija board on their birthday.

. . .

THESE PEOPLE, MY parents and my stepmother, are the humans I have understood the least in my life, though they were the first ones I had any impulse to study. That they had a hand in shaping my character is undeniable. They brought into existence the impenetrable snail shell of my imagination, a helmet I wear with great pride today. This might easily form the gateway to madness if not paired with their second gift, also bestowed inadvertently. It was the iron will to oppose them. When I really needed it most, this willpower came in very handy.

My earliest memories of my mother are standard: blank tableaus involving food and shoelaces. My very first internally processed thoughts regarding her are not so garden variety. She ate like three people, and this was reflected in her muumuu-draped body mass. She seemed to have no energy or resolve whatsoever, possibly the result of her pill collection, which had a seemingly magical effect on her disposition.

My father was quite the opposite. A stern, motivated, extremely hairy man, he was reasonably fit by slack, Southern patrician standards. He was a scientist involved in industrial food production and a real estate entrepreneur on the side. In him, too, there was a remarkable volatility in behavior. His regimen of early-morning-to-late-night drinking led him down a freeway with road signs like "Violent Behavior, Exit 1B," "Malicious Destruction, Exit 2B," and variants of "Blasting Creedence Clearwater, Last Stop."

The perfumed sewer that is my adolescent life is alive with pale, bloated nuggets offering easy insight into my camping reflex. They are monotonously uniform, so I will offer two that pretty well sum it up.

I was six when my parents divorced. I was delighted, as it meant my father was leaving. It was a dream come true. For some reason, they got us two kittens. One of them immediately latched on to me, a petite Siamese I named Lady.

Other than my brothers, this was the first creature I had ever loved wholeheartedly. Shortly thereafter, the custody games began, with each parent desperate to avoid us. My father had by then shacked up with his child-hating second wife, and my mother was courting the kingdom of the cuckoo birds for state-sponsored dough and an easy way out. I still had my cat from time to time, but she fared poorly when I was away.

We eventually wound up one dark winter living in the basement of my grandfather's farmhouse. My grandparents didn't want us either, and they made this very plain at every opportunity. In the summer we had made ourselves useful by following the tractor across the fields, ferrying rocks tossed up by the rototiller. But with the first snow the house grew close and our presence glaringly superfluous. So we hid down in that dusty, smoky place and made little noise.

My brothers and I made up endless games in that basement, telling stories and dreaming of portals to Middle Earth. Looking back, I can see that this is when my siblings began to wither in earnest. We worried about our future as only troubled children can. I spent many afternoons wandering the frozen hardwood forest, jogging and lifting buckets of rock, obsessed with physical fitness, while they drifted deeper into themselves.

Eventually we discovered that my mother was snugly ensconced in some nuthouse in Houston and was selling our home, sealing off any possible escape in her direction. My grandfather grimly set off in a U-Haul to pack everything up. I hope someone invents a time machine in my lifetime, so I can pay a visit to that dude.

"I've never seen anything like it," he thundered when he returned a week later. "The house had been ransacked! Broken windows, trash everywhere. Everything valuable was gone."

"What about the cats?" I asked nervously. My brothers were unable to speak.

"Oh, they were there. Your mother had locked them in the back

room. Even in Vietnam I never smelled such putrefication. And I've seen men covered in maggots. The big cat was dead, and it looked like the little Siamese one had eaten some of him."

"What about her?" I asked, still holding out some hope. She could have been out in the U-Haul.

"I opened the back door to air the place out. She was just a bag of sticks. Walked out into the grass a few feet, laid down, and died."

I was already a careful, cautious student of human moods. I think I was nine at the time. He evidently took some pleasure in that account. So the time machine is as much to save the cat as it is to go back and visit him in his prime, to show him in my own special way what one of the garbage-can boys grew into.

DURING HIS "CAPTAIN" of industry" phase, my father reached an unhealthy maturation. He'd graduated from science dork to plant supervisor, so for a time we found ourselves busting ass as his labor force at his new house in Albuquerque, New Mexico.

By then I was twelve. My brothers and I had gone to a different school every year so far, but as luck would have it, my father needed a small flock of servants to keep a property the size of this new one in order. We were allowed to stay for two years.

This marked the entrance to a soul-crushing dead zone beyond all others. Our meager belongings were subject to routine inspection and possible seizure. My father's alcoholism was pronounced by then, and it coincided with both the pinnacle of his career and the beginning of his physical decline. Very predictably, this made him angry.

My stepbrother and stepsister had for years lorded their superior status as real people over us. They gleefully ate when we did not, watched TV on their fat asses while we worked, and, like their mother, a creature of immeasurable cruelty, the poor, ruined things loved every minute of it.

There were no reprieves in this sentence. This was what we had, year after monotonous year. Everything was compressed into a backpack, and every dream reflexively squashed, because you don't want the help getting uppity. We were the second-class leftovers of an unfortunate union between two self-obsessed, childlike baby boomers.

When my father died years later, this perception was verified. I gather his ashes were dumped into a trash-choked drainage ditch by his inheritors (of whom I am not one), but even their exact location was withheld from me. My little brother, never a stable person after our childhood, died by his own hand shortly thereafter, but even my pleas to unite their ashes fell on deaf ears. I was just not human to these people, and whatever happened to my brother's ashes was of no concern to anyone but me.

As final proof of my father's cold-hearted contempt for me, I did learn at this time that my old man and his gorgon had maintained a life insurance policy on me for all those years. All the time in the foster homes and detention, the decade when they had no idea where I was. They were actually banking on my demise and were poised to cash in one last time.

MY OLDER BROTHER and I were shuffled out at the earliest moment, thus for me the foster homes at fifteen, followed by detention. At the ripe old age of fourteen, I had been working full time to feed my little brother, doing the graveyard dishwashing shift at the Howard Johnson's out on the interstate and selling weed on the side. At fifteen I was on my own, a step up.

So I had naturally matured into a man who wanted nothing. No gain, no loss. The aspect of character that set me apart from guys like Matt Reed was rooted in my past. Like almost everyone else, as an adult I was a blurry continuation of my personal history, carrying out my early program directives. I was afraid to succeed because any mea-

sure of that success would be pried out of my hands, if the lessons of my own history were to be believed.

But I wanted something now. I wanted this woman. I knew that in some awful way I had been locked in a behavioral loop, selecting women who reinforced my childhood image of them, that of cruel, self-centered sources of pain and sorrow. This was different. I had accidentally broken free of a cycle that would have ultimately ruined me.

It was time to kick some ass.

Back in Portland I found a new and spooky resolve. I worked for ten hours a day, seven days a week, taking only Christmas off, for a little more than two and a half years. Often I worked late into the night to prepare designs for the next day. I paid those lawyers. I paid the immigration fees. I worked like a demon and won the hand of a woman the likes of whom I'd never imagined. It was an ugly battle, and at times I wanted to fade away, but I didn't.

And the strangest thing happened along the way: I started to get really good at my job. People started interviewing me, from newspapers, radio, and magazines. I became booked weeks in advance. My income quadrupled and then exploded.

Our little apartment filled with antiques. Moses went to Seattle to explore his own great fortunes as a screenwriter. Laura and I went on vacations around the world and stayed in OK places. She decided she wanted to learn how to design Web sites, and I hatched a half-baked idea where we might be able to sell the hundreds of tattoo designs I'd drawn in my maniac phase online. Today, our site is one of the largest of its kind in the world. More money still. You can raise a human in a cage, but bars are meant to be torn from their sockets.

I owe it all to one good woman, and if you got a tattoo from me in the last few years, one that people marvel over, then you do too.

PART FIVE

SCIENCE AND THE PAIN

ow does a tattoo stay in place? Who made the infernal machine we use? How much does it hurt, and can it not hurt? Are some areas more sensitive than others? These questions and many more have surprising answers.

Let's begin with the most dreaded implement in the entire setup: the needle. Most are made of stainless steel and very small, with a diameter ranging from 0.25 to 0.36 millimeters. They are not hollow. The taper of the needle, that is, the space it takes from the beginning of the slant toward the point, ranges as well, but generally needles are classified as short, medium, and long taper. Every artist has a preference, usually based on the job at hand, but in general short tapered needles find their way into shaders, medium and long into outliners. The size of the liner or shader, that is, the swath they actually mark, is made by adding more needles, not by using a fatter one.

I could go on and on about needles, but it's dry stuff. Much of what is considered cutting edge is in this area, but I can't imagine the casual reader would have any interest. Premade, textured, carbon . . . I can barely stand to think about it myself.

The needles, whatever their composition and whatever configuration they take, rely on the machine for the actual pokey-pokey. This is much more interesting.

Some people claim that Thomas Edison invented the tattoo ma-

chine. He didn't. His Autographic Printing Pen was patented on August 8, 1876. Some fourteen years later, Samuel O'Reilly of New York City patented a rotary machine that was a direct descendant of the Autographic Printing Pen. Twenty days later, Tom Riley of London patented the true progenitor of the modern tattoo machine, a device that used coils from doorbells.

The first easily recognizable machine by modern standards was patented by Alfred South of London in late June 1899. Things were finally looking up. Little tattoo kits hit the market. They were insanely unsanitary, crude crap heaps, but you can make a case that this was the moment when electric tattooing took flight.

Then along came Percy Waters, an innovator and one smart dude. He was the real ass kicker in the pack if you ask me. The modern tattoo machine looks in many ways like his. You can look at a Waters machine circa 1934 and a machine from almost anywhere circa 2009 and identify the Waters machine as the clear design ancestor.

After looking at the schematics of Waters' machines, I noticed they had no capacitors. I interviewed some of the old-timers and found out that the capacitor had been introduced in the mid- to late seventies. Before that, every tattoo machine had a bright blue spark ripping between the front spring and the contact screw. They went through a front spring a week in those days, all hand cut from old wind-up clock spring stock.

The modern tattoo machine is a finely tuned version of the old ones. It smacks into the skin between 60 and 120 times per second and reaches a depth of between one and two millimeters.

The needles and the machines won't get you anywhere without the pigment. Today we have a fantastic smorgasbord of colors to choose from, and those mix (or sometimes do not) to form more hues. A constant battle has raged in the pigment arena for nearly a century and is still ongoing.

Ever wonder why Grandpa's tattoos had that shitty greenish qual-

ity? The same problem can be seen in the old Lucky Strike cigarette packs from World War II. In the forties and fifties, the primary supplier for tattoo pigments was an outfit called Zeisse. The red was full of mercury, all of which was needed by the wartime government for bomb switches. This was the same red used to make the bright red circle on the Lucky Strike cigarette pack, among other things. Pelican, the black of the day, was manufactured in Germany and unobtainable. So they had green. Really dark green looks black until it fades, hence Grandpa's green navy anchor.

Tattoo artists had a hard time finding any decent ink to put into their customers. On some level we still do. The first great general in this ongoing struggle was Jerry Collins. In the sixties artists were finally fed up with bad reactions and poor colors, but every time a tattoo artist got in touch with a chemical company that manufactured pigments, the company would cut contact once they found out what their product was being used for.

Mr. Collins was a very bright man. He set up a fake corporation that allegedly manufactured wooden children's toys, and he claimed he needed nontoxic pigments to spray them with. The chemical companies would send him five-pound bags of samples, and then he'd run color tests on commandos from the local navy base. DuPont was duped into making our first really good yellow. Collins then broke the blue barrier and with it the purple. Like Percy Waters, he was a true luminary. I've said that if he were alive today I doubt he would be fond of what was made of him. This man is an example of hard, clever, insightful determination. He made real progress. I think he'd like artists like Paul Booth, a master of horror-themed black and gray, more than the kids who pillage his sketchbooks. Many quality tattoo artists refer to this younger breed as "Jerry's kids," a not-so-subtle allusion to retardation.

Pigments are still a problem today. The U.S. Food and Drug Administration does not, apparently, deem an analysis of pigments

worthy of them. They are, after all, busy acting as bellhops for the pharmaceutical industry. But other more responsible governments do, such as Holland. The Dutch recently banned the use of products made by two midrange pigment manufacturers, citing health reasons. A growing number of American tattoo artists make their own mixes now to assure quality, and those who don't often refer to EU Web sites where official analyses of premade pigments are posted.

On the so-called vegan tattoo shops, well, this is utter, ignorant, snake-oil-salesman horseshit. Glycerin used to be rendered from horse and cow fat. For high-end soaps it still is. Remember in *Fight Club* Tyler Durden used human fat to make luxury soaps? Sweet. But for tattoo pigments, forget it. These guys use vegetable-based stuff (soy and corn) because it's cheaper and just as good for what they're doing. By telling you that there are animal products in everyone else's inks, "vegan" tattoo shops tell you a generous lie right from the start.

Last up is the new line of nonpermanent pigments. These are actually dyes, microencapsulations in insoluble polymers (fancy talk for a type of glass). Smack it with the right kind of laser and the bubble breaks. Unlike pigments, dyes are readily absorbable and are thus theoretically flushed away, leaving only the light scar from the tattoo application and a bizarre payload of glass fragments. In a recent *Discover* article, I saw a wondrous assortment of microscopic brown beads that the leader in this intrepid field had concocted for this purpose. Brown is not my personal favorite, but if you want a semipermanent tattoo in the color that leaves only a broken bottle behind, you might be in luck, as this crap is due to hit the market soon. They might even widen the spectrum of colors by then to include puce and eggnog yellow.

So now we have needles, machines, and pigments. Last up is the skin. Your skin.

Anyone who says that tattoos don't hurt is, unfortunately, full of shit. No matter how many times I've been tattooed, no matter where on my person, I'm always amazed at how poorly I deal with it. They say doctors make the worst patients. The same is true in tattooing, at least in my case. I am a piss-poor client.

As such, I've made a careful study of every tattoo experience I've ever had in order to whine with the greatest possible accuracy. Here are the primary things I've found to bitch about.

"The squeegee artist." While it may seem necessary to wipe the entire tattoo at every conceivable interval, it is not. After hundreds of polishing scrubs, I can say with authority that it's fucking awful.

"The dry wipe." This is a sincere bummer. Imagine buffing sand paper over a sunburn.

"The megagrip hyperstretcher." Tattoo artists develop tremendous hand strength over the years. I shit you not when I say that a ninety-pound, waifish woman with more than five years of professional tattooing under her belt could strangle you to death one-handed. I have on occasion witnessed this might overused. It can leave deep bruises. You have to stretch the skin to properly work on it, but when a hand gets that powerful, caution is in order.

"The boxer wipe." A haphazard wipe conducted with a swath of paper towel in the same hand holding the machine. That hand is balled up around a big chunk of metal, often resulting in a wicked, beating swipe.

"The scab-master speed artist." Machine zorching along with an inadvisable capacitor-spring configuration. Some obsessive machine tinkerers stray into this customer hell without realizing it. You can only hot-rod a machine so far without stepping over the line. At a certain point it stops being a tattoo machine and becomes something else, a thing not to be used on skin.

"Talking-on-the-phone guy." An artist who is talking on the phone

and tattooing simultaneously undermines my confidence and makes me nervous. To take calls and tattoo at the same time is considered poor form in many shops.

Of course, it's your skin, and everyone is different to some degree. A raw hangover is not advisable when getting a tattoo. Believe me, I know, though some people actually swear the opposite. Most women find that their skin is more sensitive around the time of their period.

Drinking doesn't help. Pills can, but if you seem like a bunny you might get dismissed. Really hairy people have a hard time with tattoos. If you smell bad, guess what? Your tattoo may be going on faster, and you'll feel the difference.

The worst thing you can do is show up on an empty stomach, mid-diet. Eat like you are going on a short hike or a bike ride. This does not mean a four-egg sausage-and-blue-cheese omelet, jalapeño hash browns, and a mimosa, nor does it mean an apple and a peyote button.

Dear reader, do not for an instant underestimate how important this last part really is. I have seen things you cannot possibly imagine that were a direct result of not eating properly. Grisly, unholy things I might have easily been spared had you followed this simple piece of advice. There have been days when I wanted to go home and pour gasoline on myself and then lie in the bathtub crying.

Every tattoo artist eventually becomes an anatomist of a peculiar stripe. The condition of the skin, the health of the bearer, and other factors play into complex calculations. But above all, a quality artist is always on guard for two potential problems, the importance of which cannot be overemphasized. All indications of these two events are constantly on our radar screen, and the customer is evaluated along these lines instant by instant, at the exact and impressive processing speed of the human brain. This is what we are trying to figure out:

1. whether you will pass out
2. whether you will vomit (or "chud")

As a rule, night hogs never learn the warning signs. They forever wonder why they walk out at least once a week with puke-spattered boots or a wrenched shoulder from trying to catch some dead-weight flower vegan, blaming everyone else for their inability to pay attention and learn the warning signs.

I love shoes. I collect them. My footwear is indeed fine, with something for every occasion. I often deliberate for more than ten minutes in the morning before settling on just the right pair. None of these works of art is puke speckled. It wasn't always so.

Throughout all of tattoo history, it has been accepted that a certain percentage of the customers would either pass out or blow chunk; sometimes both. The "puke boy" was a real job indeed once upon a time, but we cannot (thankfully) draft our children into this pre-apprenticeship position any longer. So being the mop-men ourselves, we keep a closer watch.

Like most artists of my generation, I accepted this as an unavoidable occupational hazard, but a few pivotal moments turned me around. I began looking for signs, clues that would allow me to accurately predict these troubling situations and thereby avoid them.

Originally, we would tell customers that if they passed out they would wake up with a sore ass and their underwear on backward, but this was discontinued with the arrival of the humor-free PC era. Plus, a disconcerting number of customers had begun throwing themselves on the floor without preamble.

I was pleasantly ignorant and just gliding along when one sweltering summer day I was called on to tattoo the Gold's Gym barbell on a weight lifter. It turned out to be a career-altering experience.

This guy was huge. If I had been curled in a fetal position, I might

have been able to displace the mass of his chest cavity. He was a really nice guy, and so was his equally massive buddy. They bopped around the lobby asking cheerful questions and admiring the place, occasionally flexing in the mirror while I got set up.

I set him in the biggest chair we had, the one normally reserved for fat people. The tattoo was to be on his shoulder. He leaned back in the groaning chair, and the target flesh was perfectly exposed before me. Easy money.

About a minute into the tattoo, I noticed his pal was sort of lumbering from foot to foot in an I-have-to-pee dance, sending little shock waves through the floor. I looked up, and he immediately pointed a meaty arm at my client.

"His eyes!" he shrieked in a high voice. "His eyes are gone!"

He was facing away from me, so I leaned around for a look, and sure enough, Enormo's eyes had rolled back in his head. I set the machine down and silently thanked fate that he was sagged back in the fat chair. In a moment he'd wake up, none the worse for wear.

But the next thing I knew, he was listing forward. I got him in a loose headlock and tried to pull him back, but it was a no-go. His massive head trapped my arm. He was pulling me forward with him.

This three-hundred-pound sack of creamed corn hit the floor face first. The entirety of my body, some 165 pounds, landed squarely on the back of his head with a sickening crunch.

His buddy just stood there.

"Help," I croaked.

Behemoth number two vaulted the tip wall and pulled his friend up just enough for me to get my arm out. The crunch, it turned out, was my shoulder.

Barbell dude's eyes fluttered and he awakened.

"What happened?" he asked.

"You passed out and pulled the little tattoo guy out of his chair," his friend replied gleefully. "He landed on your head!"

He reached up and fingered the tiny red spot on his wide forehead.

"You OK?" he asked.

"No," I replied.

He was fine. My shoulder still acts up in damp, cold weather, and that was twelve years ago.

IT WAS TIME to figure this shit out.

Galvanic response, breathing patterns, and scent were all clues. In short order, I developed the same evaluation protocols many other artists had.

Any sudden change in skin color is a warning sign. The appearance of a light, overall sheen of sweat is a red flag. Essentially, any rapid change is bad. The trick is to catch it before it happens or right as it does. If you go into some kind of tattoo zone and totally lose focus on the well-being of the canvas before you, all is lost. The first twenty minutes or so is the critical zone. After that you're generally free and clear.

A careful eye prevented any more occurrences of this kind for the most part, but a clever few still slipped by me. These are your zombie walkers.

Some rare individuals can actually walk after they've passed out. They evade detection by showing no symptoms of distress whatsoever. The worst case of this I've come across involved a young Mexican woman. I was tattooing her shoulder when she slowly rose and started walking toward the door.

"Hey," I called.

No response. She lurched and caught her foot on the edge of the tip wall and went down hard. On the way to the floor, her face bounced off the edge of the front door, which was propped open. An ancient shred of aluminum molding slashed her cheek.

It has never happened to me, but I've heard of zombie walkers turning on their tattoo artists and actually wrestling with them. In the case of the young Mexican woman, wrestling would have been preferable. I'm lucky she wasn't the litigious type.

Today our door is very smooth, but I still haven't gotten around to installing seat belts on the chairs. That might send the wrong message.

Of all the anomalous physiological reactions a customer can have, the one typified by the man dubbed "The Cleveland Puke Walker" is both the most impressive and the most disgusting.

I have to say, I liked this guy. He was a hard case from Cleveland, a place he had fled to get away from a life of guns, dope, and certain death. He couldn't read and made his living unloading trucks. He loved Jesus, his mother, and cheap beer.

One fine morning we were working on his Jesus-hugging-the-junkie back piece when a fine sheen of sweat blew out of his pores. I thought I knew what was happening and how to handle it.

"Let's take a break," I suggested.

He couldn't hear me through the heavy metal thundering through his earphones. I put my hand on his slick shoulder, and he violently shrugged it off and rose to his feet, his arms wide for balance.

He was sobbing. I thought for an instant that he was having some kind of profound religious experience, a TV mall-church seizure, but it turned out he wasn't sobbing at all.

He was repeatedly throwing up and swallowing it. Dudeboy made it all the way to the curb before he chudded a thick foam of Milwaukee's best.

I almost didn't want to tell that story.

CAN'T A TATTOO be done painlessly? The answer is both yes and no.

I am not one of those he-man Rambo-Balboa dipshits who insists that everyone take the pain. A tattoo is a work of art. The pain is a largely irrelevant side effect. Just because most of us went through it does not mean future tattoo collectors should as well. Progress is good, and the discomfort of getting a tattoo is certainly not exempt.

Lidocaine works pretty well, but only after the skin is open. Other products contain agents that allow lidocaine to penetrate the skin, but the pH of these ingredients can react with the skin on occasion and even react with the pigment. I use these products all the time, and I've never had any problem, but I hear that it can happen. So it's a work in progress, but a pain-free tattoo is probably just over the horizon. It's certainly not a measure of the artist whether they carry such products. Some of the greats probably never will.

I CAN'T COUNT the number of ways I've heard of to take care of a new tattoo. I usually recommend leaving the bandage on for four hours, then removing it, gently washing the tattoo with mild soap, and finally applying a product like Lubriderm twice a day until it's healed. Always wash your hands before touching the new tattoo.

Aftercare depends a lot on climate, time of year, and what your artist has done for you, so be prepared for different instructions for each tattoo. The one I've just outlined is my all-purpose, nonspecialized one, but if you have dry skin or oily skin, if it's hot as hell outside or whatever, your directions could easily differ.

Oily skin is prone to hair follicle infection, so a very light aftercare regimen is called for. Dry skin might require vitamin A and D ointment. If it's hot outside, A and D will plug the pores, so maybe apply it only at night, or not at all.

Several things are bad for healing tattoos. Tanning is not good. Neither is hot tubbing. Remember that a Jacuzzi is basically a dick-pussy-ass Frappuccino; if you've ever wondered what that foam was,

now you know. Direct sunlight is bad. Don't pick or scratch. Most of the time nowadays the process is so mild that afterward the tattoo feels like a mild sunburn, but bacteria can still grab on, as with any cut or scratch. The prime vectors here are pet fur and dander, trips to the river and the beach, and touching the tattoo with unwashed hands. Dragging bacteria out of your sinuses through nose picking and subsequently scratching a fresh piece is a hazard never to be underestimated. Old aftercare products pulled out of the back of the medicine cabinet are bad. Don't put rubbing alcohol, aloe, or peroxide on a tattoo. If you have a question, call your tattoo shop.

Here are some other good aftercare plans. Amy Cole, a kick-ass tattoo Trojan at Tiger Lily Tattoo here in Portland, Oregon, recommends a minimum bandage time of six hours, then two days of triple antibiotic ointment allowed to penetrate for fifteen minutes, patted dry, then followed by Lubriderm until healed.

My old pal Peter Archer used to run Temple Tattoo here in town but gave it up to pursue his primary passion; he's a world traveler with a personal tattoo collection that spans several continents. This dude actually got his chest done (hand-poked) by some kind of half-blind witch doctor in a remote hut in Cambodia, no lie. Talk about balls. His aftercare instructions, when I asked about them, proved to be immensely elaborate and unlike anything I'd ever heard of before. Devised with a decidedly holistic slant and a robust understanding of the chemistry of over-the-counter products, it's pretty amazing stuff. He told me in head-spinning detail how it works, but the amount of research he's put into his aftercare program makes it proprietary information, so I agreed to leave the details out.

Some states have outlawed the use of plastic wrap as a bandage. I never thought this was a good idea to begin with, personally. It's simply disgusting, for one thing, but, worse, it's a cheap move. A nice, soft, breathable bandage costs about a quarter when you buy them in bulk. On a busy day we can go through a whopping five dollars' worth

of them. Might want to consider that, but it shouldn't be a deal breaker. Some great artists still use plastic wrap, and I'm sure they can give you all kinds of complicated reasons why. (Yawn.)

It just goes to show how important aftercare is. Once the tattoo is done, it's up to you to take good care of it until it's all healed up. Ask questions, get answers, but above all follow the program. If you don't, we can tell. We've seen the results of every possible mistake before.

If you get some kind of hack tattoo from your cousin, or a souvenir piece from your weekend in jail in Tijuana, laser removal might be the answer. Tattoo pigment granules are too big for your body to latch onto and flush away. Lasers shatter the granules into smaller pieces so they can be glommed onto by your body and expelled. You're looking at five to ten sessions, and it's not always effective. It hurts, too. A cover-up tattoo done by a professional is cheaper.

Tattoos blur a little over the years. The colors fade to some degree from exposure to sunlight, but every year the colors get better, so it's not the problem it used to be. If you get a tattoo today at a reputable place, you'll have a keepsake that will last as long as you do. It's safe, and the quality of art is often better than what a middle-income person could afford to spend on a painting for their home.

And lastly, the answer to the question most often left unasked because it's embarrassing. If you get really fat, your tattoo can migrate or expand in unusual ways. Don't eat that second slice of cheesecake, and you'll be just fine.

CLASSICAL EDUCATION

D oing your first tattoo is an experience both rich and terrifying. After learning how to set up without killing anyone, ideally in a proper apprenticeship, you learn the basics of machines, needle making, and stencils, followed by (in my case at least) simple coloring, and finally line work. Then comes the magic moment when you put it all together in the first piece entirely your own.

When my first machines came in the mail all those years ago, I could barely contain myself. In fact, in the interest of full disclosure, I didn't. I tore the boxes open and set everything up on the Formica table in my kitchen for inspection.

A liner and a shader, preassembled from National Tattoo Supply. Ink caps, little bottles of bright colors, and tubes. It was all there, brand new and chrome dipped, ready to deploy.

In those days it was traditional to tattoo yourself at this all-important moment, specifically on the inside of your right leg. There are many artists with a brilliant collection of works made somehow less brilliant when viewed alongside the curiously shitty, chicken-scratch hack job on their leg. Nobody's great when they begin, no matter their training. I had been determined not to make this mistake. Now I was about to do just that.

I drew several things out on paper and on my leg as well. I remem-

ber eventually transferring a lizard onto a freshly shaved patch of skin. I set up the liner as I'd been taught (I was most of the way through my apprenticeship) and then made an exploratory dot. It hurt. The lizard didn't seem like a really good idea all of a sudden.

It was a deflating moment. I'd endured some rigorous training at the hands of three accomplished tattoo artists and felt ready to do something passably bad. It was permissible in the early to mid-1990s to set up in your kitchen to do a little work on yourself or a friend at this stage. We know better now, but that was then. I carefully considered my options. I simply had to break these machines in, but I didn't want to do it on myself. It was time to improvise. For the first time, in an event tied with my first tattoo, I employed the very beginnings of the creative problem-solving prowess so common to tattoo practitioners. In hindsight I wish I had used this ability more often and in a wider spectrum in those days, but it was a start, and as my painter friend Paul Green always says, "The tardy student walks the widest path."

Everyone I knew in those days was dirt poor, myself included. It had taken me weeks and a few shady deals to scrounge up the dough for all the brand-new technology before me. Thankfully, I still had a few bucks left over, which I had invested in the prime commodities of the time. I called my good friend Miguel.

"Dude," I said. "I have beer and weed."

"On my way."

Halfway through the first of the two six-packs and a round of bong hits, Miguel noticed the tattoo gear.

"Is that what I think it is?"

"Yep, just came in the mail today."

Miguel studied the assemblage of esoteric implements while unconsciously rubbing his hands together. He was a pretty macho, occasionally pushy guy. Every time we'd ever been roommates, he had

always wound up with our deposit when we moved out, so he pos-
sessed an opportunistic streak as well. It was time to play him against
himself and maybe even the score.

"Oh, man," he crooned. "Let's do something on my leg. But not
small! Don't you gyp me." He pointed at me to emphasize this and
opened another one of my beers.

"Aw, I dunno . . ."

"You owe me!" he thundered. For what, I've never been sure.

He drank at speed to fortify himself while I set up.

This is how drunken Miguel, my old pal from New Mexico, wound
up with a massive *Star Trek* logo on the back of his leg. I honestly
don't know what compelled me to do that to the poor dude, but I kept
with it for some reason. For fifteen years, *Star Trek* across the knuck-
les was the only free tattoo I offered.

I still have that dot. It's like the period at the end of an introduc-
tion. The real story was about to begin.

SOME YEARS AGO I noticed that the portrait market was show-
ing signs of heating up. I kept seeing more and more portraits in the
trade magazines, and people were calling the shop about them. It
seemed like a good (and profitable) thing to learn how to do, so I set
about it.

It was like learning how to tattoo all over again, except this time
there was no teacher, not even an educational pamphlet. I doubted I
could find Miguel after all this time, and even if I could, no amount
of beer or anything else would convince him to be a part of what I had
planned.

I consulted with Matt Reed and, more specifically, some of the por-
trait specialists who worked for him. Everyone had a different ap-
proach. I tapped Paul Green for some insight, and then I outlined a

complicated strategy of hypothesis and test. Because unfortunately I had to.

IT'S AN EMBARRASSING shame that the world of tattooing is so information starved in the classical sense. It's like magic in that way, or even worse, medieval medicine. Consequently, some of the best artists I've come across are self taught, like Matt Reed and another local luminary named Dan Gilsdorf.

These are two rare, almost Asperger's-level personality-to-task examples. What might the world of tattooing look like if real data were more widely available? Huck Spaulding's *Tattooing A to Z*, an early attempt at a how-to tattoo guide, is out of date. Huck's been dead for more than a decade, but it would be out of date if he'd died last year.

Where can young tattoo artists get the hard facts? What if you *are* a young genius and want to just wade in, absorb information, and go? What if you've been tattooing for years and want to advance? It pisses me off to no end when, after nearly twenty years of tattooing, as the co-owner of one of the oldest tattoo shops in America, I can't readily access technical information in print. I have to wander around like a berry collector, interviewing potentially unreceptive practitioners or designing learning programs involving hypotheses and tests and then painstakingly carrying them out. Restriction of information is always ultimately shortsighted. It contributes to ignorance. How could it not?

I drive a BMW today. If I so chose, I could fix any part of it with information gleaned from the Internet and technical books. The so-called information superhighway is just that, and the tattoo wagon has yet to genuinely touch tire to pavement. There are signs that this might be changing, but the change is both slow and late.

Most modern purveyors of tattoo supplies won't sell to you unless

you can verify that you're the real deal. I will not reveal the ways they go about this, because I'm on the fence here. This is both good and bad. I can't imagine a world where every proto-tattooer hack, every convict, and every Cousin Bubba got their preassembled machines and premade needles and then chopped up their neighbors and anyone else they could find. But I find equal flaw in a system where the best-intentioned beginners can find no hard facts.

Why not give these newbies a cookbook? Why fear them? Do we all just assume that they're all scumbags who will fuck up everything, that they will never take the time to try to learn and be earnest? Well, I call that snobbery. Who is the gatekeeper purposefully retarding the growth of these kids, reining in potential? Show me so I can shank the fucker's eye out. Matt Reed and Dan Gilsdorf deserved better than they got, and many others besides. The library is a sacred concept if ever there was one, the most precise bellwether of sophistication. It's a disgrace that we, the tattoo artists, have nothing but our history therein, and we have only ourselves to thank for it.

Here is the truth. This system was put in place by tattoo artists who believe there are enough of us out there and no more competition is needed. But competition is what makes things vibrant in other fields. It drives innovation. I'm not afraid of a beginner, because that person is years behind me. But if I were truly a cynical tyrant, I'd be afraid that this beginner would grow up to kick my complacent ass.

SO BACK TO creative problem solving. After tattooing for years now, I can study a good piece and dissect it along forensic lines, deconstructing it after a fashion, and glean a few juicy tidbits. I have enough pull in most quarters to seek out regional hotshots of a certain discipline to gather more data. But in the end, I have to set my machines up my way, work out my needle configurations and pigment mixes, and then experiment.

I am not, as you already know, the most ethical man in the world. But I am a greedy one, so while I don't actually experiment in a grandiose fashion on the paying public, I had to begin my portrait project somewhere.

Portland is a book town, and I am a shameless collector. I decided to start with a tour of the dusty places, the moldy rat traps, in search of old magazines. I came away with three useful archives. One had various black-and-white profile shots of celebrities, and the second much of the same. The third was to wind up being the charm, though I didn't know it at the time. It was a retrospective of Bill Murray.

Back at the shop, I began showing up early and running some tests with my art supplies. I lifted the basic outlines of the faces with tracing paper and then transported them over to flash board. Then I shaded them in. Up until then, my experience in drawing faces was pretty cartoony.

The first few sheets were remarkably bad, but gradually I got the hang of it, at least on paper. I eventually produced a decent sheet with Charlie Sheen, Katie Couric, the fat, bald guy from the Three Stooges, Janet Leigh from *Psycho,* and Regis Philbin. I gave them all sharpened cannibal teeth. Charlie Sheen also had a diseased, phallic proboscis jutting from his forehead. Janet Leigh had a necklace of severed fingers and toes. Katie Couric had a mucusy worm-snake weaving from her mouth. I couldn't help myself.

I hung this masterpiece up and waited for a bite.

After a few months, I realized I couldn't give these things away. People thought they were funny and maybe even interesting in an off sort of way, but there were no takers.

One day during this period, I found myself tattooing a smelly, generally strange guy. He was getting a name or something. During normal chitchat, he snorted like he'd just remembered something.

"Oh, yeah," he interrupted. "I'm supposed to ask you, you got any free tats?" He smiled, revealing an incomplete set of brown teeth.

I was about to tell him about the *Star Trek*–on–the–knuckles thing when inspiration stopped me. I looked into his cloudy eyes and made a fateful decision.

"In fact, I do," I replied. "Free portraits of Bill Murray."

"The guy from *Ghostbusters*?" he gasped.

"Yep."

An hour later he walked out with my first portrait on his leg. I considered it at least a marginally ethical exchange, as I had not charged him for it and he'd clearly been delighted. I was to reconsider the wisdom of this later.

The next day another shabby, slightly dazed guy shambled in. "This where you get the free Bill Murray pictures?"

"It is," I replied. Must be the first guy's friend or roommate, I reasoned. I made an appointment for him, and he duly showed and got the portrait. There were some twenty photos in the retrospective. Over the next few weeks, I ground through them, trying this and that, gradually getting a feel for it.

The Bill Murray guys all fit the same profile: saggy chain-smokers with dumpy clothes and vacant expressions. Almost like they were on medication.

On impulse I rifled through the last month's release forms, picking out all the Bill Murrays. Two of them had actually written Bill Murray where they should have written their own name. Troubling. Worse yet were the addresses. They were all the same. These guys all lived in the same place.

There were no apartment numbers. What kind of place was big enough for almost twenty guys?

Answer: the kind of place you need a day pass to get out of. After work I walked over to the building and stood before it, thinking of the scales of cosmic irony, as I often do at such times. It was indeed a halfway house, and they were the residents. I learned from the clerk

at the convenience store across the street that the tenants had been convicted of various crimes but had been labeled mentally defective.

I had just done a series of Bill Murray portraits on the criminally insane.

I do an average of three portraits a week these days, and if I may say so, they're not half bad.

SO THE DEFINITION of a classical education in tattooing is at its roots different from the standard concept. It is often slow, as the information is restricted, trapped in odd, outdated bottlenecks, or simply not accessible. This fact is a dark, mildewy Goliath of an overhang casting a deep shadow that needs some nuclear light. I fear the implications of rarefied information dispersion may have slipped past some in my community.

Take Thomas Kuhn and his work *The Structure of Scientific Revolutions* as perhaps the best instruction. "Paradigm shift" is his concept, and a weighty one with grave and immediate bearing on the tattoo information superstructure. I've gone on about the fact that an information net exists, for instance when dealing with scams. This is bigger by an order of magnitude.

Thomas Kuhn posited that a genius does not sit down and come up with revolutionary concepts, like tattooing perfect portraits, in isolation. There are in fact no isolated geniuses. We don't as a species have a long line of heroic individuals. Instead we have supremely gifted men and women who look at the body of information before them and see it with *different* eyes. Their contributions are based on a new understanding of it. What they add stems from perspective.

Darwin was not a smarter biologist than those who came before him. He was the first of many powerful minds in the field to study biology after a variety of factors had changed, such as the waning

power of the church over intellectualism and the increasingly refined development of tools like the microscope. A paradigm shift had occurred, a new way of seeing, and Darwin's enlightened eyes saw far into this fresh dawn.

Archimedes screaming in his bathtub, the apple plonking down on Newton's head . . . It's not quite what we thought it was. What people didn't initially like about Kuhn's now widely accepted theory is that it placed too much emphasis on environment and culture and too little on individualism.

Kuhn was the first to admit that he was no smarter than previous scientific historians. A paradigm shift had occurred in his time, and he was the first beneficiary. His cultural awareness and the intellectual environment surrounding him changed in the sixties, and his perceptions along with it. The possibility of a new perspective had arrived.

If Kuhn is right, the history of human advancement is in fact based partly on new understandings of previously existing information, and the newly minted contributions to this body of work reflect changes in social environment. Innovation is less an act of isolated genius and more a combination of a new understanding of what came before and a reflex to build on it.

So what is the recipe for innovation? A vast available body of data studied through the inspired eyes of the day and a willingness to throw convention aside. Delightful new ideas arise from this sweaty confluence.

You can see why the restriction of data is distressing to those of us who puzzle over such things. And yet we tattoo artists made this information bottleneck ourselves. Make no mistake, tattooing is growing by leaps and bounds; paradigm shifts are taking place, but are they as powerful as they could be? Kuhn gave us the answer.

In spite of all this, I see hopeful signs. It is in the increase of spe-

cialization that the paradigm shift has left its most recent calling card in tattooing. Let me explain.

Aristotle pretty much knew everything in his day. There was no one who knew more about physics, astronomy, biology . . . Dudeboy had it all. Why? There wasn't a lot of information.

As more information becomes available, specialization becomes more pronounced. There are only so many hours in a day.

It's a good sign that specialization is occurring in tattooing, because the very nature of specialization is in itself a paradigm shift. So in spite of our worst instincts, in the face of our claustrophobically secretive heritage, things will probably turn out all right.

19

DARK CLOUDS ON THE HORIZON

Don Deaton called during the year I spent in Canada and told me that my Oregon tattoo license was about to expire. Apparently I was short three continuing education credits as well.

I had plans to return to Portland in a few months to tie up some loose ends, so I thought I'd call the state and ask if it was all right if I renewed my license then. I could pick up the remaining credits at some kind of Red Cross class. I didn't want my license to lapse completely, in case living in Canada didn't work out.

After calling the Bureau of Health Licensing, I was eventually put through to some cranky, uninformed bitch. I explained my situation as politely as I could, indicating that I would be returning from points abroad a little later than expected.

"You will return to Oregon, obtain your credits as required, or lose your license," she snapped. Unexpected bummer, I thought.

"Is there any way I can get a continuance?" I pleaded. I thought I'd read that in this situation the worst that could happen would be that I'd be hit with a late fee. I had no idea the law had changed.

"A continuance?" she snorted.

"What should I do?" I asked, throwing myself on her mercy.

"You can always go through one of the schools. If that's all, I really am busy."

I spluttered. She hung up.

The last-minute ticket cost a little over $1,300. I made it in the nick of time, at the last possible hour. I drove from Portland to Salem in a rental car and turned in my fee and credit proof with minutes to spare.

That's when I discovered that she was wrong. The law hadn't changed. In fact, I would have been subject to a fifteen-dollar late fee.

Now that was irritating.

EARLIER TODAY I was sitting in a plaza in Old Monterey, California, with my sketchbook, basking in the sun and minding my own business. It rains a lot in Portland, so I'm down here quite a bit. The plaza is a wide, brick-tiled circle surrounded by soft adobe walls. Every thirty or so feet there is a stenciled sign reading "No bikes or skateboards on walls."

There is one place with no adobe, a two-foot concrete dais with an ancient, massive anchor resting on it. This was where a group of dangerous young *vatos* were pulling stunts on their low-slung BMX bikes, bunny hopping up onto it and riding their front wheels, leaping off backward, et cetera. Every once in a while I'd look up to admire them.

Two older women strolling past stopped to check them out and were soon joined by a tall, gray-haired man wearing Dockers and a short-sleeve polo shirt with a sweater tied in a yuppie cape.

"I guess those guys can't read," he observed loudly. He was clearly overjoyed to make this observation.

The *vatos* glanced at him, and one of them made a soft hissing noise. Dockers beamed at the women and then looked back at the young men.

"I guess they can't read at all," he stated, smiling and crossing his tanned arms. The *vatos* exchanged a few looks and then went back to

stunt riding, ignoring the idiot rather than stabbing him or riding over his neck.

If they had put him in his place, I had already decided I would not deploy any of my dubious emergency first-aid skills in an attempt to save his dumb ass. I took those classes to maintain my tattoo license, not to save a garden-variety American mini-sheriff.

The American mini-sheriff is a joke, but they seem to have multiplied like mosquitoes in a particularly pestilent swamp, especially since 9/11. These are the people who mistakenly think that everyone has to adhere to the law as closely as they do, the precious do-gooders with advice like "Hey, you can't park there" or "I need ID" when some old man is buying a single beer. They're bullies, really. And some of them get their asses kicked, but not often enough.

Look at how many laws we have, and how many people seem interested in enforcing them on their own time, with no pay, when it doesn't matter either way. We all know these mini-sheriff types. I reserve my darkest behavior for them, because I've seen them grow to be more than a nuisance. In Oregon, the tattoo-related mini-sheriffs banded together, made a bunch of really stupid laws, found a few enforcers, and lost control once others of their persuasion caught the scent of blood and power, and in the end everything backfired on every possible level, creating a legislative Gordian knot so embarrassing that no one wants to talk about it. Except me, of course.

SOMETHING IS ROILING just over the hills. It's low and dark and has long, elastic tentacles. If we're not careful it will roll over us like a nationwide blanket of smog, a smothering, draconian recipe for imagineering midgetry that has not been imposed on the arts since the sixteenth century. Our hard-won, fledgling renaissance is in danger of a major wing clipping.

Once again, it's the law. Rules. Codes.

Sure, it all started out well enough. Devise a test so that artists can demonstrate their knowledge of sanitation. Very good. Get an inspector to drive around and randomly check things out. Also good. Of course, then you need licenses, and that's where the iron seed is planted. A little office opens in the basement of the state capitol. A retired inspector gets a new badge, a big desk, and a small-minded secretary. The seed matures into an indestructible weed.

A few years later, some bright-minded, self-important individual forms a panel. The little basement office has moved upstairs, and the staff has grown to half a dozen. The licensing fees are up, but not by that much. A few tattoo artists have wormed their way into the infrastructure by then, some to make sure that nobody does anything stupid, and the rest with the express purpose of doing as many stupid things as humanly possible. Enter the mini-sheriffs, who also happen, of course, to hail from our night hog population.

What kind of sick human would want to be a prison guard, I ask you? Or be one of those asshole parking-ticket dorks, or a probation officer, for that matter? Only a truly weak, gaseous personality would gravitate toward a position of authority where no merit is required. The night hogs everywhere feed from just such troughs. "Let everyone be like me" is some kind of retrograde, sicko, night hog principle being played out all over the world today. But let's keep focused on their zest for fouling up art.

THE APPRENTICESHIP IS an old concept. One tyrannical teacher, one hapless student. We all went through it in the good old days. Tattooing is complicated stuff, especially when done well. As in any profession, it's important to start learning good habits from the very beginning. You have to refine your ability to draw far beyond anything that comes naturally. Sanitation, equipment, clients . . . the regimen is brutal, but it has to be. When I was an apprentice, I had three excel-

lent teachers. It's not uncommon for everyone in the shop to take a
turn beating the new kid. The learning curve is utterly unforgiving.

Today apprenticeships are legally banned in Oregon, and it's catch-
ing on elsewhere. In its place we now have state-sanctioned schools,
monitored by the Department of Education. And let me assure you,
they suck.

Can't keep up with the speed of change? Did you wake up one
morning and realize that your shop had pretty much gone under, bur-
ied in trash bags because you never paid the bill, because you didn't
have a single customer in sight for weeks, because you suck? Are you
dangerously close to being outmoded? Desperately searching for a
way to stay in the business? Were you one of those old-school stencil
jockeys who never learned how to draw? Never once had a sketch-
book? Here's an idea: start a school!

Tattoo schools are the snug nesting ground for the most luridly
incompetent frauds and night hogs. Everyone good is actually busy.
"Those who can't do teach" is an adage that has reached its fullest and
most sulfurous flower in our fair state. Every good tattoo artist I know
can't understand why this isn't obvious to these schools' potential ap-
plicants. Oregon tattoo schools charge ten thousand bucks for the
privilege of learning how to tattoo like a pro, circa 1970. Fewer than
one in ten of the graduates gets a job, and when they do they are only
eligible to begin the apprenticeship they should have undergone in
the first place. It's a scam with all the right papers.

What kind of kid pays ten thousand dollars plus to learn how to
tattoo from an industry flunk-out? It's true there are a few hopeful
maniacs in the group, like the Sea Tramp's Billy Jack (who paid his
tuition by working as a bouncer at a huge porn emporium), but the
sad fact is that an unsettling percentage of the kids who apply are
bored, talentless trust-fund kids who couldn't convince their skeptical
parents to spring for the forty-thousand-dollar-minimum art school
tab.

Recently, a feckless graduate from one of these schools had a bright idea. After a few years of struggling to get a good job, getting turned down or fired over and over again because she was woefully ill equipped to work professionally, she finally broke down and started her own school. I kid you not.

So much for Oregon's next local generation. We'll just have to import, right? There are great tattoo artists coming up in other states, guided by knowledgeable, excellent mentors, right? Surely a few great aspiring artists will want to move to our fair metropolis.

Wrong.

In an effort to close the gates and secure their future, the local night hog mini-sheriffs saw to it that this was nearly impossible early on. Only an artist with a minimum of three meticulously documented years of experience can apply to take the Oregon licensing exam. I've seen well-trained professionals with years of experience throw up their hands and walk away in defeat when confronted with our local talent-trap. The only alternative is an utterly humiliating and expensive tour through one of the schools. A guy I worked with briefly named Keith Rich had to do this after three years of tattooing in San Francisco, a gladiator pit if there ever was one. It was his misfortune to have taken a graphic design job for eighteen months afterward, more than enough time for the state to deny his application.

Recently, a guy from Rhode Island stopped in. His portfolio was impressive: a rangy mélange of styles all well executed. A perfect Trojan. He was my age, in his late thirties or early forties, with more than a decade's experience.

I hired him on the spot. He said he was having a little trouble with some niggling little detail from his Rhode Island records, but he was certain he would take the test and be issued a license in the next few days. He left with a hop in his step, obviously filled with joy. My heart sank. I knew what he was in for.

I never saw him again.

So now we have a two-tiered system. Only the very best, experienced artists with the most meticulous records can get in. And only the very worst are being trained from scratch, and they are being pumped out in record numbers. So now our shops are staffed by thirtysomethings, with virtually no young people. The average tattoo artist here is damn good as a result, but our new generation is possibly the worst in the nation, and, despite their numbers, unemployable.

Our inspectors? Yet another humorless bureaucratic joke.

Two new shops recently opened their doors in the Portland greater metropolitan area. No licenses, no compliance on any level. One seemed harmless enough, a fly-by-night New Age dump that would run out of gas on the first hill (it now has), but the other one was staffed by trembling, sweaty tweakers fresh from some penitentiary.

Our inspector popped in one day, not for an inspection but (no lie) because he was lost.

One of my artists asked him what the story was with the particularly virulent convict bubo. He brushed it off.

"We're aware of the situation," he replied primly.

It's been almost a year now. The place is still there. One of my friends finally got through to someone at the state who confided in him. This is rare, as the people at the state are uniformly hostile and so uninformed that they seldom have anything to say.

"They're never open during our inspection hours," she said, and then lowered her voice. "We deviate from our inspection roster based on the number of complaints. The place you're calling about files sanitation complaints about other shops every day, sometimes more than that. And the inspectors won't even go there without the police anyway." Pretty clever. If you're three years old.

What if every state goes through this same process, developing laws and standards that don't overlap? Is the same thing that happened to Keith Rich and that poor guy from Rhode Island going to happen to me if, say, I want to go work in Boston for a few weeks? Are

the trainers of our next generation going to be the washouts? Because of the fucking law?

I don't think so. At that point, I won't even bother with a license or any regulations. I'm sorely tempted to fuck the whole thing off already, and it's not nearly as bad as it's going to get. Let them give me a ticket if they can catch me. And I can assure you, dear reader, that I am not alone in this sentiment.

I HAVE HIRED four students from tattoo schools over the years. Only one worked out, and that was Billy Jack.

The four whom I hired were certainly the best students ever to graduate from these schools, but the reason behind their aptitude was that they were not products of the schools in the first place. All four intuited early on that they were being burned, that they were the victims of state-sponsored fraud, so while in the schools they started hanging around real tattoo shops as much as they could, describing their situation and begging for help. They made any kind of connection they could in a desperate attempt to get modern training. Sometimes these connections were unsavory.

Even after all that, only Billy survived in a real tattoo shop. It was sad to see what happened to the rest of them. One latched onto our running night hog, a lazy but somewhat talented name-and-kanji slinger who had carved out his own little niche in my fleet of ass kickers. Rather than adopt the hard-core work ethic of the rest of us, she found herself tucked under the night hog's sooty wing, fawning over his endless ability to fuck over his coworkers and slack off. I should have tried harder to save her, and that was my mistake. This was a person with potential who was being undermined by a sly and craven creep. Too bad for her. I consider this my fault, but there were extenuating circumstances. She should have known better. I am not a camp counselor.

The student before her was actually my apprentice while he was in school. I gave him real training in an attempt to skirt the system and did my best to educate him in all areas, but even after two previous years at a prestigious art school, he knew his ass was meat. He was an applicant to a broken system, after all. His art skills were poor and developing slowly. The material science side of the field baffled him. He caved in early on in spite of my hard work, which I now rightly view as an utter waste of time. He was a good man, just not a sturdy one. He lacked drive.

The last student was a thief. His trust fund was running low, and I guess he felt the world owed him. The Sea Tramp became his new free bank account.

All of them hated me with inhuman passion at one point or another. It was just so potently shitty for all of them to show up for work every day, realizing yet again that they had been fleeced by the schools for ten large when they had only the best of intentions and that their actual apprenticeships were still ongoing. This meant they got the crappiest shifts and the most uninteresting jobs, and they were always under my personal microscope. Billy Jack alone stood firm, establishing the odds for graduates. The percentage of them who find gainful employment they can hold on to after six months hovers somewhere around 8 percent.

After the departure of our last student night hog, the talented young woman who went zombie on us under the hypno-spell of her mentor's ardent self-delusion, we had a shop meeting and it was decided that we would never again hire one of these kids. Her mentor had wandered off to Thailand and never returned, and we were grateful to be rid of the gross little fiend. The odds were impossibly slim that we'd get another Billy Jack, and I had no time to be a babysitter. None of the guys had even the slightest interest in training someone who was hobbled with a head full of bad ideas from the start. They

would all rather work extra shifts. It seemed easier to them, and that's saying a lot for this overworked group.

After the meeting, Billy and I were smoking cigarettes out front and I decided to question him.

"Why you, Billy?" I asked casually. "How come you turned out so well?"

He shrugged. Then, unexpectedly, his face hardened.

"I fuckin' hated your guts, man," he said in a flat voice. "We all did."

"What?" This was the first I'd heard of it. I was shocked, even hurt.

"We just thought it would be so fun to tattoo here. You made it work."

I didn't know what to say.

"Remember when you used to make me set up and break down my station like some grease monkey on a NASCAR pit crew?"

"Ahh." I did remember. That might have been too much.

"That. Sucked. You were always watching us. I had fucking nightmares about you, dude."

I didn't know whether to be flattered or mortified. If you can experience both in tandem, I'll bet I did. I sort of felt a warm glow.

"So . . . huh. What exactly are you getting at, Billy?"

He squinted at me and then patted his wallet and winked.

20

MAKING THE CUT

Over the years, I've worked with a lot of artists, some great, some good, and some . . . not so good. I've seen people fold under the pressure, making one simple mistake that snowballed into a nightmare of ferocious intensity. I've also seen people I'd previously thought of as perfectly gutless hang in there against impossible odds, grimly crushing their way through a shift that would sear the nerves of the most hardened Trojan.

I've grown to despise some of them. The odd, worthless, shit-for-brains scumbags you couldn't seem to fire, the pathological liars, the larking trust-fund kids. But one thing I give them all: they showed up again and again, no matter how mauled they got, no matter how powerfully scorned for ineptitude, in spite of the pain in their hands, the constantly pinched nerves in the neck, the awful strings of infuriated gangsters. Deep down in every single one of them was some kind of badass.

The first month or so tells the tale. You're way behind, people are stacking up, and some of them are pretty dangerous looking. Your liner has vibrated itself to shit, and you don't really know how to fix it on the fly. Everyone is watching you. Especially me.

There have been weeks when we all thought we had gone mad, when the scales of cosmic irony tilted way out of balance, days when flocks of migrating parrots must have been wheeling overhead and

raccoons wandered in broad daylight. One such week stands out, a story still told in hushed tones in dark places, of the most spectacular wipeout imaginable. It was the week a tattoo artist we'll call Stewie was brought low, proving himself a rare exception to the badass rule. The week of the Ghost Biter.

Stewie was the new guy. He came out of some kind of boutique-type place, but what he wanted more than anything in the world was to be one of the cool Trojans hanging in a street shop. We gave him a shot and watched in horror as he was eaten alive in a single week. In an environment where you come into contact with people from every walk of life, where you can never lose creative focus, where passion runs high and a sincere, never-miss, never-err mentality is in play, you have to admire the steely nerves or gross ignorance of a person who would even consider enduring the pressures of such an occupation. I lucked into it, entering at a point when the art was gradually becoming more complex. I learned in increments over a period of years. As the art matured, I was gently dragged upward with it. Looking at the Everest it has become today, I doubt I would personally have the temerity to even consider this world as one in which I could find a place. Our boy Stewie is a good example of a kid with balls. Little ones.

Day one he showed up late. I told him how important it was to be on time and described all the shit work we had to do before opening, as in cleaning toilets, watering plants, vacuuming carpets, and all the rest. He felt he functioned better as an artist and not a janitor, plus he'd been up late playing "Guitar Hero." I wasn't happy. Maybe I should have sensed that the universe was about to punish this guy far worse than anything I or any one single agency could do, but I didn't, so I laid into him.

I was still in a foul mood when we opened and the first customer staggered in. He was big. He smelled awful. He was talking to himself and swatting randomly at bats only he could see. Stewie was in

the back monkeying around with something, so I asked this crazy person what he wanted.

"A half skull, half ninja on my arm," he replied. There was some kind of white crust around his mouth. "It's my girlfriend."

This made no sense at all. Normally I'd trick the guy into leaving, but this was a perfect opportunity to see poor Stewie in splendorous action. I don't make managerial errors of this sort today.

"Stewie! Customer!"

I sat down at the center desk and prepared for some theater. All that was missing was the popcorn. At first it was hugely enjoyable watching these two interact, but gradually I became nervous. Stewie wrung his hands and nodded at every spurt of psychotic gibberish, somehow forming a mental image of what this creepy weirdo wanted. When he brought the guy around the tip wall and started tattooing him, I felt genuinely bad. I shouldn't have thrown Stewie into the deep end without seeing if he could swim first.

My first appointment arrived and I got to work. After a few minutes I looked up to make sure Stewie was OK and found his customer staring at me. It was a sort of long, unfocused stare, almost like he was looking at something a couple of inches behind my head.

"I'm gonna bite your ghost," the guy said.

Everything stopped.

"What?" I asked. My customer looked worried. Stewie leaned back behind his customer and shook his head, indicating with a pleading look that I should just let it go.

"I'm 'o' bite your ghost, boy," he said again.

Stewie's lips were milk white. My customer looked back and forth between us, smiling uncertainly. Ghost Biter made an awful nibbling motion with his crusty mouth. Stewie shuddered and seemed to sink into himself. His tattoo machine was dangling in midair, only loosely grasped in his no-doubt-numb hand.

"I don't swing that way," I stated. Stewie gasped.

Ghost Biter was taken aback as well. A look of shame passed over his face. Stewie abandoned any effort to get the tattoo done properly and went into a sweaty, high-speed scrawl. Ghost Biter must have sensed the change in his practitioner's attitude. He focused on Stewie and let out a wet string of suckling sounds, his mouth working like a dark-water catfish over a mossy cadaver.

We had reached tension apogee. All that was required to send the situation careening out of control was a single slip, a mere feather's lick of force applied in any direction. Only a miracle could save Stewie now.

The moment stretched to the breaking point in a long, ugly, kissy-choked freestyle slide. In that crowning instant, at the summit of Stewie's worst moment, the door burst open and a thunderous voice declared:

"THE EAGLE!"

It was Roscoe, the enormous wino we'd adopted at the time. As I've mentioned, he's a Navajo, and when he's sober he's a pretty interesting guy. We gave him lunch every day in exchange for a story or a snatch of his poetry. On this particular day he was drunk as a dancing pig, and the eagle was apparently all we were going to get. Roscoe filled up the doorway, his good eye closed, the milky one rolling and blind. He held his coat open in an effort to emulate a bird and thus revealed he had written all over his hairless chest and sagging belly with what looked like red lipstick. Naturally, all the writing was upside down from our perspective.

I got up, went into the back, and came back with a hoagie. Roscoe accepted it with a flap of his coat and left. Stewie watched the sandwich exchange with an expression of stunned disbelief. You could almost hear his brain cells bursting, like he'd just done a bong hit off a quaalude.

Amazingly, Ghost Biter seemed shocked as well and remained quiet for the duration. He did not receive a good tattoo, and I made a

note of it. Stewie actually got some money out of him and ushered him out. Afterward his hands were shaking, his breathing shallow and erratic. I took a break to try and calm him down.

"Is every day like this?" he asked. He was taller than me, but at that moment he seemed like a little kid.

"Of course not," I lied. "Don't worry, buddy. You'll make it."

The next day he burned himself on a soldering iron. Really bad. Thankfully, it was on his left hand.

The day after that he made the mistake of taking this cute hippie girl home. He showed up in the morning with a wicked tooth mark high on his forehead. It already looked red and infected. Apparently she had jabbed him good mid-cowgirl. Right before she shot diarrhea all over his hips and his bed.

He spilled eighty bucks' worth of red pigment. His car broke down. His forehead was getting worse. A large gobbet of toxic floor cleaner somehow splashed up his nose, resulting in a painful and disfiguring welt. A truly gnarly gangster frightened him into making a huge, potentially deadly mistake: essentially, he put the Japanese imperial meatball behind a dragon on a Filipino. Those guys are still really sore about World War II.

By the end of the week, I was doing everything I could to protect the guy. Nothing worked. The rest of the staff shook their heads and tried to ignore his destruction, probably to save him some embarrassment. Even the people at the bar in the basement below us took an interest.

At the end of day five, Stewie was broken: wounded, burned, his apartment a stinking wreck, quivering with exhaustion, and teetering on the brink of madness. He was sincerely worried that the tooth wound would grow into a full-blown brain infection. Frankly, so was I. He handed me his keys at the end of his shift and put all his stuff in a box. Another week would have killed him.

I heard through the grapevine that he works at a plant making aluminum lawn furniture now. Someone should give that dipshit a trophy with a screaming baby on it.

TWO YEARS AGO we had another starry-eyed failure surf straight into the garbage can. This poor kid shattered Stewie's record, lasting four hours and forty-eight minutes, a start-to-finish belly flop that will probably never be outdone.

Like Stewie, he hailed from the cotton-candy world of the boutiques, though he came with a good recommendation from an artist I trust and supposedly had almost five years under his belt. This particular ass swipe started on the night shift. Maybe it was a Tuesday. He would be working alone. I was there when he arrived to give him the standard pep talk, which goes something like this:

"Remember that this is a street shop, so you have to make contact with everyone who comes in. Don't ignore them until you're done with whatever you're working on, or they'll just walk out. No one is going to wait an hour just to ask a few questions and maybe get a price quote. There's no safety net, so pay attention."

He nodded. So far so good.

"Don't worry if something weird happens. Just hold your shit together and everything will be fine."

Here his eyes narrowed a bit.

"It's the two AM thing," I continued. "When you stay open that late, well, it can get interesting. Just keep an eye on the place. Stay calm at all times. Smile a lot. Do good work. Under no circumstances call the police. If it gets to that, call the bar downstairs or call me."

A version of this is probably being said somewhere right now.

As I drove away, I checked to make sure all the outside lights were on. He was standing in the window, staring out at nothing.

Four hours later the place was packed. Don Deaton showed up to check in on him and found him trembling and pale, clearly at his wits' end. Ten people were trying to talk to him at once, and he had yet to start on any of them. The poor guy had absolutely no ability to organize the lobby and take charge. What did Don do?

Perhaps it was not the right thing. Don was seventy years old at the time. After three decades plus of tattooing, he is not overly sensitive to kids like Stewie and the wreck he found behind the counter that night. He went into the back and came out with his sword, then started practicing against imaginary pirates while singing old dirges at the top of his lungs. With his barrel chest, full beard, and crooked nose, he looks like a buccaneer in the right light.

At four hours and forty-eight minutes, I called in for a progress report. Don answered and gave the guy the phone. I could hear laughter, voices, and music in the background. The place was in full-blown carnival mode.

"I got to get out of here," came a strangled whisper.

"What?"

"I'm sensitive." He was actually panting. "I can't . . . I mean . . . This is *insane*."

"Are you sure? Don't you want to at least finish the shift?"

Silence.

"OK. Give Don your keys and the phone."

Don was laughing at something a customer had said.

"Jeff?"

"Yeah, man. What the hell happened?"

"Kid flipped out, what can I say? I guess he needs to go back to whatever kindergarten shop graduated his bimbo ass."

"You didn't say that right in front of him, did you?"

"No. He's gone. Handed me the keys and the phone and ran. I mean really ran, as in sprinting."

Don put the sword away and finished the shift solo. He found out

first what order the customers had arrived and then what they wanted. He told some story or other to brighten the mood, then gently introduced a conversational vibe so the customers would talk to one another while he set up. By midnight he was halfway through and the place was quieting down. He had a great time.

DO I FEEL bad about what happened to these guys? Not one damn bit.

There's more to this job than art. All over the country right now, tattoo artists are setting the tone in their establishments, projecting a contagious mood, working on many levels at once. Personality is a must.

You can't be scared of big black guys because they're big and black. That Asian kid with the savage burns on his face better not bother you either. The Mexican with the teardrops running down his cheek? A fine man if you give him half a chance. Skin is skin.

Previously, there was not a lot of room in tattooing for guys like Stewie and the four-hour wonder, but times are changing, and with progress we see permanent niches appearing for these personality-free types. Twenty years ago no one could have foreseen a time when a tattoo parlor resembled a futuristic Asian hair spa and your artist was a nameless, faceless character with the demeanor of a DMV clerk loaded on cough syrup, but sadly, it seems to be happening.

And it sucks. An idea can be tweaked and tuned so many times that it becomes different and worthless when compared to its starting point. I was trying to think of a good example of this that had already played out, and a particularly egregious one came to mind.

I was on vacation in Monterey, California, recently, and I decided to visit Cannery Row of Steinbeck fame. Even though I'd been to Monterey several times, I'd never been to Cannery Row, perhaps because I was afraid of what I'd find. Let me describe it to you.

The street was basically a gift shop swarming with obese families in cabana wear and matching fanny packs. Mom and Dad were both looking through camcorders, bumping along behind their vacant, sticky children. The boats got bigger, the canning factories got faster, and the fish disappeared. They sold cotton candy and hats and ugly little curios made in China, and there was a restaurant on the corner called Bubba Gump's. It didn't even smell like the ocean. Progress my ass.

The term "tattoo industry" is bad enough in and of itself. When the hell did it become something you could call an industry? What was the exact date? Soul, the tangible kind, is behind the blossoming of this craft. How can I, how can any of us, keep the ball rolling and make sure everything so many talented people worked for is never diffused or watered down or made as soulless as Cannery Row?

The only thing we can do is keep kicking ass and grinding up these sterile mineral hearts as we go. I'll certainly do my part. I've been at it for some time already.

21

THE NIGHT HOG

*P*araphrased *from a three-ring binder issued to managers at an automotive-parts chain at the end of a three-day seminar:*

. . . attire that fits our corporate hygiene profile. Employees who damage said garment or are unable to launder daily the unit furnished to them may purchase, at their own expense, secondary uniforms through the outlet referred to in the appendix. Watch for fading. It may be an indication of dangerous ambition.

Failure to comply with any of the 112 above directives merits a corrective mark in the record of any employee. Corrective marks are not to exceed a maximum of three in any twelve-month period. Exceeding this limit is grounds for the termination of any employee in the mandated six-month probationary term.

This three-ring binder is your bible, since you are too stupid to think for yourself, and should never fall into the hands of the enemy, namely your employees and customers.

THERE ARE NO three-ring binders in tattooing. Sure, there are problem employees, but if anyone ever handed me that binder and

whacked me on the back like Alec Baldwin in *Glengarry Glen Ross,* well, that might get ugly. This hypothetical jackass would be greeted with acrimony by most of my contemporaries.

Everyone starts somewhere in any field, generally at the bottom. If you boil all the way up to the surface in the business side of tattooing, you don't put a blue jacket on and carry a clipboard and refer to a three-ring binder. Your personal balls (or ovaries) are on the chopping block. I threw my meat on the wood at a particularly dreamy time.

IT'S NEVER GOOD news when the phone rings at 4:00 AM.

I looked at the clock and quickly padded into the kitchen. It was snowing outside. Again. I had managed to move to Toronto right before the worst winter the region had endured in decades, the winter of 2002.

"Hello," I whispered into the receiver.

"Jeff?"

It was Don Deaton, my mentor and cherished friend. I glanced at the clock on the stove, still groggy. It was 1:00 AM West Coast time, still an hour before the Sea Tramp Tattoo Company took its last jobs. Someone had died, I just knew.

"It's four in the morning here, man," I reminded him.

"I know, I know. You were still awake, right? I didn't know who else to call. Something terrible has happened. . . ."

I could tell from the sound of his voice that he was shaken. Don is a six-foot-one, heavily bearded ex-Airborne with a black belt, and he's been a tattoo artist for some thirty years. Very little freaks him out. It was the weekend, I realized. That night he would be working with the Beast Who Would Not Leave.

"Oh no," I said, realizing that this human time bomb had finally gone off.

"Yes," Don replied. He gulped some air. "It's bad."

I had been in Toronto for a little over a year. My wife's wonderful family lives there. All in all, I was having a pretty good time, until the brutal cold sank into my knees and elbows. Outside the kitchen window was a blasted landscape of dirty snow, falling snow, and snow that had turned into sheets of ice. Dust devils of traction salt wafted along the dark street like waltzing ghosts. In Portland it was undoubtedly raining sweet Pacific droplets that covered everything to create a landscape rendered in the muted tones of neon and glazed donuts.

"Let's hear it," I said, and sat down at the kitchen table.

The story Don told, while funny on the surface, had a chilling subtext. He needed my help, desperately, and I was on the far side of North America in a different country.

Apparently the artist who held the current night hog title at the Sea Tramp had finally fallen apart. This wretched mouth breather was a pox on any shop it landed in. For years, Don had been trying to devise a trapdoor to hurl this beast through without getting sued, stabbed, or gunned down. He was never able to. Eventually I did.

The night hog had apparently lost its mind an hour earlier. The tattoo shop was packed. They were waist-deep in a bloodbath, and it was only getting deeper. Some poor frat boy brushed up against one of the night hog's numerous imaginary boundaries, and all hell broke loose.

The night hog rose to its feet and launched into an incendiary sermon, a spit-flying, red-faced, blood-mad, cranked-out mullah-style tirade. Midshriek, two of its front teeth flew out, bounced off a mirror, and skittered to a halt on a stainless steel workstation.

Its stubby paw shot to its gaping black mouth. An eerie silence fell over the stunned customers in the crowded room, and then, in a moment of semipsychic mirror neuron communication that even total strangers are capable of in a crisis, they acted as one.

Everybody ran. The shop was completely empty in seconds.

"Wait a minute," I interrupted. "Where are you calling from?" The

shop had dropped the long distance after some customer called El Salvador years ago.

"I . . . I panicked," Don stammered. "When they ran, I ran too. I'm at home."

An Arctic wind rattled the windows. I opened the refrigerator and took out a beer, noticing how insulating the bottle in the refrigerator was the only thing that kept it from freezing. The science fiction novel I was working on had fractured into a handful of short stories, so that work was basically done. Don needed my help. It seemed like a good time to go back to Portland.

Like so many of my colleagues, this is how I rose to management. As an exorcist.

IN A HIGHLY charged environment full of creative, often eccentric people, some of whom are sincerely dangerous, an exorcist is naturally in great demand. I turned down many job offers during this time, preferring instead to wield my nasty scalpel on my old stomping grounds.

The night hog lasted an amazing two months into my gentle reign. A well-timed note on etiquette set the stage for a remarkable rebellion. By politely suggesting that this creature refrain from screaming at the customers, I had thrown down the gauntlet, inviting epic battle. When my reaction was to roll my eyes, a move carefully calculated to produce the maximum fury, the resulting tantrum was so severe that I knew I had been victorious in a psychological fencing match where my opponent had been armed with a toothpick. This animal jettisoned itself, madly destroying parts of the lobby in the process. The damage was all well documented for posterity. I never heard from this half-wit again, although I might now.

. . .

EVERYONE HAS A weakness or phobia, something they just can't stand. Most of us have a lot of overlapping imagery in this regard, quintessentially human things. No one likes eels, for instance. Not *unagi* at a sushi bar. I mean live ones, in your bed or under your car seat. People shy away from rabid dogs. Used condoms are not popular.

Our next night hog required less than an hour to get rid of once the decision was made. All I needed was an artfully dolled-up toilet.

The shop was doing well overall. We had a happy crew of hard-working people, most of whom are still with us today. There was a dark spot, however, and a day came when I had to do a little surgery.

This is a prime example of how tattoo shops differ from normal businesses. A lot of the time you can't just can someone. As I've said, even a crappy tattoo artist is a master of creative problem solving. Revenge scenarios can run the gamut, and in this case I was taking no chances. This particular night hog was actually suing his own fiancée at the same time that he was desperately trying to knock her up so she wouldn't dump him, and he sincerely had no idea why her parents shunned him.

He was stealing from the shop. Not just money, although once we probed into it we found clear proof of a few thousand missing dollars, but also curious things that no one would ever need, like bags of old, powdered pigment left over from the eighties. Things no one had ever gotten around to doing anything with. Things he mistakenly thought we'd never notice were missing.

The Fear smote this lowly cretin in a bizarre way. He hated the restroom. At first he simply refused to take any responsibility for it on his shift. Apparently he never used it himself, preferring instead to close the shop, drive all the way home, and then come back. The very notion of a communal toilet sent shivers up his spine. We went around and around about this, until he finally caved in and agreed to take care of the "little room." Otherwise he would have to work with

a second artist, splitting the walk-in traffic he relied on and ruining his ability to steal.

On the night of the surgery, I sneaked in through the side door with a fat, dripping plastic garbage bag in my hand. He was busy working in the shop, and the lobby was full. Another good night for him, especially since he would claim the place had been dead all night and keep the money for himself.

Once in the restroom, I delivered the exorcism. I opened the bag and dumped it, mostly on the rim of the toilet and the floor. The contents? One jumbo can of cat food, a handful of frozen corn, half a stale beer, some leftover cassoulet, and a shot of bourbon, all massaged together into a hellish wino lunch. Then I peed on it, took the roll of toilet paper off the rack, and dropped it into the bowl.

The next morning I found a short note. He quit rather than clean it up, so of course I had to do it. But it was a small price to pay for a job well done.

TATTOO SHOPS DON'T have large staffs. Generally, the work force is minimal, with a complement ranging from four to fifteen, counting the door and behind-the-scenes people. Managing them is sometimes like running a Special Forces unit that ate a heap of mushrooms for breakfast. Competent yet unpredictable, as a group the entire operation skews onto shaky ground rather easily. And when it does, look very closely at what happened. There you will find heroic swamp panthers and the snail trail of your own night hog, the weak link that can bring you down.

Dealing with an annoying office worker is nothing compared to working with someone who not only costs you money and makes an already difficult job harder, but can actually cut your life short by making sure you get every disease they notice on their customers' release forms. The last thing you want is for good people to leave in frustra-

tion because of the heel you hired to work the worst shifts. If for no other reason, consider that night hogs eventually become bad memories and someone else's problem once you get rid of them. Good people become competition.

Who keeps fucking their customers in the bathroom? Is that mouthy art-school kid getting his ego stroked enough so that he doesn't flip out this week? Who has trouble at home? Who's getting behind on their drawings and suffering the spooky domino effect of having every delayed appointment arrive feeling jilted?

This is scratching the bare surface. A night hog can jeopardize the subtle balance that exists in a house of art types. Invariably, they are so painful to get rid of that most of the time it doesn't seem worth it, especially since they work the worst shifts and will likely be replaced by someone just as bad.

Almost any business manager has this problem, but in a field where there are so few qualified employees and they are generally iconoclasts, we have it twice as bad. Doing the job well isn't easy. You protect your people, make them feel safe enough to be brave, help them grow, and always learn from them. That is the basis of good management.

The key to getting rid of the night hogs is to get them to leave without doing anything that will end in your own destruction. Here all businesses could conceivably take a page from tattoo shop administration. Is there an all-encompassing formula, you ask?

Well, there are some secrets I can't reveal, and I doubt any of my compatriots will either. Tomorrow is another day, and I still have a job to do.

22

INFLUENCES

I am not exaggerating when I say that I have spent more than a thousand hours drawing Spider-Man.

Some of my earliest memories are of comic books. As a boy in Houston, I spent my afternoons trolling drainage ditches, collecting bottles to buy them. On the weekends my brothers and I would descend on Roy's Memory Shop and Third Planet in the Little Village in Houston, where we stole things, ran various kinds of scams to parlay the loot into more comics, and finished the day by rifling through the dumpsters looking for more.

I loved the stories, but even after I had memorized every word of a particular comic, I could always go back and stare at the pictures. And I did, sometimes for hours. I can still remember the smell of the paper.

In the fourth grade I was to finally meet two other boys with similar interests. Their names were Adrian and Neal. It was one of those crappy ghetto schools where there were fifty kids to a class and no one cared what you did as long as you didn't make too much noise, so we spent all of our time drawing. Together we conspired to create our own comic book, pooling our talents. Adrian was the best, so he would draw the hero. I was next, so I took the villains. Neal was background. We were to call our masterwork and platform to immortal

fame Spider-Man—somewhat unoriginal, perhaps, though ours would have an afro, as both Adrian and Neal were black.

Adrian was my first great influence. That kid could really draw. I've been lucky to meet many such characters over the years, and that luck is still holding to this day. Matt Reed, Don Deaton, Peter Archer, the psychos at the shop today, these are great artists I'm always learning from, and they're a continuous source of inspiration.

Visual art is a wild continent, full of things both exotic and hypnotically boring. Long ago I was fortunate enough to make the acquaintance of Paul Green, a local painter and art teacher. I couldn't ask for a better guide and sounding board.

Paul is a pretty laid-back guy in most ways. He looks sort of like an aging extra from the set of *Serpico*. His house is a messy confusion of paintings in progress, books of every description, and overflowing ashtrays. Taped to the back of his front door is his weekly library book receipt, usually more than two feet long. The amount of research Paul does is staggering. He's looking at the kinds of things painters of his caliber look at. When he finds something that I might be interested in, or if I have a complicated compositional question, we get together and get drunk while he patiently explains things to me using his vast resource library and whatever he has at hand that week. I have Paul to thank for at least half my art vocabulary, all of my ill-advised forays into commercial design, and several wicked hangovers.

THERE WERE SEVERAL scenes in the R. Crumb documentary *Crumb* that hit home, but one of them really stands out. Crumb was lecturing his partially estranged and cynical son about drawing portraits. After so many years of drawing faces and tinkering with expressions, Crumb casually tossed off a short tutorial that was a lightning strike to lesser artists everywhere. Essentially, he was transposing fa-

cial characteristics in a very precise way, altering select aspects of people's expressions by extrapolating a vast amount of information about unknown subjects based solely on their photographs. He was trying to see some hint of their personality and tease it into the forefront, rather than just act as a human Xerox machine. This strange man is an icon to two generations of tattoo artists and maybe more to come. He made weird art and he survived, no small feat.

The biggest influence on the way I've gone about tattooing, and art in general, was not a tattoo artist. He wasn't a visual artist at all. He was a curious old Jewish stoner, a disgruntled genius, and my houseguest for the better part of a year. I'm talking about the late science fiction writer Robert Sheckley.

I'd written a batch of science fiction and mystery short stories in the late nineties and wasn't having very much luck getting them published. They sucked, for one thing. I decided I needed to take a class of some kind from an established master of the craft, someone who had a long track record of success and who might also be able to give me some insider tips.

There are lots of great writers in the Pacific Northwest. Unfortunately, after looking around for a while I discovered that none of them ever taught any classes. Apparently they were all busy writing.

That was when Robert Sheckley's name came up, during a conversation I was having with a friend who worked at a nearby bookstore. Sheckley was old. "How busy could the guy be?" my friend asked. Plus, it was known in some circles that his considerable intellect did not extend to money management. He might be game to teach a class if I could round up some other paying students.

I decided it was as good an idea as any, so I cracked open the phone book, found his number, and called him up.

"I don't think so," he stuttered after I had politely presented the idea. He had a slight speech impediment. "I've tried teaching before,

and I absolutely hated it. Let's get together for lunch instead and I'll try to answer your questions."

For the next few years, we had lunch almost every week. He didn't like to talk about writing, and he generally refused to read anything I'd written, so he wasn't a great deal of help, but I liked the old guy. His entire life was a fascinating study of disaster. He'd apparently married every woman he'd ever been even remotely fond of and had had children with most of them, none of whom he helped raise. His stories of living in Spain after the Korean War, slumming in Paris during the disco era, quaaludes . . . It was all very compelling stuff. The first time I went to Paris I went alone, as he had, mostly because he bullied me into it.

His wife at that time was much, much younger than him, and some serious disagreements eventually arose between them, so much so that one day he called me, spluttering with fury.

"Jeff," he said, "we're fighting like dogs in an old Soviet steroid experiment over here. I need to crash out on your couch for a few days."

Which is how Mr. Sheckley came to live at my house.

I CAN'T REMEMBER how I wrung the pivotal moment in question out of him. Now that he had turned our living room into a guest room and the dining room into the common area, I felt I had the right to pin him down on a few things. It was like yanking molars out of an ape with no anesthesia, but occasionally I pried one loose.

Over dinner one evening, my wife and I tricked him into talking about his long career, specifically about the turning point, the moment when he really started to kick some serious ass. There was a time in the 1950s when he wrote brilliant stories under two or three different names so he wouldn't dominate a magazine's bylines. He quickly made two astonishing points.

Apparently he started reading less science fiction and more of what, in his own words, "science fiction writers read." As in books about the brain, history, physics, economics, et cetera. Anything that furthered his understanding of the world around him. He said it was literary ammo for the imagination.

This, of course, had a clear parallel in tattooing. If I really wanted to take a step forward, I needed to look less at tattoo magazines and more at the kinds of things the better people in those magazines were looking at. Namely, the wider world of art.

Then the old man said something really profound.

"The real reward of being a writer is that you learn to be a better reader," he said around a mouthful of food. He was a notorious mouth-full talker. "It's like cooking. You like good food, so you learn how to make it. By the time you do, everything tastes different because you know something of the craft behind it. There's more subtlety, more depth. Take music. You think Hendrix heard the same thing we hear when we listen to Robert Johnson? I bet he could hear when Johnson had his eyes closed. I bet he could hear his *soul*."

Well, blow my mind.

I'LL TELL YOU something about how that night shaped the rest of my todays.

I was recently in Santa Monica, and one evening, while standing on the beach watching the sun set over the waves, I couldn't help but study the methane-rich phenomenon and wonder how it could be captured. Ages of artists have seen versions of the same thing through their own particular eyes and rendered parts of it as it filtered through them.

I knelt, and the wet sand turned neon under the low sun. Sandpipers skittered along the edges of the sea foam while plates of unnamed silver washed in and out of the surge. In the distance the waves were

black lines growing sharper as they closed together. This reflexive examination is my final reward. More than money, more than the primal satisfaction of the perfectly curved line under my hand, more than anything. Training my eyes to really *look* at things has turned all the world into something it wasn't before and might never have been. The smoky black hurricane fence on the freeway overpass, each segment slashed with halogen, the headlights of the cars flickering through the palm trees that sway in air of their passing . . .

Some flavor of all of this would have remained undiscovered to me. If you try to observe the world for long enough through the perfect lens, then one day it will surely settle permanently into place, and then every object is a still life. You live in the moments between blinks.

This is what Robert Sheckley meant.

PART SIX

23

PRANKS

I t has been my experience that when you both like and respect the artists you're working with, when the shop is stable and everyone feels appreciated, it is generally acceptable to convey your affection and admiration for your colleagues by playing the most awful practical jokes on them you can imagine, and then waste an inordinate amount of time in a hyperalert, paranoid cringe waiting for the retaliation. Designing inspired ways to torment your coworkers can be a rollicking good time, and judging from the stories handed down from the Pike, it's a time-honored tradition.

I've mentioned that even a crappy tattoo artist is often a master of creative problem solving. Imagine the possibilities. I've heard of incredible acts of depravity, but at the Sea Tramp Tattoo Company, at least during our lengthy periods of happiness, our pranks have always had a sweet quality.

Years ago, I worked for a time at a tattoo shop that had a piercer. They were a decent group and had their fair share of fun, but it was of their own variety. They convinced the new guy (not me) that his fresh nipple piercing would heal faster if he hooked the power supply for his tattoo machine up to it and gave it a mild zap. He did just that, the poor soul.

Our brand of high jinks is different. For one thing, no one at the Sea Tramp would fall for such a thing, with the possible exception of

Rick. They've been around the block already. We have a long oral history of all previous buffoonery to use as a resource, and that establishes precedent and helps define the parameters to be expanded through new action.

It is possible to booby-trap an entire tattoo shop in less than half an hour. This classic maneuver relies heavily on understanding the exact patterns of the victim. What will he or she do first? A careful study must be made for maximum impact. An ideally researched situation goes like this:

Scott Ramsay arrives for work. Patrick is still pissed about the Vicente's red sauce debacle but has been biding his time, ever watchful, waiting to strike. His analysis of his crony is complete.

"I'm out," Patrick says, handing over the reins. He bolts for a post-shift drink. Scott waves.

First he sets up his station. He takes his liner out and checks its tune.

Incomplete circuit. The machine doesn't even chirp. He studies it from various angles, even sniffs the capacitor. He's mystified. Patrick has put a tiny sliver of tape over the contact point so the machine will never run. Scott has just plugged an inert piece of metal into nothing and is wondering why it's just sitting there.

Maybe the problem is the clip cord or the foot switch. Scott sighs, then roots around in the supply area for the spares I keep on hand.

They're gone.

Now he curses softly. He's about to plug in another machine (also compromised) to find out if the problem is the cords but decides instead to open his appointment book to see how much time he has. Someone has booked him three appointments, all arriving together in a matter of minutes. The notation reads: "6:00, 3 sm on feet, they have design, strippers."

Hmm. This is not good. The forecast is busy. Better run some

tubes (the pencil-like shaft that houses the needle) and then unravel the liner problem fast. He gloves up, goes into the back, and cranks the hot water on the sink. Someone has taped the lever on the spray wand down, and the nozzle is pointed straight at his crotch. Now he will greet the strippers looking as though he has just wet his pants.

A few minutes later Patrick saunters in and casually leans up against the tip wall, a study in relaxed bonhomie.

"So," he says around a yawn, "what's the story on that red sauce from Vicente's?"

PRANK CALLS, CELLOPHANE over the toilet seat, hidden dollops of Vaseline . . . all tired components. Some people are better than others at these games. Patrick is a master-class prankster. There have been times when he just could not leave people alone.

"Little Chubs," as we called him, was a nice guy for the most part. Not bright, somewhat talented, and lazy, he was the sort of fella who had a high opinion of himself that he perpetually reinforced with subtle shit talk. We all liked him well enough. He could be funny, and when he was motivated he could fix almost anything. He knew almost as much about machines as Billy Jack and pitched in on every task that involved power tools. Patrick went after him for some reason. They were pals, and I assume they still are, but that only made it worse.

It started one night after closing, sometime around 3:00 AM. They wrapped up their last jobs and sneaked down the back stairs to the bar in the basement, having already bribed the bartender for a few quick ones.

After a drink or two, they went back up to the shop and started breaking down and cleaning up.

"I'm just going to close my eyes for a second," our portly buddy

said. He lay down on the gurney and was instantly asleep, leaving Patrick to finish all their side work by himself. A little while later, when everything was done, Patrick shook him awake.

"Time to go, dude," he said.

Our pal stopped on the way home to get some gas and a snack. People seemed unusually weird to him that night. Everyone was staring at him, for one thing. The gas-pump guy was particularly loco, making meow noises at him.

He got home, had a final drink, and sacked out, presumably without bathing or brushing his teeth. His girlfriend shook him awake the next morning.

"Whaa," he must have groaned.

"How much did you drink last night?" she likely asked. Or maybe, "What the hell did you do to your face?"

He discovered that while he was sacked out at the shop, Patrick had drawn a cat nose and whiskers on his face, with a Sharpie, no less. As an afterthought, he had added Buddy Holly glasses.

LATER PATRICK TOLD me that this same kid had revealed to him a series of nightmares wherein he arrived at work and found a body in the restroom. The restroom at the Sea Tramp is so psychically impregnated that almost everyone has these dreams from time to time. Your imagination runs like a racehorse where the "little room" is involved. Patrick and I immediately set to work dolling up Rick.

A blue wig, some cowboy clothes or maybe a bathrobe . . . certainly we'd need a hypodermic needle of some kind, fixed to his arm with some glue and a belt or some tubing. A scorched, bent-up spoon at his side would lend effect. How hard would it be to fake a really graphic head wound? What could be done with steak and some stage blood?

I eventually put the brakes on this blossoming operation after poor Little Chubs told me he was experiencing chest pains after bouts of binge eating. The general consensus was that he might suffer a heart attack after the bathroom scene, with Rick slumped over the toilet, needle in arm, blue wig in place, his brains blown out. Patrick never forgave me for calling this off. Rick still stands ready.

LAST YEAR WE all noticed that Neal had developed a nasty habit of chugging energy drinks before and during his night shifts. Neal dresses like a college preppy, with sweaters over polo shirts, new baggy jeans, and Reeboks, so when excessively wired he is just plain drippy in the tattoo hothouse environment. Once again, Patrick came up with the perfect idea, a way to point out Neal's ball-of-nerves problem and politely, or at least humorously, make him consider his sweaty demeanor more closely. Of course, we would have a great deal of fun at his expense.

Patrick had just bought a pound or so of white powdered pigment and was holding it in his hands, idly flipping the parcel around as he told me of Neal's latest bug-eyed craziness. It was an increasingly common tale of Neal going a little too fast, shaving corners here and there, barreling after the money. The pigment was in a heavyweight transparent bag crossed with duct tape. It looked like a kilo of coke from the set of *Scarface*.

"We should maybe get him to sleep better," I suggested. "Then he wouldn't need all that Red Bull."

"Have to make him realize the problem first," Patrick replied. We were concerned, after all. At least I was.

"Maybe a jolt to his nervous system," Patrick mused. "Something to show him how close he is to a fried wire." He looked down at the package in his hands, and Satan's smile graced his features.

At precisely ten o'clock that night, when the shop was sure to be

slammed and Neal was jacked up on five lattes and a few Red Bulls, I placed the call. Billy Jack was also working that night, but he was already in on it. Neal answered the phone, just as planned.

"Dudeboy, it's Jeff," I said in a hoarse whisper. "I only have a second, so listen! My house is surrounded by cops. Go into the back room as soon as I hang up. There's a package at the bottom of my box of old photos. Take it and put it in the bathroom up under the sink. Patrick will be there in a minute to pick it up. *Don't tell anyone!"*

I hung up. This had the benefit of being plausible, as in such a situation you would need someone trustworthy, fearless, and shady, a rare combination of attributes that fit our Patrick to a tee. He's just the person you would call if you were being hunted by the cops and needed a kilo or two shuffled around for safekeeping.

Here is what transpired next. Neal set the phone down amid the chaos of his shift and stared into the inky blackness beyond the windows with a blank expression. Then he rose and walked in a jerky gait like a poorly controlled marionette into the back.

"Billy," he shrieked a moment later.

Billy Jack went back to find him standing there with the kilo of white pigment. Neal was crouched in an unnatural position, a Niagara of perspiration streaming from his sparsely covered scalp over his terror-stricken face.

"Holy shit," Billy said.

"Ju . . . Jeff called . . . fuckin' bathroom . . . Patrick." On speaking Patrick's name, he looked up like a condemned man.

Billy turned and sensibly walked away.

Neal tucked the package into his mop bucket of an armpit and sprinted down the hall like someone in the chunky-kid Olympics. Moments later he emerged and took his station, but he was too rattled to work.

Patrick let him sweat for a full twenty minutes before blasting through the door. He was dressed in full ghetto garb, wild insanity in

his eyes. He looked directly at Neal and made a minute gesture with his head that said "approach me with all possible haste or share my peril and impending doom." Neal scrabbled over and hunched at his side, trembling.

"I did it," he whispered, "it's in the—"

Patrick silenced him with a chop of his hand and ran through the crowd in the lobby. A minute later he emerged and departed without a word, the pigment a bulge under his jacket.

I guess I thought Patrick would call poor Neal later that night and tell him it was all a joke (a thoughtful one). By then I'd already nipped off to one of the bars around the corner from my house and forgotten about it. I thought at least Billy Jack would clue him in.

But no one did. Not until well after 2:00 AM and closing time. Billy realized that neither Patrick nor I was going to call or stop by. Neal had soaked his sweater/polo outfit through by then, and a rich bloom of wetness was sprouting along the ass crack of his new jeans. He was rubbing his face, and his eyes were red and puffy. Billy finally told him.

I felt a little bad about how that prank turned out. I was going over the details of the incident with Patrick when he said something that made me feel much better.

"I can't believe that poor fucker actually snorted a fat rail of the stuff," he said, shaking his head and smiling at the very notion.

"What?" I hadn't heard about this.

"You didn't know?" Patrick was laughing now. "When he took it back to the bathroom, he decided to steal some. Cut the bag and stole a good ounce or two. At the end of the night he went back there, laid out a great big line, and snorted it."

Amazing. I wonder what that did to his sinuses. Thus the red eyes, the rubbing his face. He must have known instantly it wasn't coke. When Billy finally told him, apparently just a little too late, he must have been pissed.

. . .

LAST SUMMER THAT evil bastard Scott Ramsay really got me good. His personal shenanigans always have a distinct psychological edge. I suppose in another life, if he had no artistic skills, he'd be working in a secret military prison convincing people they were insane.

My first appointment that day was trouble, and I knew it. She was the younger sister of a client of mine whom I'd spent a lot of time with. In the course of two sleeves and a back piece, I'd learned all about his job, his personal life, even his family.

His sister was one unstable roadside bomb. I'd met her once, months before, after she'd moved to town fleeing a failed relationship with some king of ghetto monsters. After we'd been introduced, she got right to the point.

"I want a big flower here and here," she stated matter-of-factly. She'd drawn her short skirt up and exposed her inner thighs, the "here and here" areas. She wore no underwear. Her mons pubis was as bald as a store-bought chicken breast, gleaming with tanned athletic perfection as she arched it up at me. "And I want some vines and smaller flowers to trail up in here as far as you can." And then she left.

Well, it's a hard life. Having a naked, crazy chick with her legs spread in front of you for hours and hours is . . . I don't know. I usually barely escape these tests of my flimsy moral fiber. At that moment I was feeling a mixture of surly resignation, simple primate anxiety, and the all-too-familiar onset of an eerie, pre-contamination-guilt complex. I hadn't done anything even vaguely inappropriate so far, and yet I knew I'd at least think about it at some point. Even a monk would. My identity was afloat on a sea of poison.

I'd told Scott about all this, of course, grousing on and on about my precarious mental state, how it was too early in the morning to

face such a job. He was noncommittal as we set up. He seemed glad he wasn't me, and that didn't help.

At 11:30, a full half hour early, she arrived. Brown hair, same height, same swaggering, swinging-the-world-around-by-the-dick strut. It had to be the same girl. It looked grim already.

She wasn't wearing shoes, for starters, only a short coat. No pants either. She sashayed into the shop and my tongue went as dry as an ashtray and swelled in the same instant. In the movies you can always tell when something horrific is about to happen by the cues in the music. This was a moment where I strained desperately to catch a mere echo of a riff in my part of the cosmic symphony, once again to no avail.

In one hand she was carrying a greasy paper bag. As the door closed behind her, the coat swung open. She was naked underneath, with strips of black tape randomly adhered to her full breasts.

"You're Jeff Johnson?" she purred. She held the bag out. "I brought you a hot, steaming Reuben."

There was no way I was going to eat whatever was in that bag. I would not even open it. No fucking way in hell. I took a step back. She moved closer.

I was going to run for it. I looked at the counters and noticed Scott's machines lying out. Fuck it, he was on his own, I thought. This was a bona fide emergency.

I backed away through the gate in the tip wall, and she swished through after me. Looking at those long, powerful legs and the graceful arc of her feet, her pantherish stride, I knew I'd never make it. I'd selected vintage wingtip shoes that morning, not the footwear of choice for vaulting over tip walls, sprinting down corridors, and climbing fences to escape a deranged tigress with a fucking Reuben.

With a shaking hand, I reached out and took the bag, handling it gingerly, as if it contained parts of a disintegrating leper, if only to mollify her for a moment until I could manage to sacrifice Scott.

She winked, showed her ass with a vaudeville peekaboo, and walked out.

I stood there frozen, the bag still dangling from my outstretched hand. When I could move again, I went to the door and locked it, then watched as she climbed into a black truck. The truck idled where it was.

From far in the back of the shop came a choking, sneezing sound. I looked back and saw Scott's red face, his hand over his mouth, trying not to burst into hysterical laughter. I guess the expression on my face was way too much for him, because he buckled and howled like a drunken yeti.

"Gotcha," he crowed when he could finally speak.

"What?"

He could barely contain his laughter long enough to reply.

"I gotta go pay that stripper for your lunch before your appointment gets here."

I just stared at him. He was really enjoying this.

"The Reuben really is the most masculine of sandwiches," he said, and staggered out, holding his sides, after the black truck.

24

ARTFIGHT

Warfare is not what it used to be.
True, it's ugly, and it probably always will be, but now there seems to be a new component made up of wealthy old men pushing buttons. They're not one-eyed buccaneers screaming mad with ergot poisoning and bad rum, hobbling at the head of a shaggy horde looking for some piss-scared kid to chop down. They wear business suits and base their decisions on stocks and bullshit futures markets these days. They lack the understanding bound to dawn on even the slowest mind when a fight has been won and all it cost you was an eye and most of your teeth.

Warfare between directly competing tattoo shops has evolved over the years as well, though not along these sobering, conventional lines. We have something today's global powers lack: style. There is little in this world with the potential to be as terrible, as unwholesome, as unspeakably Machiavellian as tattoo jihad. The battles can rage for years across radioactive, crater-pocked fields of salt, through wrecked urban landscapes decorated with nuclear flash-point carbon shadows and populated by wild zombie dogs. The impressively creative energies unleashed will no doubt lead many to administrative positions in hell.

Shop-to-shop combat scenarios from the golden age run an almost quaint, period gamut. Arson, blackmail, hired beatings that often

backfired, even good old-fashioned murder. Driving cars into each other's lobbies was common.

Any modern tattoo artist can dig these time-honored tactics out of their arsenal, but few resort to them anymore. Shops still find time to mess around with each other, but the struggle today is generally waged on a higher plane. Subtlety counts. Creativity is paramount. A certain whimsical cruelty is to be admired. Art above all, in all things, is the credo.

STEALING EMPLOYEES IS sort of funny, except it has an air of garbology, as in digging through other people's trash. You generally get a prima donna malcontent nobody will miss. It can still work, but only if you get the patsy to run a savage burn on the way out, such as leaving without notice or leaving with shop property.

Stealing art and then brazenly displaying it has a certain flair, but it's sort of tacky and implies a weird suburban entitlement. It's the kind of thing Ted Nugent might do if he were a tattoo artist. Some measure of balls comes into play in this one. I know of at least one example of Bert Grimm flash stolen from the Sea Tramp that is currently hanging on another shop's wall. We just ignore it. But we do have pictures.

Ripping off a portfolio, often the sum of a career, is indeed a low blow, but stylistically worthless unless you pass it off to some scratcher who can then claim to be the mind behind everything and potentially cast a shadow over someone's reputation.

All these stunts are rightly viewed as amateur unless they employ a sweet twist, which is rare among such lowbrow practitioners. The real minds in this game break it off at the hilt and lick your face simultaneously in one smooth stroke.

Case in point: the "I Made You Move to L.A." sting.

This gnarly bit of judo was thrown down by a friend of mine a few years ago. To be honest, this dude scares me. I recently met up with him at a strange bar that was going out of business, literally being crated up and packed into a truck as we sat there, the only two customers, carefully ignored. I asked him if I could include this story in my book, and he leaned back and blew twin jets of smoke through his nostrils, studying me through slitted eyes.

"Call me . . . Ishmael," he said eventually.

"How about Nigel?" I countered.

He shrugged.

SO OUR SINISTER boy Nigel had a problem. A nasty one. Some hapless asshole had sauntered over his curious turf looking for a fight, and Nigel was upset. He wanted to solve the problem in a long-term sort of way. Somewhere in the dark laboratory of his mind, a plan was born, a strange, sulfurous vision I couldn't help but admire, in the same way one might admire a two-headed horse fetus in a jar.

The poor heel in question, Nigel's then-nemesis, was a well-to-do tattoo dork at a fairly well-known shop. A sort of handsome, crotch-rocket-riding name dropper with some sort of fako tattoo moniker like "Drip" or "Dribble." I honestly can't remember.

As near as I can figure, everyone despised this peculiar piece of shit. I met him once while visiting Nigel's fair metropolis, and I certainly did. For some reason, this witless gasbag decided he was fit to tangle with one of the truly spooky big boys in his hometown scene. Maybe he had a David-and-Goliath complex. Someone should have explained the ephemeral nature of parables to him, I guess.

It might have started innocently enough. No one seems to remember. Maybe in a nightclub while they were getting drinks at the same time they took one look at each other and it was DEFCON 1 at first

sight. Maybe Nigel just couldn't stomach this guy for reasons known only to him. Whatever the case, they locked horns. You must understand that Nigel is preternaturally cunning, reflexively creative, experienced and tasteful in everything. A brilliant tattoo artist, he is occasionally a gentleman, an atypical scholar, and something of a brooding lunatic, the kind of guy who is not generally dissuaded from achieving his strange goals.

The kid in his sights was meat.

NIGEL FIRST APPOINTED an accomplice, a guy who worked at a shop in Southern California. It all came down like this:

Nigel drafted a letter offering the kid a job and had it mailed from L.A. The letter was chock full of statements like, "I'm looking for an artist with your qualities and reputation to help shape and sculpt my staff. From what I've heard, you may be the man for the job, a rising star who can bring in an energetic perspective."

When the letter arrived, the kid called instantly. Nigel's accomplice fielded the call.

"Right, I was told to expect your call. Let me give you the boss's cell."

The cell phone was a pay-as-you-go deal purchased at a 7-Eleven. It rang right away.

An acquaintance of Nigel's answered, possibly his tailor or manicurist. Over the next half hour, they talked things over while Nigel hovered in the background scribbling out suggestions and priming the pump.

The kid's initial skepticism gradually gave way to a sort of mean-spirited sense of superiority. He must have known he was a hack on some level, but he was perfectly willing to be convinced otherwise. He got a little pushy and demanding. Nigel's mouthpiece allowed that he

might be receptive to some of the kid's demands. The kid said he'd think about it but doubted he'd go for it.

He called the shop again a few days later and was, luckily, intercepted by the accomplice again. This time they put on some pressure.

First the kid was instructed to call only the cell phone for the time being. The boss didn't really want his staff to know he was considering a new manager, as he hadn't let the old one go, and he didn't want any advance ass kissing to take place.

This appealed to the kid. Power over other people. An apparently lesser person's imminent demise. He was warming to the idea. Some inflated estimates of money were bandied about. The kid said he'd consider flying out for a few days on Nigel's dime to see if it was a "good fit."

At this point Nigel had to ramp things up or this would end in an inadequate disaster. Over the next few days, he had various people place calls to the shop the kid was working at, all posing as concerned customers who wanted something fixed or finished before the kid lit out for the coast. Nigel was banking on the fact that the kid had been bragging about the offer.

The kid's boss was naturally unhappy to learn that the little shit was about to leave town with little or no notice. It can take weeks to find a replacement, during which time the rest of the staff gets overworked and the shop totals go down. Only scumbags pretend this isn't true. There are several versions of the final confrontation that occurred between the kid and his boss. Most renditions have the following in common:

The kid broke down and confessed all. He was leaving their sorry asses in the dust, bound for glory and riches in sunny California. He wasn't even taking his girlfriend, as it was an established fact that pussy grew on trees in L.A. and was especially available to hot-rod tat-

too movers and shakers. The kid's boss told him he had exactly five minutes to pack his shit and get out of the shop and out of his sight or there would be savage violence.

That was that. The kid packed his crap, having both quit and been fired simultaneously. He left town a few days later.

The weird wrinkle is this: he never called the L.A. shop or the cell phone again. Nigel kept the phone for a month or so before he finally lost it or threw it away. Apparently he wanted to answer it when the kid called and say something pithy like "gotcha." But the kid never called.

Sometime later a rumor floated around that the chump had in fact moved to Denver, where he had family. He was in rehab.

Now that, dear reader, is panache.

The worst artfights begin like hurricanes. A dust cloud fails to form off the coast of Africa, a mule hiccups into the wind, a butterfly flaps its wings in just the wrong way. There are many stories like Nigel's. The main things are to leave the hands and face intact and never involve the law or a gun. Explosives, yes, bullets, no. A stripper in a pink cowboy hat, a stolen limo, and a briefcase full of spiders, yes. A trail of lawyers, no.

It occurs to me that Nigel would be an ideal secretary of defense.

THE RISE AND FALL OF A TATTOO SHOP

There are always signs.

Sometimes they're obvious: a brightly lit landing strip of crack pipes, blasted, naked dancers with rolling eyes, and wads of tar-streaked foil. The once-pristine shop has now taken on a dingy quality. Some of the lights have burned out, and the plants are all dead. Greasy, scabby-faced people with mullets are furtively coming and going. Customers are greeted with unhealthy desperation. A motorcycle has been partially dismantled in the lobby, and the entire place reeks of bad teeth and boozy urine.

I've had front-row seats at two spectacular wipeouts along these lines, though I've been witness to many lesser ones this year alone. One of them I'll always feel sad about; the other, relieved.

Rob and Coco claimed they met in the army, but it came out later that they crossed paths in state prison. While serving out their lengthy sentences (manslaughter and drug trafficking, respectively), these two hatched a brilliant plan, working it over detail by minute detail, with a strategic precision that Pentagon tacticians could learn a thing or two from. I can almost picture them holding court in the exercise yard, consulting with accountants in for murder, probing the minds of business management coke dealers, conversing with larcenous designers and corrupted admen, steadily pursuing degrees in their own

brand of market insanity. When they were released they hit the pavement on fast-forward.

I have to say, I liked these guys, even admired them for their laser focus and utter commitment. I never really went in for the convict set, but these two were somehow different. They borrowed some money from God knows where, made a few fast deals, and wound up with a big, well-turned-out parlor in a prime, heavily trafficked location. The business took off instantly. Practically overnight they went from slightly creepy left fielders to serious power brokers. They bought expensive motorcycles and parked them in the front windows. They traded in their faded blue jeans for leather pants, their old T-shirts for the very finest that Metallica's merchandising arm had to offer.

At first a lot of the money they made was wisely plowed right back into the shop. I don't think I've ever seen so much neon packed into a window. Stainless steel seemed to be growing everywhere, across the counters and up the walls like a live organism. The floors were redone several times until Rob and Coco were finally satisfied. Hats, shirts, bumper stickers, they did it all. Even their hair took on a certain moussed-up majesty.

They started a band, and that took off too. At this point in the story, Rob and Coco were living the high life, tattooing in their dream shop by day, neck-deep in an endless river of cash, surrounded by a bevy of admiring, slutty women, and rocking out like high-school heavy-metal gods by night. It was a round-the-clock party, and they were the guests of honor.

Some tattoo artists' territorial hackles go up when you visit them, but these guys were way too smooth for that. They always seemed genuinely glad to see me, stopping whatever they were doing for a quick chat about suppliers or to talk shop about machines whenever I popped in. They never gloated about their success, never once implied any superiority. They were geographically close to us and thus our direct competition, yet they never acted like it.

Then one summer day Rob's girlfriend stopped by to borrow a box of gloves, an item every tattoo shop with its shit together is generally well stocked up on. She seemed remarkably different from the last time I'd seen her. Only a month before, she'd been an obnoxious (but undeniably beautiful) stripper, always ready with a cold come-hither expression, strutting around in high heels and a super-mini with her butt cocked out like a baboon in heat. Now her face was pale and bloated and her eyes didn't seem to be tracking together. Her clothes were baggy, and her bare feet were filthy. She was as high as she could get and still walk.

A month later, Rob wrecked his motorcycle, mangling his leg in the process. And then Coco beat the shit out of him with the crutch he kept behind his wheelchair to lever himself onto the toilet. Shortly after that, Coco's girlfriend stabbed him in the armpit in a hotel room, paralyzing his right arm. Of course, Coco was right-handed.

The doors to their dream shop closed. Days went by and there was no sign of them. For a month or so, the last remaining neon sign blinked in the window, until it burned out or the power was cut. For some reason, an old car tire was lying in the middle of the floor when I looked through the grimy windows one last time. I went across town to visit their landlord, an old Jewish guy who ran a deli. I was interested in all the stainless steel they'd abandoned, and also, frankly, curious if he had any news about what had happened to them.

The landlord flew into a rage. Apparently the building was going to be condemned (it was demolished a year later). The toilet had broken *months* ago. The basement was filled with two feet of fecal soup. Rob and Coco and God knew who else had been squatting at the brink of this diseased subterranean pond and using it as a latrine. At some point, they started throwing used hypodermic needles into the thickening stew, so that hundreds of them now floated on the fetid, black surface. The landlord offered me five thousand dollars to find them

and "just say where, no questions asked." There was murder in his eyes.

They both went back to prison. Some time later I learned the origin of the dispute that had wrecked their little empire. Rob liked heroin; Coco preferred crank. It was actually that simple.

A decade later an old, fat guy walked into the shop. His grizzled rocker 'do was gray and thin on top. He looked at me and his eyes grew wide in recognition.

"Du-hude," he said. He threw his head back in a heavy-metal-wizard hair toss and crossed his skinny arms over his sagging belly.

"Rob," I said. He was my age, but he looked like he was ready for the retirement home. We reminisced about the old days for a while, which mostly involved listening to him revisit the high points of his career, the glory days before the drugs caught up with him. He still hated Coco.

And that's nothing.

Several years later I was eyewitness to a grotesquely extravagant level of destruction, a combination train wreck/meteor impact/nuclear detonation. By then I had learned to smell doom well before the sky filled with vultures. I knew this place was destined for numinous fire almost the instant it opened.

The captain of this particular *Titanic* was a great big blowhard who wore chunky gold jewelry and often sported a panama hat with a brightly dyed feather in it, loud Hawaiian shirts, and a fake cane to gesture with. For the life of me I could never understand how this dim, outmoded huckster rose to such Olympian heights, but he did. At its peak, the shop he ran was perhaps the largest tattoo shop on the West Coast. Their hourly rates were higher than those of the tattoo kings of Tokyo or San Francisco. They were booked solid for weeks in advance and turned business away with a laugh and a sneer. Their receptionist was insanely rude and almost entirely incomprehensible, and she was the charming one in the group. They had the best of ev-

erything, and they rubbed it right in everyone's face. I really enjoyed what came next.

Don Deaton and I went to a gala event they threw commemorating some anniversary of theirs; I forget which one—certainly less than five. While I was standing to one side with a plate of sushi, watching the milling crowd, a door opened behind me and the owner swanned out of his office on a contrail of sickly sweet heroin smoke, his big nostrils red-rimmed after a blast of what was probably really good coke. The tips of his waxed handlebar mustache quivered like rat whiskers. With his bizarre, almost color-blind clothing ensemble, he could have been some missing member of the Village People. He might also have been the reincarnation of whatever Roman emperor was getting a blow job the instant the Visigoths chewed into the border. His fate, though still over the horizon, had been sealed.

In a stupendous feat of rodent vitality, he rose even from there. The next annual party was held at his ranch, by all accounts a well-tended, sprawling affair where he lived in a geodesic dome with an indoor koi pond, the type of place where the postmodern and the ostentatious vied for stylistic dominion, like in an imposing, Swiss-made self-sterilizing toilet.

The fireworks started shortly thereafter.

The shop burned, the result of a "misplaced cigarette." I remember standing in the crowd of onlookers watching the shattered windows barf impressive gouts of oily black smoke. No amount of water the firemen hosed into the place made the slightest difference. It was like a giant magma pimple from the floor of hell had sprouted in the center of their lobby. There were a few other tattoo artists in the crowd, and some of the older ones shook their heads knowingly. I was really enjoying myself.

He pressed on, undaunted by this setback. The new shop was bigger still and even boasted an espresso stand, but this incarnation was circling the drain from the very start. Dealers were waiting around in

the lobby for the money to come in. Artists split for safer circles, by then hopelessly besmirched themselves. Secondhand accounts of depraved and sweaty madness filtered down to us every day. They ran the gamut, from gnarly sex shows with coke as the entrance fee to artists passing out on their customers and drilling gory holes into them with their tattoo machines. Eventually, the place was considered nothing more than a flagrant, balls-out dope emporium. The landlord closed the doors, and everything that was left inside, the pitiful remnants of what was once a small art fortune, was loaded into a dumpster in the rain. I watched the workmen for a while, smoking cigarettes in my car, wondering if I should go and ask them if I could buy some of the stuff that still had value. In the end I decided it was all probably cursed or stolen, so I drove away.

MOST OF THE time, the demise of a tattoo shop is a quieter thing. A good place, one that talented people worked really hard to raise above a high average, can go sour in myriad subtle ways. They start to close early. Then they begin to open a little late. They start taking sizable deposits on custom art and then don't spend much time on any of it, and it shows. They don't clean quite as much, and sometimes they seem a little stoned. A shift in public perception takes place, and soon enough everyone there is scratching their heads and wondering what the hell happened. The brightest artists with no stake in the ownership move on in search of that fresh energy sparking off shops on the rise. The doors close or the sign out front changes. This is the slow death associated with a lack of creative stamina.

A successful street shop can almost never transition into an all-custom, off-the-beaten-path boutique joint. I've seen this wrecking-ball, boneheaded move countless times. You get a handful of guys and gals with big heads who move from a location with good traffic to some kind of exclusive no-man's-land, and they quickly drop off the

public radar screen. Like the death from a thousand cuts, this one is painful to watch and takes a while.

People move. Some of them dream up new art projects and change gears. Some burn out and never grow back. Some hit a short bad streak, like a broken thumb or a torn rotator cuff, and without money in the bank they succumb to the vagaries of modern economics. Some find they like drugs too much and wind up in jail.

In this business there's no such thing as a warhorse in the traditional sense. Day in and day out, the goal is always the same. It's not to win the race; it's just to move as fast as you can, loping along like an indefatigable swamp panther. In a purely creative field, there are no real points of comparison to establish the anatomy of the racer other than an unerring ability to dodge oblivion. Everyone on the far side of this metaphorical field got there under a different steam, and they are all something better than winners. I look at the old guys I know, like Don Deaton and his contemporaries, and I see ancient tattoo artists with great stories and contented smiles, like they've eaten something vast and complicated and tasty and it's sitting well. I don't know what kind of otherworldly internal engines drove them across that finish line, but I'll let you know if I ever get there.

How did I, you ask, avoid getting sucked up into any of these tornadoes? Why was I spared? I can't say exactly, but a prime contributing factor is the Fear.

26

THE SHOP THAT TIME LEFT BEHIND

A couple of years ago, a fellow local artist from another shop (the very same Keith Rich who had been screwed over by our state laws) and I were called upon to work for a few days in Washington State. An artist we'd both been working on for the last year or so was going out of town, and he needed someone he could trust to man his shop. The days he needed covered were our days off, so we agreed. The place was apparently right next to a casino and catered to an assortment of drunks, bikers, and gamblers. It smelled like adventure. Our buddy dropped the keys by the Sea Tramp on his way south.

The shop wound up being a pretty nice place. The flash on the walls was out-of-date material bought through magazines, and I had to clean the toilet, but other than that we were reasonably well set up. We put out the "open" sign, and then we did something we don't normally do. We . . . waited.

The first few people through the door were just looking. What's more, they had absolutely no idea who we were. I decided to show off with some old-fashioned hucksterism, the type of hustle that seemed appropriate for the place, and landed them with some really lame grab.

Keith one-upped me by pulling some fancy footwork on an unsuspecting guy who was dropping off something for the shop's owner.

He went from wondering if we were insanely bold burglars to having Keith fill in a big piece of his arm.

The game was afoot.

For the rest of the day, the melee surged back and forth, each of us employing outmoded sales tactics from the early nineties. The Touching Therapist, the shameless Shared Interest Bond, the scuzzy Direct-to-Skin Custom Job, the earnest Let Me Fix That, and combinations thereof.

This was fun!

After we finished and cleaned up, we hit the casino. It was appalling, like some kind of tawdry relic from a seventies movie set in Atlantic City. The baroque patterned carpet had been bleached orange in spots where old people had vomited their gin and sodas. The plastic plants were gray with dust. The patrons were uniformly obese. Everyone stared at us like we were cavemen or Martians.

The bar was, well, a shit hole. They were actually reusing plastic cups, so that the transparent plastic was streaked with white stress marks and scratches. The fat guys at the sagging pool table in the corner stopped playing and gave us angry, territorial stares. We sat down at the bar and ordered a couple of martinis.

"You're a greaseball, dude," Keith said matter-of-factly, summing up my day's performance.

"I know," I replied, accepting his gracious acknowledgment of my superior nineties tattoo scumbag repertoire. "Did you get the weird feeling that we had somehow gone back in time?"

He had. Everything we did that day was from a different era. Cartoon characters, completely flat, dimensionless butterflies, and cheesy fairies with mullets. It was all straight from a portfolio circa 1990.

The second day was even better. Apparently word had spread that something unusual was happening at this quiet little tattoo shop. What ensued was a bloodbath of semiepic proportions.

Everyone from the day before returned with his or her relatives. I

drew one of Keith's designs for him, an image so utterly saccharine he could barely stand to look at it. He lashed back with surrealistic cruelty, throwing me into a wrestling match with a large woman's foot and then glowing with hellish delight. All the while, the feeling of those simple first days was all around us.

Everything was easy. It didn't really matter if we acted like animals, flirting with big, missing-toothed girls and generally acting like the worst sort of carnies, because we sure as hell were never coming back.

I felt sort of sad when we closed the doors that day. I half expected to hear the phone ring and have it be a long-lost friend. We went over to the casino and had a couple of martinis again, ready to fight the fat guys at the pool table and get kicked out by security.

I don't remember what we talked about, but I do remember a feeling of warm camaraderie. I'd never worked with Keith before, and, as it turned out, I never did again. He moved to Kansas or maybe Cleveland shortly afterward. But on that day we were just a couple of carefree guys doing what we loved, as giddy as eighteen-year-old weed dealers.

On the way back to Portland, he suddenly switched off the radio.

"We have to go back," he said.

"You forget something?" We had hurled the keys through the mail slot so they slid all the way across the lobby. No simple retrieval of them was possible. If he could actually break into the place with nothing more than the tattoo implements in the car, I was prepared to be impressed.

"Oh, yeah. I need to call my younger, dumb-ass self and steer him clear of this one particular woman, plus he should probably invest in Microsoft."

Reminiscing thus, we traveled back into the present.

.　.　.

IT'S NOT REALLY a paradox in tattooing that the shops that time left behind, the ones that are grossly out of sync with convention, are seldom actually old. They usually have fewer than five years under their belts and are located in the suburbs or small towns. You might want to reconsider the wisdom of getting a tattoo from a new place in the boonies. Businesses in sophisticated, competitive urban markets, no matter what they are, age and grow venerable without going under in only one way: by kicking ass.

Like the dentist who refused to learn anything after 1981, or the fish burrito stands of yesteryear, a tattoo shop that time left behind is a crappy place to find yourself. Personally, I love these places for purely sentimental reasons. But maybe you shouldn't.

It's still possible to go back in time in this field, and that can be a rewarding experience for everyone but the consumer. To the poor hack who thought tattooing was a glamorous, easy gig with good hours and a low overhead, the margins of civilization will always suffice in a bare-subsistence fashion. These operations are a snapshot of a breezy time in tattooing, the final era before the puritanical and, for many, career-wrecking introduction of "art" and sanitation.

WHY DO I tell this story? What the hell is the difference?

When I first started tattooing, the shops were very similar to this antiquated example. The customers were drunks, bikers, weirdos, and college kids. But more than that, we the artists were predominantly fuckups. No one really cared all that much about what we did, least of all me. Today that is not the case.

Back then we wore gloves when tattooing, but that was it. Scrubbing out buckets of used, bloody equipment in the back? Rinsing off used needles to be sterilized for reuse in the groaning chemclave that exploded from time to time? We wore no gloves. Like peasants in a remote village in a secluded alpine valley three centuries ago, the pre-

vailing wisdom of the time was that germs were a topic best not discussed. To even think about them was bad karma, bad enough to bring your entire past barreling into the present for an immediate reckoning. To change your ways was to admit you had been wrong about them all along, and that was psychologically destabilizing. It's amazing even one of us survived.

In those heady days, we poked ourselves all the time. Don Deaton's left hand is a speckled testament to what he calls "going too fast." The dots and streaks probably number in the thousands. No one covered their spray bottles. We didn't know to keep the pigments in the dark to prevent mold. We smoked cigarettes while working, an act of purely insane bravado, considering what got smeared all over them. Every day was a heinous orgy of contamination.

And the tools. Liners that used a single needle that you would re-sharpen, sterilize, and use over and over again, and tiny, crooked shaders of no definable structure that were about as sophisticated as sharpened raccoon femurs. The money was terrible and the hours were long, but the perks were unbeatable. No dress code or early mornings, no dickhead boss, a total lack of reality-based ethos all around, and just enough countercultural power to access the universe's greatest untapped reservoir of college pussy.

LAST YEAR MY wife and I flew into Vegas on vacation. The shops there are so clean and modern you could deliver a baby on the floor with no worries. The goal of our trip was to rent a fast car and tear out into the desert for a week of exploration. Somewhere in New Mexico, I found another time machine. I could sense its presence even before I saw it, like the smell of low tide in a place too dark to see the water, or an eerie disturbance in the Force.

The plastic sign read "tattoo" and was nailed above the door of a ramshackle 1970s modular. I pulled up in front, cut the engine, got

out, and stared through the grime-streaked window. There were flies and ghosts inside.

The walls were lined with tattered old magazine flash. A fat dude with a Confederate flag headband was hunkered over his belly in a cheap folding chair, grinding something into a Mexican kid's arm with a sparking, garbage machine in desperate need of an overhaul it would never receive. His naked spray bottle was a filth-encrusted death trap, streaked with the gore of his last thousand customers. His proud assortment of pigments sat rotting in the sun, the bottles so splattered it was impossible to discern the color of their contents. A pigment-streaked can of Bud sat within easy reach next to an over-flowing ashtray.

The guy looked up at me with stoned eyes and idly scratched the side of his nose with a red-streaked, gloved index finger, not a care in the world. The Mexican kid's face was a portrait of agony and misgiving.

I could have looked through that portal all day, but the guy was los-ing his buzz, my wife was getting restless, and I was sure to find one of these places again.

27

THE LOST PAINTINGS

A day will come when all my life's work will be buried or burned. Every last bit of it. Every piece of art I've ever slaved over, the countless hours I've spent in the chair, hunched over and concentrating, will all be gone. Every moment of every vision, the far-too-rare instances of near perfection, the fortuitous accidents, the mediocre, and the bad will all turn to ash or dust. Every trace of my artistry will be lost because people don't last forever.

Some of the designs will no doubt wander through time in the form of blurry images in photographs. The last people I ever tattoo will be young, I hope. Someday far in the future a genealogist may uncover a photo of one of them and notice the tattoo on their wrist. They might wonder who did it. Such is the quasi-immortality of this trade.

Tattoos all mean something. We'll get to that last, but they are all the work of someone, a work *on* someone, something personal that transpired between artist and patron in a way that is far different from any relationship you have with a kitchen designer or wardrobe stylist, or even the painter of your portrait. A tattoo is on you for good, and someone with a name did it. It's there for as long as you are, a testament to your taste and our skill, or the mutual lack thereof.

. . .

DISPLAYS OF RAW humanity are rare in my crowd. I've hurled a few into the group of my most trusted friends over the years. When my old pal Matt called me late one night, clearly distraught, I was ready to listen.

"Mason's dead," he said, and I knew instantly why he was so upset, and also why he wasn't telling his wife or a family member this story instead of me. Matt had just lost something sincerely important to him, something unique that he had no doubt hoped would last far longer, that he could age in tandem with and appreciate over the long years, a thing he might peek at from time to time and see something of himself in, a measure of the quality he gave to the world at a certain time.

To begin with, Mason was a real character. He owned a bar on the far outskirts of the city and drove an hour to get to the shop with a Bloody Mary in the drink rest of his SUV. Over the course of two or three years, Matt covered Mason's entire body with one of the most complicated tattoos imaginable. It was an underwater scene, though frankly Mason never struck me as the scuba-diving sort. Matt was one or two sessions away from finishing when Mason's liver failed and he went into a coma. His kidneys shut down. Mason died.

It's hard to understand unless you've been there exactly how this hurt my friend. In this instance, it was more than just the art that was gone. After all the time spent together, of course some relationship had formed between them. Mason was like a strange breed of cousin, or brother-in-law, or perhaps dude-he-went-to-high-school-with to Matt. It's hard to say, really, what he was. But that he was gone was painful, and what he took with him made it all the worse.

You feel a loss to some degree every time, really, no matter how small the tattoo. There's something bright and wonderful about decorating people, and something dark and awful when they go cold and pale and that piece of art goes down the well.

I still remember most of them, the ones I am aware of who are

gone. The very first was this kid: I can't recall his name, but I remember a great deal about him. What he looked like, the tattoos he got, his love of horror movies, the black backpack he carried around. His next-door neighbor was this old lady who would give him blow jobs whenever he was drunk, and he hated himself for this weakness. Some fucker stabbed that sweet little mutant to death in the parking lot of a bar called Tiny Bubbles.

There are many more.

The two very worst for me were pretty wrecking experiences. One day a middle-aged woman walked by the shop. She stopped, peered through the window, and then turned around and came in. She was carrying a bag of crap she had just purchased at the Saturday Market under the Burnside Bridge. She looked around for a minute and started asking me standard questions about tattoos. Eventually, she told me in a halting voice that her only child, her son, had died of a heroin overdose. He had been a college student majoring in international studies, not the type at all. He had a tattoo, she explained, and she wanted to get one herself, in memory of him. It would be at some point in the future, as he had died very recently.

"What kind of tattoo did he have?" I asked sympathetically. Her eyes immediately lit up.

"Oh, it was a fantastic Medusa head. The face was like a portrait with little gems along the hairline. It covered most of his back."

This was bad. Right over her shoulder was a picture of her son's back. I'd done his tattoo. She followed my eyes and slowly turned around. Her sobbing sounded like the cooing of nesting pigeons, real and heartfelt, somehow not even human. I gave her the picture and she stumbled out clutching it to her chest.

A few months later, she came back and got a tattoo. I tried to flirt with her, to make her feel young again, anything but a woman who had outlived her child and saw only sorrow and wrinkles in the mirror. Somehow everything came out wrong and jumbled, and by the

end I felt like I was on acid in a police station. I don't know what she felt, but it couldn't have been pretty.

A guy named Vince used to come around and get tattooed. I think the last one he ever got was a rope around his neck. Sometimes he'd just stop in and tell me about his life. We became friends of a sort. I'd buy him a beer every once in a while if I ran into him out on the town. He drifted further and further into himself, and a time came when it seemed like he didn't have anybody. It made me uncomfortable to spend a few minutes alone chatting with him, giving him stupid advice about genital warts or whatever he wanted to talk about, but I always did. I guess I was his last link to humanity, some guy in a tattoo shop. Then one day, even I wasn't there.

My wife and I had gotten married in Canada and then gone to Europe for a few weeks. When we got back I learned that Vince's bloated corpse had just been cut down a few days earlier. He'd hanged himself under a bridge in Forest Park. A jogger found him. I have a picture of me and Vince, one that he gave me, from a bar where we had run into each other on some New Year's Eve. I never showed it to the guy who covered my shifts to see if Vince had come into the shop looking for me. I don't want to know.

So many of them died in the Gulf Wars. Car wrecks. Drugs. Suicide. Every one of them took a little piece of me with them, and someday there won't be a single one of them left.

I wonder if during the cremation process the pigment sparkles, like metal in a microwave oven. I sort of hope it does. It's the kind of thing I think about late at night when I can't sleep.

WHEN BERT GRIMM died years ago, Don Deaton was one of the pallbearers at the funeral. One of the other people carrying the casket was much younger than Don, in his midtwenties. There was a reasonably fresh tattoo on his arm, unmistakably Bert's work.

That somehow made Don feel better, as though a little piece of Bert were still alive. But I've known the old guy long enough to read between the lines. Don has a very expressive face. As he relayed this story, I could see he was looking at the band of roses he had done on my wrist, the symbol in our venerable establishment of a relationship between teacher and student. I put off getting the tattoo for almost two decades. In the end, I got it because Don was finally slowing down. He turned seventy that year. The starter pistol in his personal race to oblivion was ready to fire.

THE AVERAGE AMERICAN works way too much. Under our glorious, enlightened, humanist system of capitalism, we get to spend a significant chunk of our life span doing something for someone somewhere, when most of us would rather be doing almost anything else for anyone, anywhere. The small window of freedom comes at the end, when you're too old and broken and worthless to be of any use to the grinding machine any longer. Most of my customers don't really like their jobs. They tolerate them or despise them. People have largely given up on trying to be happy or content all the time and now unfortunately reserve such notions for their shrinking, increasingly impoverished and restricted private time. It's ugly but so pervasive that no one seems to notice, like the way every number is now art-lessly displayed using the digital template of the numeral 8. It's just another drop in the Kool-Aid–dark tsunami. Sometimes I wonder when the great freak-out will occur.

So I and many of my colleagues don't really feel all that bad in the end about the grisly fate awaiting the sum total of our efforts in this life. It seems, in fact, quintessentially American that the product of those few who managed to find both happiness and contentment in their working lives should disappear completely. It's a high price, but I'm willing to pay it. Like the notion of my own eventual destruction,

I'll just try to ignore it as best I can. When my last piece vanishes from the world, I'll be long gone anyway.

On a lighter note, I occasionally console myself with the fact that my early tattoos, the embarrassingly crappy ones, will be the first to go. Cold comfort, maybe, but then again, you haven't seen them.

TATTOOING THE SUPEROLD is always a gas. I have a picture somewhere of an eighty-plus-year-old woman and myself, in which I'm tattooing a replica of her favorite bracelet around her wrist. She'd been a milliner her entire adult life, and as a result, her arthritis had gotten so bad that she could no longer fasten the tiny clasps. She loved her hats and finery.

This was a delightful character. Her wizened face was a map of millions of smiles and secret delights, an old woman's most excellent ornament. I hope my wife's face looks like that when she reaches her eighties. The old woman glowed with some quality I am still too young to understand, but I can guess that there must have been great love in her life, disasters overcome, challenges met that only made her stronger. I could easily be wrong. What I knew for certain was that this tattoo was going to have a short shelf life. Someone should have done it long ago.

You can't help but wonder in such situations. Did this old milliner always want a tattoo? Was she one of the women of that distant black-and-white-movie era who yearned for something both ripe and conventionally impure? Did she wait until the very end to cut her bonds with some Pentecostal programming by marking herself with her chosen signature? Did any of the old men at the home have some Viagra and a martini for this noble creature? Could she still dance?

I don't like these experiences and the train of thought they inevitably lead to. Neither do many of my colleagues, but, like them, I'll swamp panther through, introspection be damned.

A few years ago a client of mine booked an appointment for her grandmother. When they arrived, I was shocked to see a withered, failing, gray-faced old lady with an oxygen tank in tow. She moved slowly, as though something in her middle was broken, leaning heavily on her granddaughter.

The tattoo was to be a version of a family logo I had designed for them. Hers was to have a heart around it. I settled her into the chair with great care after the standard preamble. I didn't want to do this. Her doctors might be mad at me, for one thing. After a quick aside with her granddaughter, I was assured that she had consulted with them and had been informed that it wouldn't make any difference at this point.

We talked quietly during the process. This crone seemed bitter, like a person who had lived for a long time in a place with no color. And now the curtains were closing. The show was almost over.

Of course I selfishly reflected on my own life. What might I have done differently? Was I paying all that much attention? Had I "optimized" my human experience? Oscar Wilde said that the greatest work of art was the human experience, to be viewed alone by the person who lived it at its conclusion. What the fuck did my life-painting look like?

When the tattoo was done and the old lady was bandaged up, she hobbled out under her own steam, like a penguin with a spinal injury. She looked back in the doorway and caught my eye. I was watching intently, afraid she might fall.

"Remember this old gal," she rasped.

Like I'd ever forget.

28

WHAT DOES IT ALL MEAN?

We were ten minutes into this awful little soiree and everything had already gone to hell. It was held in some quaint suburban condo with stark, asylum-white walls and garish Indian slave-labor decor. The great man in question, an alleged associate of Gandhi and the reason behind this gathering, had already peed his pants. There were at least three hours to go before I could return to my home planet.

No matter what I asked, no matter how hard I tried to steer the conversation around to some story about Gandhi, I was met with a dodge that led right back to the dogma of the cult that was currently desperate to indoctrinate me.

"What did he like to eat?" I asked. A simple question for which there could be no evasion.

"A very interesting question," Pee Dude replied. "Baba says that what we eat is reflected in our souls. Gandhi believed this." Everyone clapped, like this meant anything.

It was all a ruse, a last-ditch attempt by the parents of the woman I had married in Vegas all those years ago to smack some sense into my hollow head. They were whipping out the big guns, I realized. They knew I couldn't resist a chance to interact with even a pale remnant of world history. Pee Dude was their finest mouthpiece, their high-plains drifter, their pussy-eating swamp panther.

After a little more of this bumpkin preacher routine, I drifted away in search of a beer and a safe place to smoke a cigarette. I found neither. Instead, I chain-smoked in the driveway while being gently prodded and probed by some lesser functionary. After three cigarettes he gave up and became surprisingly civil. Eventually, it was time to eat.

There was chanting, of course, which succeeded in finally creeping me out. The food turned out to be a light, greasy snack. The conversation ranged from evidence that their prophet's coming was foretold in the Bible to long, gibbering, gushing testimonials of spiritual bliss that sent shivers up my tightening scrotum. Pee Dude presided over the table like the regal trainer of a pack of housebroken baboons. The entire presentation was so painfully retarded that I found myself at a loss. I could barely think under the cloying, suffocating cloud of psychic Prozac.

I started to get cranky.

Someone made an awkward segue into current social trends and began pointing out how it was all a desperate, sorry cry for guidance. Furtive looks were cast my way. The pile of deep-fried soggy vegetables and grayish yogurt in my stomach slowly roiled around like a half-dead carp in an old sweat sock. My temperament was decidedly surly when the inevitable happened: all glassy eyes turned to me, the spiritless outsider.

"So, Jeff," began the little ape woman who owned the place, "what are you going to do when you grow up and decide you don't want those tattoos on your temple?" Everyone had on their best Stepford smiles. Pee Dude's eyes twinkled, his round face set in a rictus of profound inner wisdom. Here I was, lured in by the promise of talking with someone who knew Gandhi, one of the last century's most enduring symbols of coexistence. If I could have vomited a glittering distillation of pure irony onto the table, I would have done so in peaceful protest. Big time, and twice.

"I guess that will be too fucking bad," I replied. In that instant I felt

like a peacock: proud, loud, and stupid. But still smarter than domesticated turkeys.

That was that. I was shunned like a gay Amish porn star. Pee Dude shambled off to take a nap, two chubby women doting on him and holding his arms. I was informed, among other things, that my short-lived Vegas dalliance was over.

I HAVEN'T LOST very much by being heavily tattooed, or by being a tattoo artist. This is a scenario played out more and more often as this highly personal art form grows. It's happened over and over in recent history, and eventually, after a long fight, the self-righteous get their pedestals kicked out from under them.

Why do people even bother? What the hell does it mean? Why are people getting tattooed?

I asked a few random customers. Some of them had sentimental reasons, but most of them didn't.

"Why a hummingbird?" I asked one woman.

She shrugged. "I like them."

That's the truth.

Why eat a bloated goose liver instead of a corn dog?

Because it's good.

Why drive an Alfa Romeo instead of a Pinto?

It's a cool car.

Maybe it is that simple. Maybe enabling the general population to learn about art, to actually buy original art for themselves, will lead to the downfall of Thomas Kinkade. That would be sweet. What we are doing is in fact the exact opposite of what that schlocky fraud is up to. One of my buddies told me a while ago of a terrible snowstorm in Buffalo. He was trapped in some kind of hellhole with nothing but a Thomas Kinkade puzzle. When he finished it, he realized he was close to suicide.

You can go a step further. A hummingbird is a topic. Why not just get a picture of a hummingbird and put it on your desk?

Maybe the reason is all around us.

Pee Dude and his buddies are real. As real as the manager of your local grocery store, as demanding as the guy behind the big desk at your bank, as compelling as the dickhead promoting team building at some midsized corporation, as profound as the inspirational speaker at the company picnic.

The tools of homogenization brought to bear on the average person today are many and powerful and clever, much more so than Pee Dude, though he's a perfectly transparent example. After that bizarre encounter, I began to notice more sophisticated Pee Dudes on every channel, in public office, behind uncounted podiums. We're fucking surrounded. Mass media, the corporate labor environment, and personal identity existing together in harmony, well, I can sense a problem there. Look at the military, for instance. Those people are really pressed to conform, and they have a history of getting tattoos like no other group. It could be that the thought of fitting in fills a growing number of people with some measure of disgust. Everyone started out thinking they were special in some way, different from everyone else. Then they grew up and got herded into the cattle chutes, and what they could hear in the darkness in front of them sounded a lot like screaming.

A lot of tattoo guys and gals I know have a suspicion that I sometimes agree with, especially in my less cynical moments.

There is a singular quality in every person, a thing inside all of us that yearns to be free, to stab the boss in the eye with a pencil, to screw off some pressing obligation and get drunk on the porch, to just take a deep breath and stop worrying for a single afternoon, to say, "I live in this skin. I will be me from now on, and I respect your right not to give a shit what I'm doing in here." Everyone knows those people are out there, the ones who slipped through the cracks, dodged

the man, foiled their family's bleak dreams, and sprinted over the star-speckled horizon into the land of dreams of their own design.

There are a lot of tattoos in that crowd, some good, some bad, and some that defy evaluation, and the numbers are growing. I hope more than I'd like to admit that this is true, that the rise of this very personal art form is a sign, a harbinger of something good that is as yet a hazy outline flickering in tomorrow but growing stronger. And if it is?

Welcome to the party.

ACKNOWLEDGMENTS

For me, at least, writing a book was like driving through a foreign land without a road map. It was a damn fine adventure. I made some new friends along the way and was cheered on by many of my old ones.

I'd like to thank the great Pacific Northwest bookman Charles Seluzicki for suggesting that I write about my life in tattooing and then helping at every turn to see the project through. Thanks to great pals Don Deaton and Robert Setchell, the very finest of people, who would offer a hand if I decided to dig my way to China. I tip my hat to Karen Kirtley and her students at PSU, and to Jimmy Eyebrows. To my agent, Richard Pine, a swamp panther if there ever was one, *gracias*. To Masie Cochran at InkWell as well. And to my crack team of Trojan hooligans at the Sea Tramp Tattoo Company. Thanks for keeping our sweet madhouse under control while I had other stuff on my mind. And to my editor, Tina Pohlman, as well as Julie Grau, Michael Mezzo, Mya Spalter, and the Spiegel & Grau cast of characters. It was a pleasure. And to early readers Josie Lilly, Jacque Laura, Nathan Winters, and Nika Helmer, for letting me know I was on the right track.

A special thanks to my wife's wonderful family, who have come to mean so much to me, especially my father-in-law, Larry Gifford, who told me to pull no punches at just the right time (the beginning of this project). And finally, thanks to the beautiful woman herself, Laura J, for letting me work all the time, and for peeling me away when I needed it, filling me with great food and love. It was all for you.

ABOUT THE AUTHOR

JEFF JOHNSON has been tattooing professionally for eighteen years and is the co-owner of the Sea Tramp Tattoo Company, the oldest tattoo shop in Portland, Oregon. This is his first book.

ABOUT THE TYPE

This book was set in Scala, a typeface designed by Martin Majoor in 1991. It was originally designed for a music company in the Netherlands and then was published by the international type house FSI FontShop. Its distinctive extended serifs add to the articulation of the letter forms to make it a very readable typeface.